INSECTS/S
S01-57

Page	C.N°	Object Name
218	S48	ARANEA
216	S32	CELOSTERNA
216	S34	CERAMBYCIDAE
214	S16	CHALCOLEPIDIUS
214	S23	CHELODERUS
217	S44	CHRYSINA BEYERI
217	S43	CHRYSINA VICTORINA
214	S22	CHRYSOCARABUS AUR.
218	S51	CHRYSOCHROA
215	S28	CHRYSOPHORA AURON.
217	S39	CHRYSOPHORA CHRYS.
218	S47	CHRYSOPHORA PYROS.
218	S53	DICRANORRHINA D.
217	S45	EUCHROEA CLEMENTI
219	S56	EUPATORUS GRACIL.
217	S38	EUPHOLUS BENNETTI
218	S46	EUPHOLUS SP 01
219	S55	EUPHOLUS SP 02
214	S24	EURYPHAGUS LUNDI
218	S49	FORMICA
219	S57	GOLOFA PIZARRO
216	S35	GYMNETIS PANTHER.
216	S36	GYMNESIS STELLATA
219	S54	LOCUSTA
217	S41	MOUHOTIA PLANIPEN.
216	S33	PACHYTERIA DIMID.
214	S25	PACHYTERIA EQUEST.
213	S07	PAPILIO 01
212	S03	PAPILIO 02
213	S12	PAPILIO 03
213	S06	PAPILIO 04
212	S04	PAPILIO 05
212	S01	PAPILIO 06
213	S13	PAPILIO 07
212	S02	PAPILIO 08
212	S05	PAPILIO 09
213	S09	PAPILIO 10
213	S10	PAPILIO 11
213	S11	PAPILIO 12
213	S08	PAPILIO 13
213	S14	PAPILIO 14
214	S15	PAVIEIA SUPERBA
214	S20	PELIDNOTA AUREOCU.
214	S21	PELIDNOTA PUNCTATA
217	S40	PHAEDIMUS JAGO
216	S31	PLINTHOCOELIUM
214	S19	POLYBOTHRIS SUMPT.
217	S42	POYBOTHRIS QUADRI.
215	S29	PSEUDOMYAGRUS
215	S27	ROSALIA ALPINA
218	S50	SEMIOTUS LETEIPEN.
218	S52	SEMIOTUS LIGNEUS
216	S37	STEPHANORRHINA
215	S26	STERNOTOMIS
216	S30	THEODOSIA PARAKEN.
214	S17	TRAGOCEPHALA
214	S18	TRAGOCEPHALA CRAS.

BIRDS/T
T01-15

Page	C.N°	Object Name
223	T15	BIRD
222	T02	DUCK 01
222	T08	DUCK 02
223	T11	DUCK 03
223	T09	EAGLE
223	T13	HERON
222	T03	OSPREY
222	T06	PIGEON 01
222	T07	PIGEON 02
222	T04	PIGEON 03
222	T05	PIGEON 04
222	T01	SEAGULL 01
223	T10	SEAGULL 02
223	T12	SEAGULL 03
223	T14	TITMOUSE

MAMMALS/U
U01-15

Page	C.N°	Object Name
226	U02	BOXER
226	U10	CAT
226	U01	DALMATIAN
226	U07	GUINEA PIG
226	U08	HORSE
227	U11	PIG 01
227	U13	PIG 02
227	U12	PIG 03
227	U14	PIG 04
227	U15	PIG 05
226	U05	PITBULL 01
226	U09	PITBULL 02
226	U03	RAT 01
226	U04	RAT 02
226	U06	TURTLE

FOOD/V
V01-39

Page	C.N°	Object Name
231	V14	APPLE 01
231	V15	APPLE 02
232	V24	ARTICHOKE
232	V17	AVOCADO
232	V22	BANANA
233	V28	CHERRY TOMATO 01
233	V25	CHERRY TOMATO 02
233	V26	CHERRY TOMATO 03
233	V29	CHERRY TOMATO 04
230	V03	CHILI 01
230	V04	CHILI 02
230	V05	CHILI 03
230	V07	CHILI 04
230	V08	CHILI 05
230	V10	CHILI 06
230	V11	CHILI 07
234	V33	CRAB
232	V18	FENNEL
230	V02	FIELD MUSHROOMS
235	V39	FISHBONE
230	V09	GREEN PEPPER 01
230	V12	GREEN PEPPER 02
232	V23	LEEK
234	V30	LOBSTER 01
234	V35	LOBSTER 02
235	V36	OCTOPUS 01
235	V37	OCTOPUS 02
235	V38	OCTOPUS 03
232	V16	ONION 01
232	V20	ONION 02
232	V21	ONION 03
232	V19	PEAR
231	V13	PINEAPPLE
230	V01	ROCKET
230	V06	ROCKET LEAVES
234	V34	SHRIMP 01
234	V32	SHRIMP 02
234	V31	SHRIMP 03
233	V27	TOMATOES

MUSHROOMS/W
W01-16

Page	C.N°	Object Name
238	W02	AGARICUS AUGUST
239	W12	AMANITA MUSCARIA
239	W16	BOLETUS EDULIS 01
239	W09	BOLETUS EDULIS 02
239	W15	BOLETUS EDULIS 03
239	W11	BOLETUS EDULIS 04
238	W08	CALOCERA VISCOSA
238	W01	LECCINUM SCABRUM
239	W14	MACROLEPIOTA PROC.
238	W05	OUDEMANSIELLA M. 02
239	W10	OUDEMANSIELLA M. 01
238	W04	PANAELUS CINCTULUS
238	W06	PSEUDOCLYTOCYBE C.
238	W07	PSYLOCIBE AZUR.
239	W13	RAMARIA EUMORPHIA
238	W03	RUSSULA AURATA

LEAVES/X
X01-37

Page	C.N°	Object Name
242	X01	LEAVES 01.01
242	X02	LEAVES 01.02
242	X03	LEAVES 01.03
242	X04	LEAVES 01.04
242	X05	LEAVES 01.05
242	X06	LEAVES 01.06
242	X07	LEAVES 01.07
243	X08	LEAVES 01.08
243	X09	LEAVES 01.09
243	X10	LEAVES 01.10
243	X11	LEAVES 01.11
243	X12	LEAVES 01.12
243	X13	LEAVES 01.13
244	X14	LEAVES 02.01
244	X15	LEAVES 02.02
244	X16	LEAVES 02.03
244	X17	LEAVES 02.04
245	X18	LEAVES 02.05
245	X19	LEAVES 02.06
245	X20	LEAVES 02.07
245	X21	LEAVES 02.08
246	X22	LEAVES 03.01
246	X23	LEAVES 03.02
246	X24	LEAVES 03.03
246	X25	LEAVES 03.04
247	X26	LEAVES 03.05
247	X27	LEAVES 03.06
247	X28	LEAVES 03.07
247	X29	LEAVES 03.08
248	X30	LEAVES 04.01
248	X31	LEAVES 04.02
248	X32	LEAVES 04.03
248	X33	LEAVES 04.04
249	X34	LEAVES 04.05
249	X35	LEAVES 04.06
249	X36	LEAVES 04.07
249	X37	LEAVES 04.08

PLANTS/Y
Y01-23

Page	C.N°	Object Name
255	Y18	PLANT 01
253	Y04	PLANT 02
254	Y11	PLANT 03
254	Y10	PLANT 04
252	Y01	PLANT 05
254	Y13	PLANT 06
253	Y08	PLANT 07
253	Y03	PLANT 08
253	Y06	PLANT 09
253	Y07	PLANT 10
252	Y02	PLANT 11
253	Y05	PLANT 12
254	Y09	PLANT 13
255	Y17	PLANT 14
255	Y15	PLANT 15
254	Y14	PLANT 16
254	Y12	PLANT 17
255	Y16	PLANT 18
255	Y19	PLANT 19
256	Y20	PLANT ON A TROLLEY
256	Y21	POTTED PLANT 01
257	Y22	POTTED PLANT 02
257	Y23	POTTED PLANT 03

TREES/Z
Z01-23

Page	C.N°	Object Name
268	Z16	ALDER TREE
263	Z10	CHESTNUT TREE 01
262	Z09	CHESTNUT TREE 02
265	Z13	CHESTNUT TREE 03
268	Z17	CHESTNUT TREE 04
261	Z05	ELM TREE 01
261	Z06	ELM TREE 02
261	Z07	ELM TREE 03
269	Z18	ELM TREE 04
264	Z12	LIME TREE 01
264	Z11	LIME TREE 02
270	Z21	MAPLE TREE
262	Z08	NEUBAUM
271	Z23	OAK TREE
267	Z15	POPLAR TREE 01
266	Z14	POPLAR TREE 02
269	Z19	TREE 01
260	Z01	TREE 02
260	Z03	TREE 03
260	Z02	TREE 04
260	Z04	TREE 05
270	Z22	TREE 06
269	Z20	WHITE POPLAR TREE

INDEX/TECTONIC

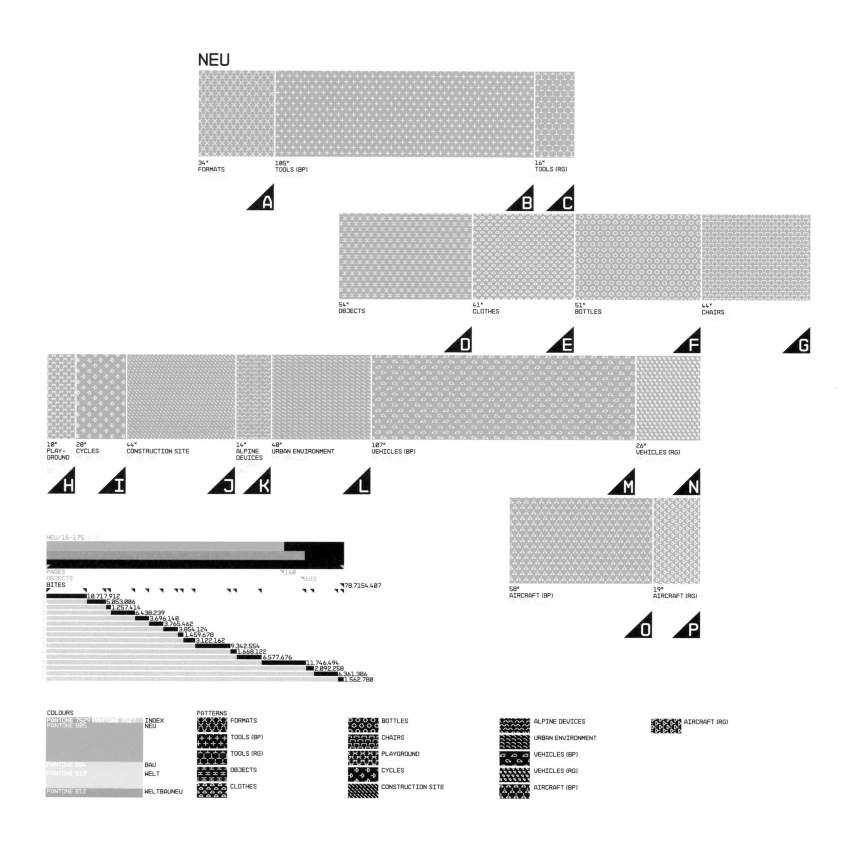

BAU

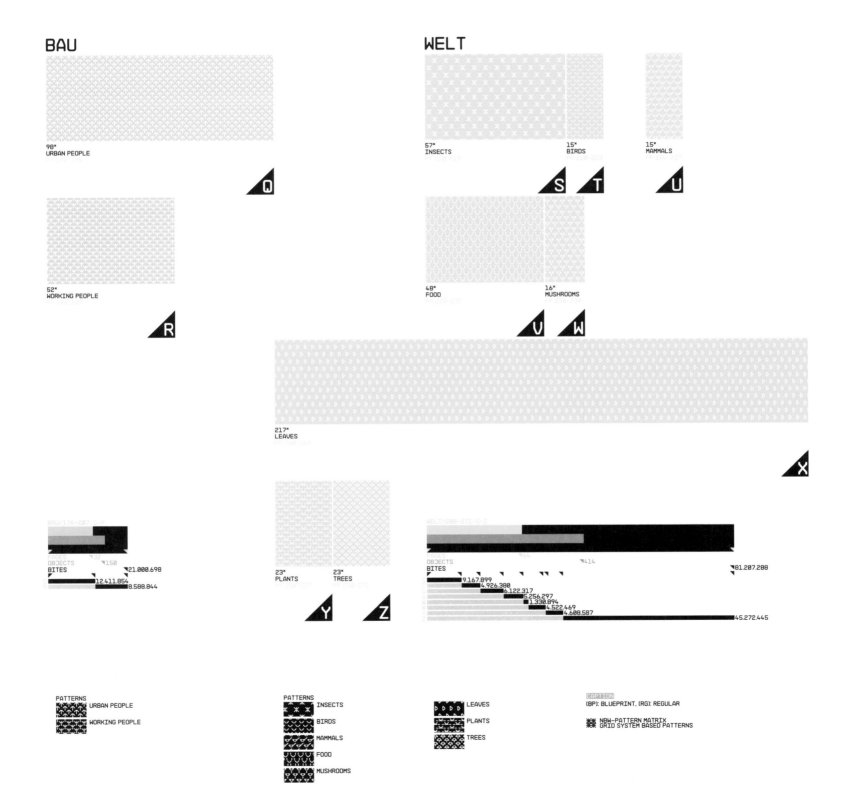

90%
URBAN PEOPLE

Q

52%
WORKING PEOPLE

R

WELT

57%
INSECTS

S T

15%
BIRDS

15%
MAMMALS

U

48%
FOOD

V W

16%
MUSHROOMS

217%
LEAVES

X

BAU/176-207/1-R

PAGES
OBJECTS 150
BITES 21.000.698
 12.411.854
 8.588.844

23%
PLANTS

23%
TREES

Y Z

WELT/208-271/S-Z

PAGES
OBJECTS 414
BITES
 9.167.899
 4.926.380
 6.122.317
 5.256.297
 1.330.894
 4.522.469
 4.608.587 81.207.288
 45.272.445

PATTERNS
URBAN PEOPLE
WORKING PEOPLE

PATTERNS
INSECTS
BIRDS
MAMMALS
FOOD
MUSHROOMS

LEAVES
PLANTS
TREES

CAPTION
(BP): BLUEPRINT, (RG): REGULAR

NBW-PATTERN MATRIX
GRID SYSTEM BASED PATTERNS

IMPRINT

EDITED BY ROBERT KLANTEN & MIKA MISCHLER
PUBLISHED BY DIE GESTALTEN VERLAG, BERLIN, 2005 ISBN 3-89955-072-2

AUTHOR STEFAN GANDL/NEUBAU
CONCEPT, DESIGN & GESTALTUNG NBWELTMEISTER/NEUBAU

SEREINA ROTHENBERGER (SUI)/CHRISTOPH GRÜNBERGER (GER)
CLAUS MAYR (GER)/BENJAMIN METZ (GER)
MIKKEL DUE PEDERSEN (NOR)/JOEN SZMIDT (SWE)
STEFAN GANDL (AUT)

NEUBAU WWW.NEUBAUBERLIN.COM CONTACT WELT@NEUBAUBERLIN.COM
SHOP WWW.NEUBAULADEN.COM

ENGLISH TRANSLATION ROBERT MEEK LEGAL CLEARANCE JULIAN SORGE
PRODUCTION MANAGEMENT JANNY MILSTREY
PRINTED BY KHL PRINTING PRINTING CO PTE LTD PRODUCTION SUPERVISION AVA BOOK
PRODUCTION PTE LTD/SINGAPORE PAPER IKPP ORIGINAL WHITE

TYPEFACES NB55R™ & NB55RBX™, DESIGNED BY STEFAN GANDL
COPYRIGHT (C) 2002 ALL RIGHTS RESERVED

/THANKS

AUDI AG/BMW AG/
CADILLAC & COR
VETTE DEUTSCHL
AND GMBH/CITRO
EN DEUTSCHLAND
AG/DAIMLERCHR
YSLER AG/FIAT A
UTOMOBIL AG/HO
NDA MOTOR EUROP

/THANKS

E (NORTH) GMBH/L
ANDROVER DEUTSC
HLAND GMBH/ADAM
OPEL AG/PEUGEOT
DEUTSCHLAND GMB
H/SAAB DEUTSCHL
AND GMBH/SCHOPF
MASCHINENBAU GM
BH/SKODA AUTO D

EUTSCHLAND GMB
H/VOLVO CAR GER
MANY GMBH/VOLK
SWAGEN AG/KNOL
L INTERNATIONA
L SPA

THANKS TO THE FOLLOWING CORPORATIONS FOR THEIR KIND SUPPORT AND PERMISSION
SECTION/VEHICLES/OPEL: BY COURTESY OF ADAM OPEL AG, SECTION/AIRCRAFT/PUSHBACKS: BY COURTESY OF SCHOPF MASCHINENBAU GMBH
SECTION/OBJECTS/DESIGN CHAIRS: BY COURTESY OF KNOLL INTERNATIONAL SPA
SPECIAL THANKS TO WERNER FRANKE, ALEXANDER DEWHIRST, FLURINA ROTHENBERGER, FREDERIK FREDE, TOBIAS KESTEL

NEU (A-P)

FORMATS/TOOLS
(BP/RG)/OBJECTS
/CLOTHES/BOTT
LES/CHAIRS/PLA
GROUND/CYCLES/
CONSTRUCTION S
ITE/ALPINE DEV
ICES/URBAN ENV
IRONMENT/VEHI
LES (BP/RG)/AIR
CRAFT (RP/RG)/+

+34
OBJECTS

+56
OBJECTS

+15
OBJECTS

+52
OBJECTS

+40
OBJECTS

+51
OBJECTS

+44
OBJECTS

+11
OBJECTS

+24
OBJ

+44
OBJECTS

+14
OBJECTS

+41
OBJECTS

+131
OBJECTS

+24
OBJECTS

+58
OBJECTS

+19
OBJECTS

FORMATS A01-34

CIRCLE STENCIL /PROTRACTOR/PARABOLIC STENCIL/RULER/SET SQUARE/LITHO GAUGE/TYPE GAUGE/FLOPPY DISC/GAMEBOY CARTRIGE/MD/SIM CARD/CD/ZIP/BETA/VHS/DAT/MC/... →

+349 KILOBYTES

+147 KILOBYTES

+525 KILOBYTES

+754 KILOBYTES

+2690 KILOBYTES

+143 KILOBYTES

+160 KILOBYTES

+85 KILOBYTES

+176 KILOBYTES

+375 KILOBYTES

+286 KILOBYTES

+189 KILOBYTES

▼100 ▼090 ▼080 ▼070 ▼060 ▼050 ▼040

LOAD BAR REFERENCE
(INDICATES THE NUMBER OF OBJECTS WITHIN THE ACTIVE SECTION, RELATIVE TO THE OTHER INDIVIDUAL SECTIONS OF THE COMPENDIUM).

A01-10

CAT.Nº	GROUP			CAT.Nº	GROUP			CAT.Nº	GROUP		
A01	FORMATS			A03	FORMATS			A05	FORMATS		
FORMAT	SIZE	CAT.NAME		FORMAT	SIZE	CAT.NAME		FORMAT	SIZE	CAT.NAME	
LEGACY EPS	195KB	CIRCLE STENCIL 01		LEGACY EPS	77KB	PROTRACTOR		LEGACY EPS	254KB	RULER 01	
A02	FORMATS			A04	FORMATS			A06	FORMATS		
FORMAT	SIZE	CAT.NAME		FORMAT	SIZE	CAT.NAME		FORMAT	SIZE	CAT.NAME	
LEGACY EPS	154KB	CIRCLE STENCIL 02		LEGACY EPS	147KB	PARABOLIC STENCIL		LEGACY EPS	271KB	RULER 02	

CAT.Nº GROUP		CAT.NAME		CAT.Nº GROUP		CAT.NAME	
A07	FORMATS	SET SQUARE 01		A09	FORMATS	LITHO GAUGE	
FORMAT	SIZE			FORMAT	SIZE		
LEGACY EPS	291KB			LEGACY EPS	2.69MB		

CAT.Nº GROUP		CAT.NAME		CAT.Nº GROUP		CAT.NAME	
A08	FORMATS	SET SQUARE 02		A10	FORMATS	TYPE GAUGE	
FORMAT	SIZE			FORMAT	SIZE		
LEGACY EPS	463KB			LEGACY EPS	3.64MB		

DTL

CAT Nº A09

CAT Nº A10

A11-22

DTL

CAT Nº **A11**

CAT Nº **A12**

CAT Nº **A13**

CAT Nº **A14**

CAT Nº **A15**

CAT Nº **A16**

CAT Nº **A18**

CAT Nº **A17**

CAT.№	GROUP		
A17	FORMATS	CAT.NAME	
FORMAT	SIZE	SIM CARD	
LEGACY EPS	69KB		

CAT.№	GROUP		
A18	FORMATS	CAT.NAME	
FORMAT	SIZE	CD	
LEGACY EPS	85KB		

DTL

CAT.№	GROUP		
A19	FORMATS	CAT.NAME	
FORMAT	SIZE	FLOPPY DISC 02F	
LEGACY EPS	74KB		

CAT.№	GROUP		
A20	FORMATS	CAT.NAME	
FORMAT	SIZE	FLOPPY DISC 02B	
LEGACY EPS	79KB		

CAT.№	GROUP		
A21	FORMATS	CAT.NAME	
FORMAT	SIZE	ZIP F	
LEGACY EPS	86KB		

CAT.№	GROUP		
A22	FORMATS	CAT.NAME	
FORMAT	SIZE	ZIP B	
LEGACY EPS	90KB		

CAT N° A19

CAT N° A20

CAT N° A21

CAT N° A22

A23-34

CAT.Nº	GROUP		CAT.NAME
A23	FORMATS		BETA F
FORMAT	SIZE		
LEGACY EPS	110KB		

CAT.Nº	GROUP		CAT.NAME
A25	FORMATS		MINI TAPE B
FORMAT	SIZE		
LEGACY EPS	141KB		

CAT.Nº	GROUP		CAT.NAME
A27	FORMATS		VHS F
FORMAT	SIZE		
LEGACY EPS	254KB		

CAT.Nº	GROUP		CAT.NAME
A24	FORMATS		BETA B
FORMAT	SIZE		
LEGACY EPS	357KB		

CAT.Nº	GROUP		CAT.NAME
A26	FORMATS		MINI TAPE F
FORMAT	SIZE		
LEGACY EPS	137KB		

CAT.Nº	GROUP		CAT.NAME
A28	FORMATS		VHS B
FORMAT	SIZE		
LEGACY EPS	121KB		

CAT Nº ▾ A23

BETACAM SP ™

CAT Nº ▾ A24

SONY

CAT Nº ▾ A25

CAT Nº ▾ A26

CAT Nº ▾ A27

CAT.Nº	GROUP		
A29	FORMATS	CAT.NAME	
FORMAT	SIZE	DAT F	
LEGACY EPS	121KB		

CAT.Nº	GROUP		
A31	FORMATS	CAT.NAME	
FORMAT	SIZE	MC F	
LEGACY EPS	94KB		

CAT.Nº	GROUP		
A33	FORMATS	CAT.NAME	
FORMAT	SIZE	MINI DV F	
LEGACY EPS	77KB		

CAT.Nº	GROUP		
A30	FORMATS	CAT.NAME	
FORMAT	SIZE	MC B	
LEGACY EPS	95KB		

CAT.Nº	GROUP		
A32	FORMATS	CAT.NAME	
FORMAT	SIZE	MINI DV B	
LEGACY EPS	107KB		

CAT.Nº	GROUP		
A34	FORMATS	CAT.NAME	
FORMAT	SIZE	DAT B	
LEGACY EPS	106KB		

DTL

CAT Nº A29

CAT Nº A30

CAT Nº A31

CAT Nº A28

CAT Nº A32

CAT Nº A33

CAT Nº A34

TOOLS (BP) B01-56

NAILS/RATCHET SET/ALLEN KEY/ DRILL BIT SETS/ SCREW DRIVERS/ COMPASSES/INDI AN INK/CUTTER/ COPIC MARKER/I SOGRAPH PEN/ED DING/HAMMER/SC ISSORS/PLIERS/ SYRINGE/...➜

LOAD BAR REFERENCE
(INDICATES THE NUMBER OF OBJECTS WITHIN THE ACTIVE SECTION, RELATIVE TO THE OTHER INDIVIDUAL SECTIONS OF THE COMPENDIUM)

B01-12

CAT.Nº	GROUP			CAT.Nº	GROUP			CAT.Nº	GROUP		
B01	TOOLS (BP)		CAT.NAME	B03	TOOLS (BP)		CAT.NAME	B05	TOOLS (BP)		CAT.NAME
FORMAT		SIZE	NAILS	FORMAT		SIZE	ALLEN KEY	FORMAT		SIZE	RATCHET 04
LEGACY EPS	107KB			LEGACY EPS	109KB			LEGACY EPS	92KB		

CAT.Nº	GROUP			CAT.Nº	GROUP			CAT.Nº	GROUP		
B02	TOOLS (BP)		CAT.NAME	B04	TOOLS (BP)		CAT.NAME	B06	TOOLS (BP)		CAT.NAME
FORMAT		SIZE	RATCHET SET	FORMAT		SIZE	RATCHET 05	FORMAT		SIZE	RATCHET 03
LEGACY EPS	170KB			LEGACY EPS	71KB			LEGACY EPS	65KB		

DTL

CAT Nº B01

CAT Nº B02

CAT Nº B03

CAT Nº B04

CAT Nº B05

CAT Nº B06

CAT Nº B07

CAT Nº B08

CAT.Nº	GROUP		CAT.NAME	
B07	TOOLS (BP)			RATCHET 02
FORMAT		SIZE		
LEGACY EPS		82KB		

CAT.Nº	GROUP		CAT.NAME	
B08	TOOLS (BP)			RATCHET 01
FORMAT		SIZE		
LEGACY EPS		80KB		

CAT.Nº	GROUP		CAT.NAME	
B09	TOOLS (BP)			DRILL BIT
FORMAT		SIZE		
LEGACY EPS		70KB		

CAT.Nº	GROUP		CAT.NAME	
B10	TOOLS (BP)			WOOD DRILL BIT SET
FORMAT		SIZE		
LEGACY EPS		124KB		

CAT.Nº	GROUP		CAT.NAME	
B11	TOOLS (BP)			TWIST DRILL BIT SET
FORMAT		SIZE		
LEGACY EPS		109KB		

CAT.Nº	GROUP		CAT.NAME	
B12	TOOLS (BP)			MASONRY DRILL BIT S.
FORMAT		SIZE		
LEGACY EPS		102KB		

DTL

CAT Nº B09

CAT Nº B10

CAT Nº B11

CAT Nº B12

B13-25

CAT.Nº	GROUP		CAT.Nº	GROUP		CAT.Nº	GROUP	
B13	TOOLS (BP)	CAT.NAME	B15	TOOLS (BP)	CAT.NAME	B17	TOOLS (BP)	CAT.NAME
FORMAT	SIZE	SCREWDRIVER 03	FORMAT	SIZE	SCREWDRIVER 11	FORMAT	SIZE	SCREWDRIVER 10
LEGACY EPS	72KB		LEGACY EPS	73KB		LEGACY EPS	113KB	

CAT.Nº	GROUP		CAT.Nº	GROUP		CAT.Nº	GROUP	
B14	TOOLS (BP)	CAT.NAME	B16	TOOLS (BP)	CAT.NAME	B18	TOOLS (BP)	CAT.NAME
FORMAT	SIZE	SCREWDRIVER 01	FORMAT	SIZE	SCREWDRIVER 02	FORMAT	SIZE	SCREWDRIVER 09
LEGACY EPS	70KB		LEGACY EPS	74KB		LEGACY EPS	109KB	

DTL

CAT.Nº	GROUP		
B19	TOOLS (BP)	CAT.NAME	
FORMAT	SIZE	SCREWDRIVER 08	
LEGACY EPS	113KB		

CAT.Nº	GROUP		
B20	TOOLS (BP)	CAT.NAME	
FORMAT	SIZE	SCREWDRIVER 07	
LEGACY EPS	81KB		

CAT.Nº	GROUP		
B21	TOOLS (BP)	CAT.NAME	
FORMAT	SIZE	SCREWDRIVER 06	
LEGACY EPS	81KB		

CAT.Nº	GROUP		
B22	TOOLS (BP)	CAT.NAME	
FORMAT	SIZE	SCREWDRIVER 05	
LEGACY EPS	83KB		

CAT.Nº	GROUP		
B23	TOOLS (BP)	CAT.NAME	
FORMAT	SIZE	SCREWDRIVER 04	
LEGACY EPS	83KB		

CAT.Nº	GROUP		
B24	TOOLS (BP)	CAT.NAME	
FORMAT	SIZE	SPANNER 01	
LEGACY EPS	75KB		

CAT.Nº	GROUP		
B25	TOOLS (BP)	CAT.NAME	
FORMAT	SIZE	SPANNER 02	
LEGACY EPS	230KB		

DTL

CAT Nº B24

CAT Nº B25

CAT.Nº	GROUP		
B19	TOOLS (BP)	CAT.NAME	
FORMAT	SIZE	SCREWDRIVER 08	
LEGACY EPS	113KB		

CAT.Nº	GROUP		
B21	TOOLS (BP)	CAT.NAME	
FORMAT	SIZE	SCREWDRIVER 06	
LEGACY EPS	81KB		

CAT.Nº	GROUP		
B23	TOOLS (BP)	CAT.NAME	
FORMAT	SIZE	SPANNER 01	
LEGACY EPS			

B26-41

DTL

CAT N° ▶ B26

CAT N° ▶ B27

CAT N° ▾ B28

CAT N° ▾ B29

CAT N° ▾ B30

CAT N° ▾ B31

CAT N° ▾ B32

CAT N° ▾ B33

CAT.Nº	GROUP		
B32	TOOLS (BP)	CAT.NAME	
FORMAT	SIZE	ISOGRAPH PEN 050	
LEGACY EPS	70KB		

CAT.Nº	GROUP		
B33	TOOLS (BP)	CAT.NAME	
FORMAT	SIZE	ISOGRAPH PEN T070	
LEGACY EPS	70KB		

DTL

CAT.Nº	GROUP		
B34	TOOLS (BP)	CAT.NAME	
FORMAT	SIZE	EDDING 01 CLOSED	
LEGACY EPS	74KB		

CAT.Nº	GROUP		
B35	TOOLS (BP)	CAT.NAME	
FORMAT	SIZE	EDDING 01 OPEN	
LEGACY EPS	74KB		

CAT.Nº	GROUP		
B36	TOOLS (BP)	CAT.NAME	
FORMAT	SIZE	EDDING 3300 CLOSED	
LEGACY EPS	73KB		

CAT.Nº	GROUP		
B37	TOOLS (BP)	CAT.NAME	
FORMAT	SIZE	EDDING 3300 OPEN	
LEGACY EPS	75KB		

CAT.Nº	GROUP		
B38	TOOLS (BP)	CAT.NAME	
FORMAT	SIZE	EDDING 500 CLOSED	
LEGACY EPS	75KB		

CAT.Nº	GROUP		
B39	TOOLS (BP)	CAT.NAME	
FORMAT	SIZE	EDDING 500 OPEN	
LEGACY EPS	76KB		

CAT.Nº	GROUP		
B40	TOOLS (BP)	CAT.NAME	
FORMAT	SIZE	EDDING 850 CLOSED	
LEGACY EPS	77KB		

CAT.Nº	GROUP		
B41	TOOLS (BP)	CAT.NAME	
FORMAT	SIZE	EDDING 850 OPEN	
LEGACY EPS	77KB		

CAT Nº B41

CAT Nº B40

CAT Nº B37

CAT Nº B35

CAT Nº B39

CAT Nº B36

CAT Nº B38

CAT Nº B34

1-5 mm

1-5 mm

1-5 mm

1-5 mm

2-7 mm

2-7 mm

5-16 mm

5-16 mm

B42-56

CAT N°	GROUP			CAT N°	GROUP			CAT N°	GROUP		
B42	TOOLS (BP)			B44	TOOLS (BP)			B46	TOOLS (BP)		
FORMAT	SIZE	CAT.NAME		FORMAT	SIZE	CAT.NAME		FORMAT	SIZE	CAT.NAME	
LEGACY EPS	76KB	SCISSORS 01A		LEGACY EPS	76KB	SCISSORS 01B		LEGACY EPS	77KB	SCISSORS 02	
CAT N°	GROUP			CAT N°	GROUP			CAT N°	GROUP		
B43	TOOLS (BP)			B45	TOOLS (BP)			B47	TOOLS (BP)		
FORMAT	SIZE	CAT.NAME		FORMAT	SIZE	CAT.NAME		FORMAT	SIZE	CAT.NAME	
LEGACY EPS	74KB	HAMMER		LEGACY EPS	81KB	PLIERS 03		LEGACY EPS	89KB	PLIERS 01	

CAT.Nº	GROUP		CAT.NAME	
B48	TOOLS (BP)			WALL PLUG 01
FORMAT		SIZE		
LEGACY EPS		77KB		

CAT.Nº	GROUP		CAT.NAME	
B49	TOOLS (BP)			WALL PLUG 02
FORMAT		SIZE		
LEGACY EPS		73KB		

CAT.Nº	GROUP		CAT.NAME	
B50	TOOLS (BP)			PLIERS 02
FORMAT		SIZE		
LEGACY EPS		87KB		

CAT.Nº	GROUP		CAT.NAME	
B51	TOOLS (BP)			FOLDING RULE
FORMAT		SIZE		
LEGACY EPS		68KB		

CAT.Nº	GROUP		CAT.NAME	
B52	TOOLS (BP)			SYRINGE 01
FORMAT		SIZE		
LEGACY EPS		129KB		

CAT.Nº	GROUP		CAT.NAME	
B53	TOOLS (BP)			GASPIPE PLIERS
FORMAT		SIZE		
LEGACY EPS		84KB		

CAT.Nº	GROUP		CAT.NAME	
B54	TOOLS (BP)			VICE
FORMAT		SIZE		
LEGACY EPS		120KB		

CAT.Nº	GROUP		CAT.NAME	
B55	TOOLS (BP)			SYRINGE 02
FORMAT		SIZE		
LEGACY EPS		110KB		

CAT.Nº	GROUP		CAT.NAME	
B56	TOOLS (BP)			LIGHTER
FORMAT		SIZE		
LEGACY EPS		61KB		

DTL

CAT Nº B51

CAT Nº B53

CAT Nº B54

CAT Nº B55

CAT Nº B52

CAT Nº B56

TOOLS (RG) C01-15

CLAW HAMMER/RA KES/AXE/HACKSA W/WOOD SAW/LUM P HAMMER/JACK- HAMMER/SCISSOR S/WIRE CUTTERS /PRUNING SHEAR S/WRENCH/→

+161
KILOBYTES

+73
KILOBYTES

+74
KILOBYTES

+100
KILOBYTES

+78
KILOBYTES

+84
KILOBYTES

+154
KILOBYTES

+152
KILOBYTES

+164
KILOBYTES

+82
KILOBYTES

+81
KILOBYTES

▼100 ▼090 ▼080 ▼070 ▼060 ▼050 ▼040 ▼030 ▼020 ▼010 ▼000

LOAD BAR REFERENCE
(INDICATES THE NUMBER OF OBJECTS WITHIN THE ACTIVE SECTION RELATIVE TO THE OTHER INDIVIDUAL SECTIONS OF THE COMPENDIUM)

C01-15

CAT.Nº	GROUP		CAT.NAME	
C01	TOOLS (RG)		CLAW HAMMER	
FORMAT		SIZE		
LEGACY EPS		81KB		

CAT.Nº	GROUP		CAT.NAME	
C02	TOOLS (RG)		HAND RAKE	
FORMAT		SIZE		
LEGACY EPS		84KB		

CAT.Nº	GROUP		CAT.NAME	
C03	TOOLS (RG)		AXE	
FORMAT		SIZE		
LEGACY EPS		73KB		

CAT.Nº	GROUP		CAT.NAME	
C04	TOOLS (RG)		RAKE	
FORMAT		SIZE		
LEGACY EPS		77KB		

CAT.Nº	GROUP		CAT.NAME	
C05	TOOLS (RG)		HACKSAW	
FORMAT		SIZE		
LEGACY EPS		74KB		

CAT.Nº	GROUP		CAT.NAME	
C06	TOOLS (RG)		WOOD SAW	
FORMAT		SIZE		
LEGACY EPS		100KB		

DTL

CAT Nº C03

CAT Nº C04

CAT Nº C06

CAT Nº C01

CAT Nº C05

CAT Nº C02

CAT Nº C07

CAT.Nº	GROUP			CAT.NAME
C07	TOOLS (RG)			LUMP HAMMER
FORMAT		SIZE		
LEGACY EPS		78KB		

CAT.Nº	GROUP			CAT.NAME
C09	TOOLS (RG)			SCISSORS 03
FORMAT		SIZE		
LEGACY EPS		73KB		

CAT.Nº	GROUP			CAT.NAME
C11	TOOLS (REG)			PRUNING SHEARS 01
FORMAT		SIZE		
LEGACY EPS		85KB		

CAT.Nº	GROUP			CAT.NAME
C13	TOOLS (RG)			SCISSORS 04
FORMAT		SIZE		
LEGACY EPS		81KB		

CAT.Nº	GROUP			CAT.NAME
C08	TOOLS (RG)			JACK-HAMMER
FORMAT		SIZE		
LEGACY EPS		84KB		

CAT.Nº	GROUP			CAT.NAME
C10	TOOLS (RG)			WIRE CUTTER 01
FORMAT		SIZE		
LEGACY EPS		74KB		

CAT.Nº	GROUP			CAT.NAME
C12	TOOLS (REG)			WIRE CUTTER 02
FORMAT		SIZE		
LEGACY EPS		78KB		

CAT.Nº	GROUP			CAT.NAME
C14	TOOLS (RG)			PRUNING SHEARS 02
FORMAT		SIZE		
LEGACY EPS		79KB		

CAT.Nº	GROUP			CAT.NAME
C15	TOOLS (RG)			WRENCH
FORMAT		SIZE		
LEGACY EPS		82KB		

DTL

CAT Nº C08
CAT Nº C09
CAT Nº C10
CAT Nº C11
CAT Nº C12
CAT Nº C13
CAT Nº C14
CAT Nº C15

OBJECTS D01-52

+1212
ANCHOR POINTS

+138
ANCHOR POINTS

+95
ANCHOR POINTS

+284
ANCHOR POINTS

+192
ANCHOR POINTS

+92
ANCHOR POINTS

+1375
ANCHOR POINTS

+185
ANCHOR POINTS

+72
ANCHOR POINTS

+51
ANCHOR POINTS

+27
ANCHOR POINTS

+57
ANCHOR POINTS

+31
ANCHOR POINTS

+56
ANCHOR POINTS

+1642
ANCHOR POINTS

DRUM KIT/TAMBO
URINE/CYMBAL/H
IHAT/MUSIC STA
ND/BASS DRUM PE
DAL/CRUTCH/BLE
NDER/LAMP/CUTL
ERY/COFFEE POT
/PLUNGER/DISH
WASHING DETERG
ENT/ASHTRAY/AI
R BRUSH/...➔

+353
KILOBYTES

+71
KILOBYTES

+73
KILOBYTES

+88
KILOBYTES

+83
KILOBYTES

+299
KILOBYTES

+83
KILOBYTES

+160
KILOBYTES

+80
KILOBYTES

+77
KILOBYTES

+74
KILOBYTES

+73
KILOBYTES

+31
KILOBYTES

+220
KILOBYTES

▼100 ▼090 ▼080 ▼070 ▼060 ▼050 ▼040 ▼030 ▼020 ▼010 ▼000

LOAD BAR REFERENCE
(INDICATES THE NUMBER OF OBJECTS WITHIN THE ACTIVE SECTION, RELATIVE TO THE OTHER INDIVIDUAL SECTIONS OF THE COMPENDIUM)

D01-12

OTL

CAT.Nº	GROUP		CAT.NAME
D01	OBJECTS		DRUM KIT 01A
FORMAT		SIZE	
LEGACY EPS		89KB	

CAT.Nº	GROUP		CAT.NAME
D03	OBJECTS		TAMBOURINE
FORMAT		SIZE	
LEGACY EPS		73KB	

CAT.Nº	GROUP		CAT.NAME
D05	OBJECTS		CYMBAL
FORMAT		SIZE	
LEGACY EPS		77KB	

CAT.Nº	GROUP		CAT.NAME
D02	OBJECTS		DRUM 01A
FORMAT		SIZE	
LEGACY EPS		90KB	

CAT.Nº	GROUP		CAT.NAME
D04	OBJECTS		DRUM 01B
FORMAT		SIZE	
LEGACY EPS		90KB	

CAT.Nº	GROUP		CAT.NAME
D06	OBJECTS		HI HAT
FORMAT		SIZE	
LEGACY EPS		88KB	

CAT.Nº	GROUP		
D07	OBJECTS	CAT.NAME	
FORMAT	SIZE	DRUM KIT 01B	
LEGACY EPS	84KB		

CAT.Nº	GROUP		
D09	OBJECTS	CAT.NAME	
FORMAT	SIZE	GUITAR	
LEGACY EPS	88KB		

CAT.Nº	GROUP		
D11	OBJECTS	CAT.NAME	
FORMAT	SIZE	BASS DRUM PEDAL 01B	
LEGACY EPS	119KB		

CAT.Nº	GROUP		
D08	OBJECTS	CAT.NAME	
FORMAT	SIZE	MUSIC STAND	
LEGACY EPS	83KB		

CAT.Nº	GROUP		
D10	OBJECTS	CAT.NAME	
FORMAT	SIZE	BASS DRUM PEDAL 01A	
LEGACY EPS	96KB		

CAT.Nº	GROUP		
D12	OBJECTS	CAT.NAME	
FORMAT	SIZE	BASS DRUM PEDAL 01C	
LEGACY EPS	84KB		

DTL

CAT Nº D08

CAT Nº D09

CAT Nº D11

CAT Nº D10

CAT Nº D12

D13-27

CAT.Nº	GROUP		CAT.NAME
D13	OBJECTS		CRUTCH
FORMAT	SIZE		
LEGACY EPS	80KB		

CAT.Nº	GROUP		CAT.NAME
D14	OBJECTS		BLENDER 02
FORMAT	SIZE		
LEGACY EPS	80KB		

CAT.Nº	GROUP		CAT.NAME
D15	OBJECTS		LAMP
FORMAT	SIZE		
LEGACY EPS	88KB		

CAT.Nº	GROUP		CAT.NAME
D16	OBJECTS		CUTLERY
FORMAT	SIZE		
LEGACY EPS	83KB		

CAT.Nº	GROUP		CAT.NAME
D17	OBJECTS		COFFEE POT 01
FORMAT	SIZE		
LEGACY EPS	77KB		

CAT.Nº	GROUP		CAT.NAME
D18	OBJECTS		PLUNGER
FORMAT	SIZE		
LEGACY EPS	74KB		

DTL

CAT Nº D15

CAT Nº D13

CAT Nº D18

CAT Nº D16

CAT Nº D14

CAT Nº D19

CAT Nº D20

CAT Nº D17

CAT Nº D21

CAT Nº	GROUP	CAT.NAME
019	OBJECTS	BLENDER 01
FORMAT	SIZE	
LEGACY EPS	80KB	

CAT Nº	GROUP	CAT.NAME
021	OBJECTS	ASHTRAY
FORMAT	SIZE	
LEGACY EPS	72KB	

CAT Nº	GROUP	CAT.NAME
023	OBJECTS	AIRBRUSH 01
FORMAT	SIZE	
LEGACY EPS	103KB	

CAT Nº	GROUP	CAT.NAME
025	OBJECTS	TELEPHONE
FORMAT	SIZE	
LEGACY EPS	88KB	

CAT Nº	GROUP	CAT.NAME
027	OBJECTS	BLOOD PRESSURE M.
FORMAT	SIZE	
LEGACY EPS	86KB	

CAT Nº	GROUP	CAT.NAME
020	OBJECTS	DISH WASHING DET.
FORMAT	SIZE	
LEGACY EPS	73KB	

CAT Nº	GROUP	CAT.NAME
022	OBJECTS	AIRBRUSH 02
FORMAT	SIZE	
LEGACY EPS	117KB	

CAT Nº	GROUP	CAT.NAME
024	OBJECTS	WATERING CAN
FORMAT	SIZE	
LEGACY EPS	73KB	

CAT Nº	GROUP	CAT.NAME
026	OBJECTS	COFFEE POT 02
FORMAT	SIZE	
LEGACY EPS	97KB	

DTL

CAT Nº D22

CAT Nº D23

CAT Nº D24

CAT Nº D25

CAT Nº D26

CAT Nº D27

CAT Nº	GROUP	CAT.NAME
019	OBJECTS	BLENDER 01
FORMAT	SIZE	

CAT Nº	GROUP	CAT.NAME
021	OBJECTS	ASHTRAY
FORMAT	SIZE	

CAT Nº	GROUP	CAT.NAME
023	OBJECTS	AIRBRUSH 01
FORMAT	SIZE	

CAT Nº	GROUP	CAT.NAME
025	OBJECTS	TELEPHONE
FORMAT	SIZE	

CAT Nº	GROUP	CAT.NAME
027	OBJECTS	BLOOD PRESSURE M.
FORMAT	SIZE	

CAT Nº	GROUP	CAT.NAME
020	OBJECTS	DISH WASHING DET.
FORMAT	SIZE	

CAT Nº	GROUP	CAT.NAME
022	OBJECTS	AIRBRUSH 02
FORMAT	SIZE	

CAT Nº	GROUP	CAT.NAME
024	OBJECTS	WATERING CAN
FORMAT	SIZE	

CAT Nº	GROUP	CAT.NAME
026	OBJECTS	COFFEE POT 02
FORMAT	SIZE	

D28-40

CAT.Nº	GROUP			CAT.Nº	GROUP			CAT.Nº	GROUP		
D28	OBJECTS			D30	OBJECTS			D32	OBJECTS		
FORMAT	SIZE	CAT.NAME		FORMAT	SIZE	CAT.NAME		FORMAT	SIZE	CAT.NAME	
LEGACY EPS	87KB	VACUUM CLEANER		LEGACY EPS	88KB	MIXER		LEGACY EPS	118KB	BUGGY	

CAT.Nº	GROUP			CAT.Nº	GROUP			CAT.Nº	GROUP		
D29	OBJECTS			D31	OBJECTS			D33	OBJECTS		
FORMAT	SIZE	CAT.NAME		FORMAT	SIZE	CAT.NAME		FORMAT	SIZE	CAT.NAME	
LEGACY EPS	75KB	SCREEN		LEGACY EPS	75KB	BLACK BOARD		LEGACY EPS	94KB	TRIPOD	

CAT Nº **D28**

CAT Nº **D30**

CAT Nº **D32**

CAT Nº **D29**

CAT Nº **D31**

CAT Nº **D33**

CAT.Nº	GROUP			CAT.Nº	GROUP		
D30	OBJECTS			D32	OBJECTS		
FORMAT	SIZE	CAT.NAME		FORMAT	SIZE	CAT.NAME	
LEGACY EPS	88KB	MIXER		LEGACY EPS	118KB	BUGGY	

CAT.Nº	GROUP			CAT.Nº	GROUP		
D31	OBJECTS			D33	OBJECTS		
FORMAT	SIZE	CAT.NAME		FORMAT	SIZE	CAT.NAME	
LEGACY EPS	75KB	BLACK BOARD		LEGACY EPS	94KB	TRIPOD	

CAT.Nº	GROUP		CAT.NAME	
D34	OBJECTS		STRETCHER	
FORMAT	SIZE			
LEGACY EPS	82KB			

CAT.Nº	GROUP		CAT.NAME	
D35	OBJECTS		RADIATOR	
FORMAT	SIZE			
LEGACY EPS	82KB			

DTL

CAT.Nº	GROUP		CAT.NAME	
D36	OBJECTS		STETHOSCOPE 01A	
FORMAT	SIZE			
LEGACY EPS	80KB			

CAT.Nº	GROUP		CAT.NAME	
D37	OBJECTS		TOILET	
FORMAT	SIZE			
LEGACY EPS	76KB			

CAT.Nº	GROUP		CAT.NAME	
D38	OBJECTS		STETHOSCOPE 01B	
FORMAT	SIZE			
LEGACY EPS	88KB			

CAT.Nº	GROUP		CAT.NAME	
D39	OBJECTS		NBW TEA BAG	
FORMAT	SIZE			
LEGACY EPS	91KB			

CAT.Nº	GROUP		CAT.NAME	
D40	OBJECTS		BINOCULARS	
FORMAT	SIZE			
LEGACY EPS	87KB			

CAT Nº D34

CAT Nº D36

CAT Nº D38

CAT Nº D35

CAT Nº D37

CAT Nº D39

CAT Nº D40

D41-52

CAT Nº	GROUP		CAT.NAME
D41	OBJECTS		SHOPPING CART 04
FORMAT	SIZE		
LEGACY EPS	249KB		

CAT Nº	GROUP		CAT.NAME
D42	OBJECTS		SHOPPING CART 03
FORMAT	SIZE		
LEGACY EPS	529KB		

CAT Nº	GROUP		CAT.NAME
D43	OBJECTS		SHOPPING CART 06
FORMAT	SIZE		
LEGACY EPS	308KB		

CAT Nº	GROUP		CAT.NAME
D44	OBJECTS		SHOPPING CART 01
FORMAT	SIZE		
LEGACY EPS	391KB		

CAT Nº	GROUP		CAT.NAME
D45	OBJECTS		SHOPPING CART 05
FORMAT	SIZE		
LEGACY EPS	255KB		

CAT Nº	GROUP		CAT.NAME
D46	OBJECTS		SHOPPING CART 02
FORMAT	SIZE		
LEGACY EPS	391KB		

DTL

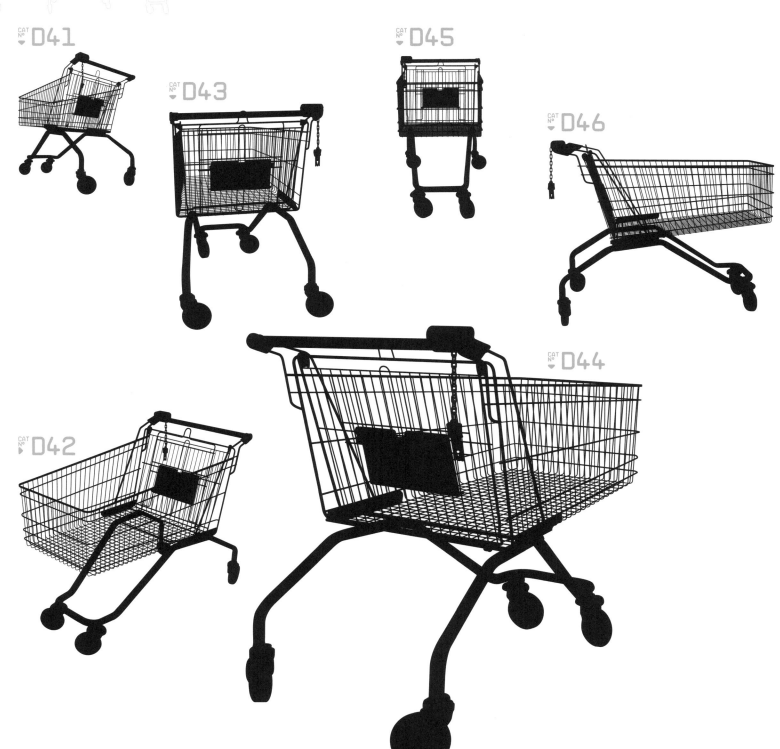

CAT Nº D41

CAT Nº D45

CAT Nº D43

CAT Nº D46

CAT Nº D42

CAT Nº D44

CAT.№	GROUP		
D47	OBJECTS	CAT.NAME	
FORMAT	SIZE	CLOTHES HORSE 01	
LEGACY EPS	100KB		

CAT.№	GROUP		
D49	OBJECTS	CAT.NAME	
FORMAT	SIZE	CLOTHES HORSE 03	
LEGACY EPS	106KB		

CAT.№	GROUP		
D51	OBJECTS	CAT.NAME	
FORMAT	SIZE	CLOTHES HORSE 04	
LEGACY EPS	139KB		

CAT.№	GROUP		
D48	OBJECTS	CAT.NAME	
FORMAT	SIZE	CLOTHES HORSE 02	
LEGACY EPS	115KB		

CAT.№	GROUP		
D50	OBJECTS	CAT.NAME	
FORMAT	SIZE	CLOTHES HORSE 06	
LEGACY EPS	99KB		

CAT.№	GROUP		
D52	OBJECTS	CAT.NAME	
FORMAT	SIZE	CLOTHES HORSE 05	
LEGACY EPS	121KB		

DTL

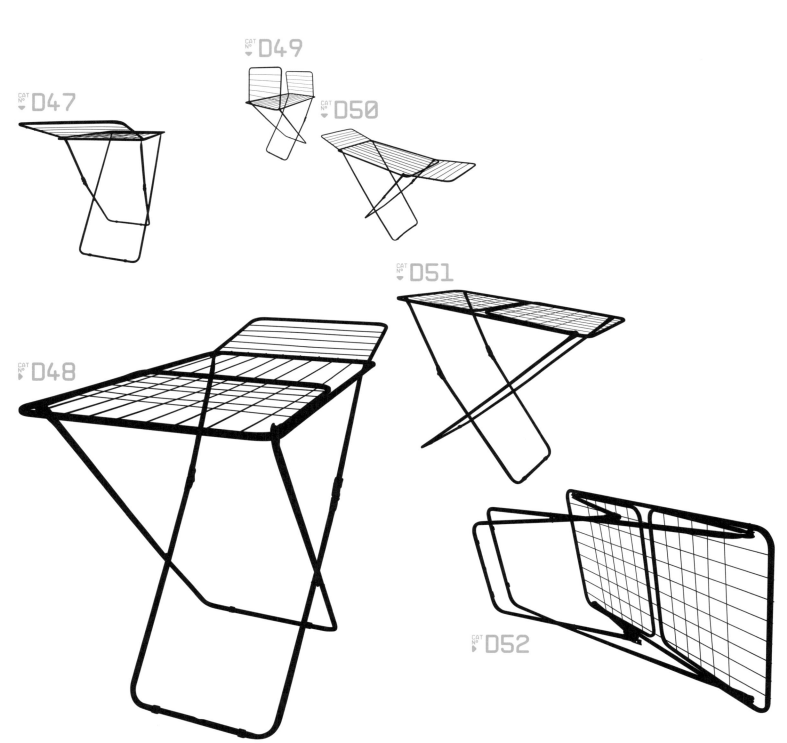

CAT N° D49

CAT N° D47

CAT N° D50

CAT N° D51

CAT N° D48

CAT N° D52

CLOTHES E01-40

SHIRTS/T-SHIRT
S/UNDERWEAR/SW
EATERS/SCARF/J
EANS/TROUSERS/
BELTS/HANGERS/
SHOES/CONVERSE
/COAT/JACKETS/

+176 KILOBYTES

+174 KILOBYTES

+436 KILOBYTES

+287 KILOBYTES

+319 KILOBYTES

+355 KILOBYTES

+436 KILOBYTES

+86 KILOBYTES

➡

▼100 ▼090 ▼080 ▼070 ▼060 ▼050

LOAD BAR REFERENCE
(INDICATES THE NUMBER OF OBJECTS WITHIN THE ACTIVE SECTION, RELATIVE TO THE OTHER INDIVIDUAL SECTIONS OF THE COMPENDIUM)

E01-13

CAT N°	GROUP			CAT N°	GROUP			CAT N°	GROUP		
E01	CLOTHES		CAT.NAME	E03	CLOTHES		CAT.NAME	E05	CLOTHES		CAT.NAME
FORMAT		SIZE	SHIRT 01	FORMAT		SIZE	UNDERWEAR 02	FORMAT		SIZE	SHIRT 02
LEGACY EPS		89KB		LEGACY EPS		92KB		LEGACY EPS		87KB	
E02	CLOTHES		CAT.NAME	E04	CLOTHES		CAT.NAME	E06	CLOTHES		CAT.NAME
FORMAT		SIZE	T-SHIRT 02	FORMAT		SIZE	SWEATER 02	FORMAT		SIZE	SCARF
LEGACY EPS		87KB		LEGACY EPS		87KB		LEGACY EPS		105KB	

DTL

CAT N° E01

CAT N° E03

CAT N° E05

CAT N° E07

CAT N° E02

CAT N° E04

CAT N° E06

CAT N° E08

CAT.Nº	GROUP		CAT.Nº	GROUP		CAT.Nº	GROUP		CAT.Nº	GROUP	
E07	CLOTHES	CAT.NAME	E09	CLOTHES	CAT.NAME	E11	CLOTHES	CAT.NAME	E13	CLOTHES	CAT.NAME
FORMAT	SIZE	JEANS 04	FORMAT	SIZE	BELTS 04	FORMAT	SIZE	HANGER 02	FORMAT	SIZE	HANGER 03
LEGACY EPS	86KB		LEGACY EPS	117KB		LEGACY EPS	75KB		LEGACY EPS	89KB	

CAT.Nº	GROUP		CAT.Nº	GROUP		CAT.Nº	GROUP	
E08	CLOTHES	CAT.NAME	E10	CLOTHES	CAT.NAME	E12	CLOTHES	CAT.NAME
FORMAT	SIZE	TROUSERS 02	FORMAT	SIZE	HANGER 04	FORMAT	SIZE	HANGER 01
LEGACY EPS	88KB		LEGACY EPS	71KB		LEGACY EPS	76KB	

DTL

CAT Nº ▶ E09

CAT Nº ▶ E10

CAT Nº ▶ E11

CAT Nº ▶ E12

CAT Nº ▶ E13

E14-24

CAT.№	GROUP		
E14	CLOTHES	CAT.NAME	
FORMAT	SIZE	SHOES 03	
LEGACY EPS	87KB		

CAT.№	GROUP		
E15	CLOTHES	CAT.NAME	
FORMAT	SIZE	SHOES 01	
LEGACY EPS	86KB		

CAT.№	GROUP		
E16	CLOTHES	CAT.NAME	
FORMAT	SIZE	SHOES 02	
LEGACY EPS	91KB		

CAT.№	GROUP		
E17	CLOTHES	CAT.NAME	
FORMAT	SIZE	CONVERSE 06	
LEGACY EPS	86KB		

CAT.№	GROUP		
E18	CLOTHES	CAT.NAME	
FORMAT	SIZE	CONVERSE 01	
LEGACY EPS	75KB		

CAT.№	GROUP		
E19	CLOTHES	CAT.NAME	
FORMAT	SIZE	CONVERSE 02	
LEGACY EPS	91KB		

DTL

CAT N° E14

CAT N° E15

CAT N° E16

CAT N° E17

CAT N° E18

CAT N° E19

CAT N° E20

CAT N° E21

CAT N° E22

CAT N° E23

CAT.Nº	GROUP	
E20	CLOTHES	CAT.NAME
FORMAT	SIZE	CONVERSE 05
LEGACY EPS	98KB	

CAT.Nº	GROUP	
E22	CLOTHES	CAT.NAME
FORMAT	SIZE	SHOES 04
LEGACY EPS	91KB	

CAT.Nº	GROUP	
E21	CLOTHES	CAT.NAME
FORMAT	SIZE	CONVERSE 03
LEGACY EPS	86KB	

CAT.Nº	GROUP	
E23	CLOTHES	CAT.NAME
FORMAT	SIZE	CONVERSE 04
LEGACY EPS	93KB	

CAT.Nº	GROUP	
E24	CLOTHES	CAT.NAME
FORMAT	SIZE	T-SHIRT 01
LEGACY EPS	87KB	

DTL

CAT Nº ▶ E24

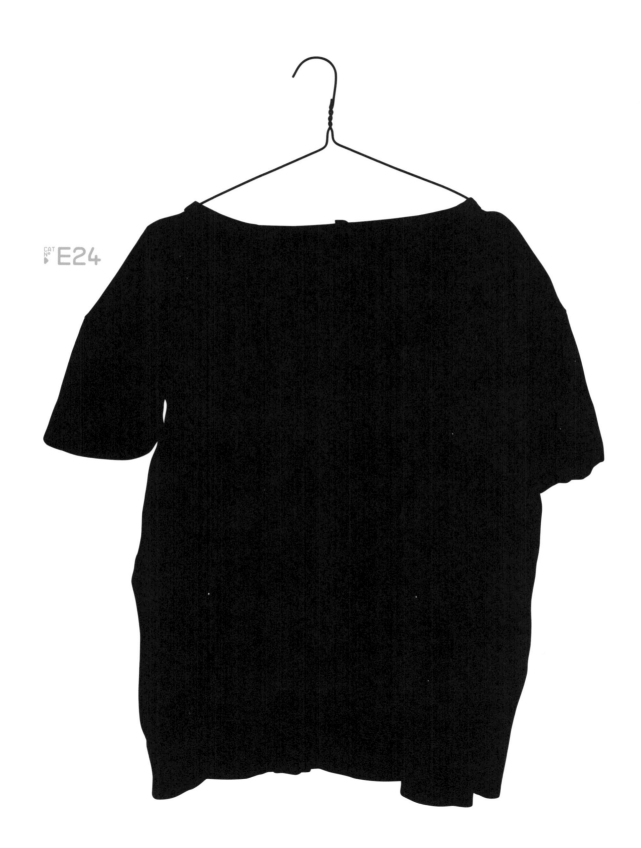

E25-40

CAT.Nº	GROUP		CAT.NAME
E25	CLOTHES		BELTS 03
FORMAT		SIZE	
LEGACY EPS	110KB		

CAT.Nº	GROUP		CAT.NAME
E26	CLOTHES		COAT
FORMAT		SIZE	
LEGACY EPS	86KB		

CAT.Nº	GROUP		CAT.NAME
E27	CLOTHES		JACKET 01
FORMAT		SIZE	
LEGACY EPS	83KB		

CAT.Nº	GROUP		CAT.NAME
E28	CLOTHES		BELTS 01
FORMAT		SIZE	
LEGACY EPS	92KB		

CAT.Nº	GROUP		CAT.NAME
E29	CLOTHES		JACKET 03
FORMAT		SIZE	
LEGACY EPS	96KB		

CAT.Nº	GROUP		CAT.NAME
E30	CLOTHES		JACKET 02
FORMAT		SIZE	
LEGACY EPS	99KB		

DTL

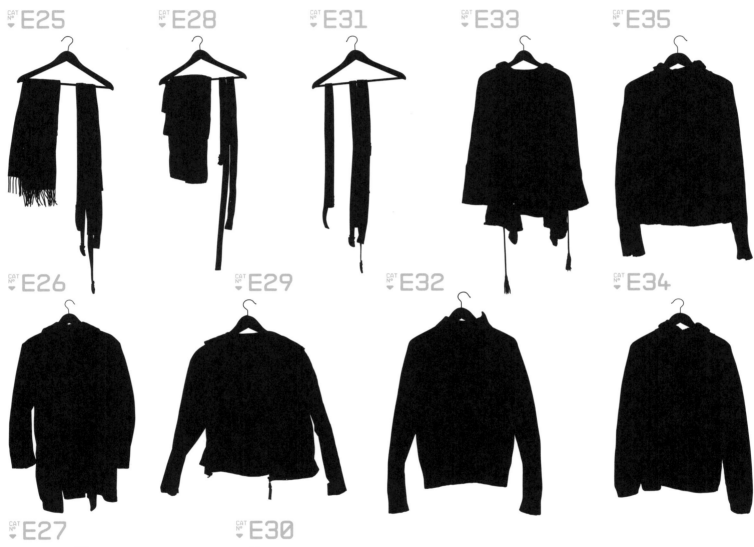

CAT Nº E25

CAT Nº E28

CAT Nº E31

CAT Nº E33

CAT Nº E35

CAT Nº E26

CAT Nº E29

CAT Nº E32

CAT Nº E34

CAT Nº E27

CAT Nº E30

CAT Nº	GROUP		CAT.NAME	
E31	CLOTHES		BELTS 02	
FORMAT	SIZE	LEGACY EPS	92KB	

CAT Nº	GROUP		CAT.NAME	
E33	CLOTHES		SWEATER 05	
FORMAT	SIZE	LEGACY EPS	94KB	

CAT Nº	GROUP		CAT.NAME	
E35	CLOTHES		SWEATER 03	
FORMAT	SIZE	LEGACY EPS	85KB	

CAT Nº	GROUP		CAT.NAME	
E37	CLOTHES		TROUSERS 01	
FORMAT	SIZE	LEGACY EPS	90KB	

CAT Nº	GROUP		CAT.NAME	
E39	CLOTHES		UNDERWEAR 01	
FORMAT	SIZE	LEGACY EPS	89KB	

CAT Nº	GROUP		CAT.NAME	
E32	CLOTHES		SWEATER 01	
FORMAT	SIZE	LEGACY EPS	86KB	

CAT Nº	GROUP		CAT.NAME	
E34	CLOTHES		SWEATER 04	
FORMAT	SIZE	LEGACY EPS	84KB	

CAT Nº	GROUP		CAT.NAME	
E36	CLOTHES		JEANS 03	
FORMAT	SIZE	LEGACY EPS	97KB	

CAT Nº	GROUP		CAT.NAME	
E38	CLOTHES		JEANS 01	
FORMAT	SIZE	LEGACY EPS	96KB	

CAT Nº	GROUP		CAT.NAME	
E40	CLOTHES		JEANS 02	
FORMAT	SIZE	LEGACY EPS	94KB	

DTL

CAT Nº E36

CAT Nº E38

CAT Nº E40

CAT Nº E37

CAT Nº E39

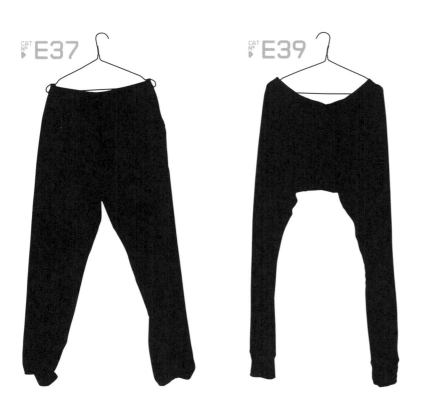

BOTTLES F01-51

VIC BITTER/7 UP
/ROYAL SALUTE/
ABSOLUT/BUD/BL
UNA/GLENFIDDIC
H/DIMPLE/BLUE
GIRL PILSENER/
CHATEAU ST. JEAN
NE/BELLS/WILD
TURKEY/JAEGERM
EISTER/BRAUERE
I PFEFFER/...➡

▼100 ▼090 ▼080 ▼070 ▼060 ▼050 ▼040 ▼030 ▼020 ▼010 ▼000

LOAD BAR REFERENCE
(INDICATES THE NUMBER OF OBJECTS WITHIN THE ACTIVE SECTION, RELATIVE TO THE OTHER INDIVIDUAL SECTIONS OF THE COMPENDIUM)

F01-11

CAT.Nº **GROUP**
F01 BOTTLES **CAT.NAME**
FORMAT **SIZE** VIC BITTER
LEGACY EPS 70KB

OTL

CAT
Nº ▶ **F01**

CAT.Nº	GROUP		CAT.NAME
F02	BOTTLES		7 UP
FORMAT	SIZE		
LEGACY EPS	71KB		

CAT.Nº	GROUP		CAT.NAME
F03	BOTTLES		ROYAL SALUTE
FORMAT	SIZE		
LEGACY EPS	72KB		

DTL

CAT.Nº	GROUP		CAT.NAME
F04	BOTTLES		ABSOLUT
FORMAT	SIZE		
LEGACY EPS	70KB		

CAT.Nº	GROUP		CAT.NAME
F05	BOTTLES		BUD
FORMAT	SIZE		
LEGACY EPS	71KB		

CAT.Nº	GROUP		CAT.NAME
F06	BOTTLES		BLUNA
FORMAT	SIZE		
LEGACY EPS	71KB		

CAT.Nº	GROUP		CAT.NAME
F07	BOTTLES		GLENFIDDICH
FORMAT	SIZE		
LEGACY EPS	70KB		

CAT.Nº	GROUP		CAT.NAME
F08	BOTTLES		DIMPLE
FORMAT	SIZE		
LEGACY EPS	72KB		

CAT.Nº	GROUP		CAT.NAME
F09	BOTTLES		BLUEGIRL PILSENER
FORMAT	SIZE		
LEGACY EPS	71KB		

CAT.Nº	GROUP		CAT.NAME
F10	BOTTLES		CHATEAU ST. JEANNE
FORMAT	SIZE		
LEGACY EPS	71KB		

CAT.Nº	GROUP		CAT.NAME
F11	BOTTLES		BELLS
FORMAT	SIZE		
LEGACY EPS	73KB		

CAT Nº F02

CAT Nº F04

CAT Nº F06

CAT Nº F08

CAT Nº F10

CAT Nº F11

CAT Nº F03

CAT Nº F05

CAT Nº F07

CAT Nº F09

F12-27

OTL

CAT Nº F12

CAT Nº F14

CAT Nº F16

CAT Nº F18

CAT Nº F20

CAT Nº F22

CAT Nº F13

CAT Nº F15

CAT Nº F17

CAT Nº F19

CAT Nº F21

CAT Nº F23

CAT Nº F24

CAT.Nº	GROUP		CAT.NAME
F18	BOTTLES		MARTINI BIANCO
FORMAT	SIZE		
LEGACY EPS	69KB		

CAT.Nº	GROUP		CAT.NAME
F20	BOTTLES		AFRI COLA
FORMAT	SIZE		
LEGACY EPS	72KB		

CAT.Nº	GROUP		CAT.NAME
F22	BOTTLES		FOSTERS
FORMAT	SIZE		
LEGACY EPS	70KB		

CAT.Nº	GROUP		CAT.NAME
F24	BOTTLES		BOLS AMARETTO
FORMAT	SIZE		
LEGACY EPS	73KB		

CAT.Nº	GROUP		CAT.NAME
F26	BOTTLES		FLENSBURGER
FORMAT	SIZE		
LEGACY EPS	76KB		

CAT.Nº	GROUP		CAT.NAME
F19	BOTTLES		JB RARE
FORMAT	SIZE		
LEGACY EPS	71KB		

CAT.Nº	GROUP		CAT.NAME
F21	BOTTLES		JOHNNY WALKER
FORMAT	SIZE		
LEGACY EPS	71KB		

CAT.Nº	GROUP		CAT.NAME
F23	BOTTLES		JIM BEAM
FORMAT	SIZE		
LEGACY EPS	76KB		

CAT.Nº	GROUP		CAT.NAME
F25	BOTTLES		GROLSCH LAGER
FORMAT	SIZE		
LEGACY EPS	75KB		

CAT.Nº	GROUP		CAT.NAME
F27	BOTTLES		BR. SCHÄFLESHIMMEL
FORMAT	SIZE		
LEGACY EPS	76KB		

DTL

CAT Nº F25

CAT Nº F26

CAT Nº F27

F28-43

CAT.Nº	GROUP		
F28	BOTTLES	CAT.NAME	
FORMAT	SIZE	WU LIANG LE	
LEGACY EPS	72KB		

CAT.Nº	GROUP		
F29	BOTTLES	CAT.NAME	
FORMAT	SIZE	PEPSI	
LEGACY EPS	73KB		

CAT.Nº	GROUP		
F30	BOTTLES	CAT.NAME	
FORMAT	SIZE	WOODS. BOURBON COLA	
LEGACY EPS	72KB		

CAT.Nº	GROUP		
F31	BOTTLES	CAT.NAME	
FORMAT	SIZE	TSING TAO BEER	
LEGACY EPS	70KB		

CAT.Nº	GROUP		
F32	BOTTLES	CAT.NAME	
FORMAT	SIZE	SVENZKA WODKA	
LEGACY EPS	73KB		

CAT.Nº	GROUP		
F33	BOTTLES	CAT.NAME	
FORMAT	SIZE	RIGGS DRY COLA	
LEGACY EPS	72KB		

OTL

CAT Nº F28

CAT Nº F30

CAT Nº F32

CAT Nº F34

CAT Nº F36

CAT Nº F38

CAT Nº F29

CAT Nº F31

CAT Nº F33

CAT Nº F35

CAT Nº F37

CAT Nº F39

CAT.Nº	GROUP		CAT.NAME	
F34	BOTTLES		PERRIER	
FORMAT		SIZE		
LEGACY EPS		72KB		

CAT.Nº	GROUP		CAT.NAME	
F35	BOTTLES		DR PEPPER	
FORMAT		SIZE		
LEGACY EPS		71KB		

DTL

CAT.Nº	GROUP		CAT.NAME	
F36	BOTTLES		TIGER	
FORMAT		SIZE		
LEGACY EPS		72KB		

CAT.Nº	GROUP		CAT.NAME	
F37	BOTTLES		MEYERS	
FORMAT		SIZE		
LEGACY EPS		76KB		

CAT.Nº	GROUP		CAT.NAME	
F38	BOTTLES		SMIRNOFF GR. APPLE	
FORMAT		SIZE		
LEGACY EPS		72KB		

CAT.Nº	GROUP		CAT.NAME	
F39	BOTTLES		GUINNESS 01	
FORMAT		SIZE		
LEGACY EPS		71KB		

CAT.Nº	GROUP		CAT.NAME	
F40	BOTTLES		WOODPECKER CIDER	
FORMAT		SIZE		
LEGACY EPS		71KB		

CAT.Nº	GROUP		CAT.NAME	
F41	BOTTLES		ORANGINA	
FORMAT		SIZE		
LEGACY EPS		71KB		

CAT.Nº	GROUP		CAT.NAME	
F42	BOTTLES		SQUIRT	
FORMAT		SIZE		
LEGACY EPS		70KB		

CAT.Nº	GROUP		CAT.NAME	
F43	BOTTLES		DREH & TRINK	
FORMAT		SIZE		
LEGACY EPS		71KB		

CAT Nº F40

CAT Nº F41

CAT Nº F42

CAT Nº F43

F44-51

CAT Nº	GROUP		CAT.NAME			CAT Nº	GROUP		CAT.NAME			CAT Nº	GROUP		CAT.NAME
F44	BOTTLES					F46	BOTTLES					F48	BOTTLES		
FORMAT		SIZE	BACARDI			FORMAT		SIZE	BAYLEYS			FORMAT		SIZE	COCA COLA
LEGACY EPS	72KB					LEGACY EPS	72KB					LEGACY EPS	73KB		
CAT Nº	GROUP		CAT.NAME			CAT Nº	GROUP		CAT.NAME			CAT Nº	GROUP		CAT.NAME
F45	BOTTLES					F47	BOTTLES					F49	BOTTLES		
FORMAT		SIZE	HOSMER COLA BLUE			FORMAT		SIZE	MEI KWEI LU CHIEW			FORMAT		SIZE	ASTRA
LEGACY EPS	71KB					LEGACY EPS	75KB					LEGACY EPS	70KB		

OTL

CAT Nº **F44**

CAT Nº **F46**

CAT Nº **F48**

CAT Nº **F47**

CAT Nº **F45**

CAT Nº GROUP
F50 BOTTLES CAT.NAME
FORMAT SIZE SANBITTER
LEGACY EPS 69KB

CAT Nº GROUP
F51 BOTTLES CAT.NAME
FORMAT SIZE GUINNESS 02
LEGACY EPS 72KB

DTL

CAT Nº ▶ F49

CAT Nº ▼ F50

CAT Nº ▶ F51

CHAIRS G01–44

WESIFA/MAUSER/
FOLDING CHAIRS
/LAWN CHAIRS/C
ANTINA CHAIR/B
ENCHES/EASY CH
AIR/SUPAHOPPA/
WASSILY/ →

+396
KILOBYTES

+676
KILOBYTES

+177
KILOBYTES

+81
KILOBYTES

+92
KILOBYTES

▼100 ▼090 ▼080 ▼070 ▼060 ▼050

▼040 ▼030 ▼020 ▼010 ▼000

LOAD BAR REFERENCE
(INDICATES THE NUMBER OF OBJECTS WITHIN THE ACTIVE SECTION, RELATIVE TO THE OTHER INDIVIDUAL SECTIONS OF THE COMPENDIUM).

G01-13

CAT.Nº	GROUP		CAT.NAME
G01	CHAIRS		WESIFA 01A
FORMAT		SIZE	
LEGACY EPS		79KB	

CAT.Nº	GROUP		CAT.NAME
G03	CHAIRS		WESIFA 01C
FORMAT		SIZE	
LEGACY EPS		80KB	

CAT.Nº	GROUP		CAT.NAME
G02	CHAIRS		WESIFA 01B
FORMAT		SIZE	
LEGACY EPS		79KB	

CAT.Nº	GROUP		CAT.NAME
G04	CHAIRS		WESIFA 01E
FORMAT		SIZE	
LEGACY EPS		81KB	

CAT.Nº	GROUP		CAT.NAME
G05	CHAIRS		WESIFA 01D
FORMAT		SIZE	
LEGACY EPS		79KB	

DTL

CAT Nº G01

CAT Nº G02

CAT Nº G03

CAT Nº G04

CAT Nº G05

CAT.N°	GROUP		CAT.NAME	
G06	CHAIRS		MAUSER 01C	
FORMAT		SIZE		
LEGACY EPS	78KB			

CAT.N°	GROUP		CAT.NAME	
G08	CHAIRS		MAUSER 01A	
FORMAT		SIZE		
LEGACY EPS	79KB			

CAT.N°	GROUP		CAT.NAME	
G10	CHAIRS		MAUSER 01H	
FORMAT		SIZE		
LEGACY EPS	82KB			

CAT.N°	GROUP		CAT.NAME	
G12	CHAIRS		MAUSER 01D	
FORMAT		SIZE		
LEGACY EPS	83KB			

CAT.N°	GROUP		CAT.NAME	
G07	CHAIRS		MAUSER 01G	
FORMAT		SIZE		
LEGACY EPS	82KB			

CAT.N°	GROUP		CAT.NAME	
G09	CHAIRS		MAUSER 01B	
FORMAT		SIZE		
LEGACY EPS	82KB			

CAT.N°	GROUP		CAT.NAME	
G11	CHAIRS		MAUSER 01E	
FORMAT		SIZE		
LEGACY EPS	82KB			

CAT.N°	GROUP		CAT.NAME	
G13	CHAIRS		MAUSER 01F	
FORMAT		SIZE		
LEGACY EPS	80KB			

OTL

CAT N° G06

CAT N° G08

CAT N° G10

CAT N° G12

CAT N° G09

CAT N° G07

CAT N° G11

CAT N° G13

G14-21

CAT.Nº	GROUP		
G14	CHAIRS	CAT.NAME	
FORMAT	SIZE	FOLDING CHAIR 01A	
LEGACY EPS	81KB		

CAT.Nº	GROUP		
G15	CHAIRS	CAT.NAME	
FORMAT	SIZE	FOLDING CHAIR 01F	
LEGACY EPS	88KB		

CAT.Nº	GROUP		
G16	CHAIRS	CAT.NAME	
FORMAT	SIZE	FOLDING CHAIR 01C	
LEGACY EPS	84KB		

CAT.Nº	GROUP		
G17	CHAIRS	CAT.NAME	
FORMAT	SIZE	FOLDING CHAIR 01D	
LEGACY EPS	79KB		

CAT.Nº	GROUP		
G18	CHAIRS	CAT.NAME	
FORMAT	SIZE	FOLDING CHAIR 01G	
LEGACY EPS	87KB		

CAT.Nº	GROUP		
G19	CHAIRS	CAT.NAME	
FORMAT	SIZE	FOLDING CHAIR 01H	
LEGACY EPS	89KB		

DTL

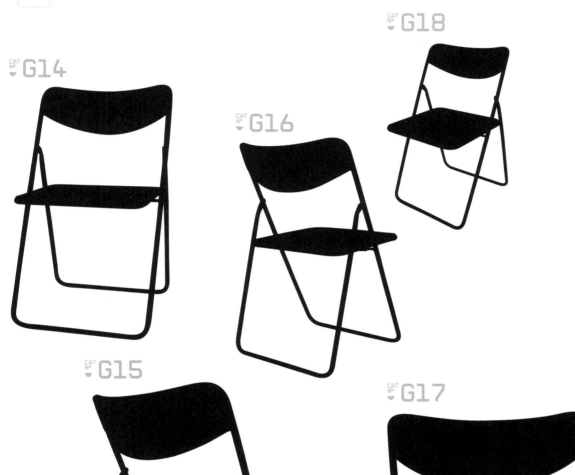

CAT Nº G14

CAT Nº G16

CAT Nº G18

CAT Nº G15

CAT Nº G17

CAT Nº G19

CAT.Nº	GROUP		
G20	CHAIRS	CAT.NAME	
FORMAT	SIZE	FOLDING CHAIR 01B	
LEGACY EPS	86KB		

CAT.Nº	GROUP		
G21	CHAIRS	CAT.NAME	
FORMAT	SIZE	FOLDING CHAIR 01E	
LEGACY EPS	82KB		

DTL

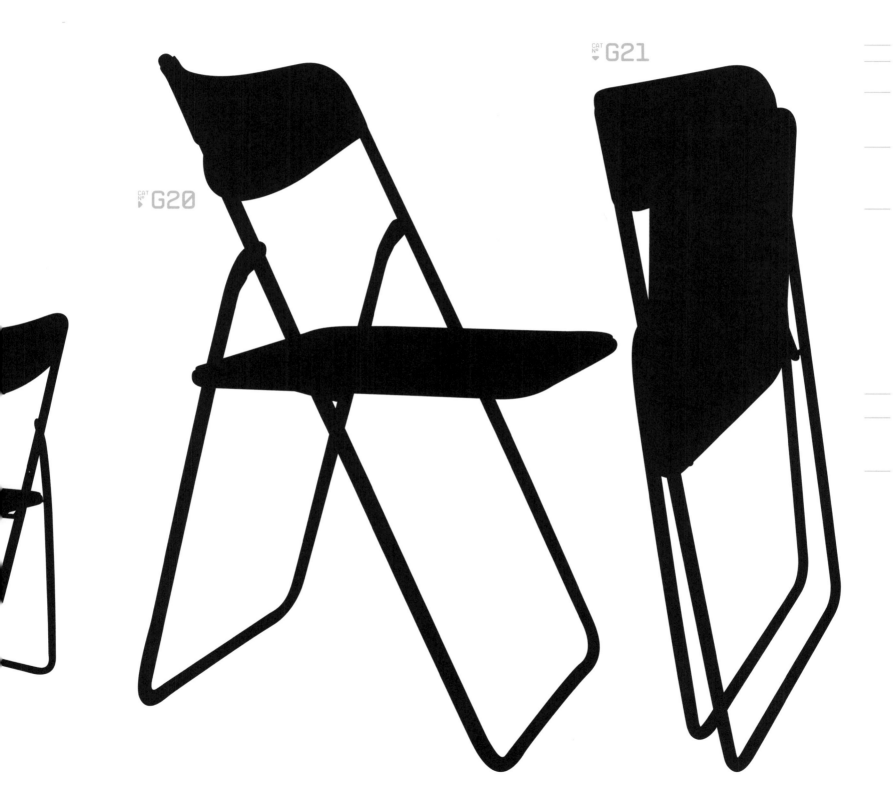

CAT Nº G20

CAT Nº G21

G22-35

OTL

CAT Nº **G22**

CAT Nº **G24**

CAT Nº **G26**

CAT Nº **G25**

CAT Nº **G23**

CAT Nº **G28**

CAT Nº **G27**

CAT Nº **G29**

CAT.Nº	GROUP		CAT.NAME
G28	CHAIRS		
FORMAT		SIZE	LAWN CHAIR 01A
LEGACY EPS	85KB		

CAT.Nº	GROUP		CAT.NAME
G30	CHAIRS		
FORMAT		SIZE	LAWN CHAIR 03A
LEGACY EPS	83KB		

CAT.Nº	GROUP		CAT.NAME
G32	CHAIRS		
FORMAT		SIZE	EASY CHAIR
LEGACY EPS	81KB		

CAT.Nº	GROUP		CAT.NAME
G34	CHAIRS		
FORMAT		SIZE	BENCH 02
LEGACY EPS	75KB		

CAT.Nº	GROUP		CAT.NAME
G29	CHAIRS		
FORMAT		SIZE	LAWN CHAIR 06
LEGACY EPS	84KB		

CAT.Nº	GROUP		CAT.NAME
G31	CHAIRS		
FORMAT		SIZE	LAWN CHAIR 03B
LEGACY EPS	83KB		

CAT.Nº	GROUP		CAT.NAME
G33	CHAIRS		
FORMAT		SIZE	SUPAHOPPA
LEGACY EPS	77KB		

CAT.Nº	GROUP		CAT.NAME
G35	CHAIRS		
FORMAT		SIZE	WASSILY
LEGACY EPS	92KB		

DTL

CAT Nº G30

CAT Nº G32

CAT Nº G34

CAT Nº G33

CAT Nº G31

CAT Nº G35

G36-44

CAT.Nº	GROUP		CAT.NAME
G36	CHAIRS		OFFICE CHAIR 01A
FORMAT	SIZE		
LEGACY EPS	85KB		

CAT.Nº	GROUP		CAT.NAME
G37	CHAIRS		OFFICE CHAIR 01B
FORMAT	SIZE		
LEGACY EPS	94KB		

CAT.Nº	GROUP		CAT.NAME
G38	CHAIRS		EIERMANN 01D
FORMAT	SIZE		
LEGACY EPS	95KB		

CAT.Nº	GROUP		CAT.NAME
G39	CHAIRS		EIERMANN 01E
FORMAT	SIZE		
LEGACY EPS	87KB		

CAT.Nº	GROUP		CAT.NAME
G40	CHAIRS		EIERMANN 01C
FORMAT	SIZE		
LEGACY EPS	93KB		

CAT.Nº	GROUP		CAT.NAME
G41	CHAIRS		EIERMANN 01F
FORMAT	SIZE		
LEGACY EPS	89KB		

CAT Nº G36

CAT Nº G37

CAT Nº G38

CAT Nº G40

CAT Nº G39

CAT Nº **G42**

CAT Nº **G44**

CAT Nº **G43**

CAT Nº **G41**

+459
ANCHOR POINTS

+396
ANCHOR POINTS

+668
ANCHOR POINTS

+12887
ANCHOR POINTS

+153
ANCHOR POINTS

+386
ANCHOR POINTS

PLAYGROUND H01-10

CLIMBING FRAME /SWINGS/ROUNDABOUT/SLIDES/SPRING RIDER/SEE-SAW/PING PONG TABLE/➡

+111
KILOBYTES

+202
KILOBYTES

+542
KILOBYTES

+271
KILOBYTES

+81
KILOBYTES

+87
KILOBYTES

+116
KILOBYTES

▼100 ▼090 ▼080 ▼070 ▼060 ▼050 ▼040 ▼030 ▼020 ▼010

LOAD BAR REFERENCE
(INDICATES THE NUMBER OF OBJECTS WITHIN THE ACTIVE SECTION, RELATIVE TO THE OTHER INDIVIDUAL SECTIONS OF THE COMPENDIUM)

H01-10

CAT.Nº	GROUP		CAT.NAME
H01	PLAYGROUND		CLIMBING FRAME
FORMAT		SIZE	
LEGACY EPS		111KB	

CAT.Nº	GROUP		CAT.NAME
H03	PLAYGROUND		ROUNDABOUT
FORMAT		SIZE	
LEGACY EPS		542KB	

CAT.Nº	GROUP		CAT.NAME
H05	PLAYGROUND		SLIDE 01
FORMAT		SIZE	
LEGACY EPS		84KB	

CAT.Nº	GROUP		CAT.NAME
H02	PLAYGROUND		SWINGS
FORMAT		SIZE	
LEGACY EPS		102KB	

CAT.Nº	GROUP		CAT.NAME
H04	PLAYGROUND		SWING
FORMAT		SIZE	
LEGACY EPS		100KB	

CAT.Nº	GROUP		CAT.NAME
H06	PLAYGROUND		SLIDE 02
FORMAT		SIZE	
LEGACY EPS		98KB	

OTL

CAT Nº H01

CAT Nº H02

CAT Nº H03

CAT Nº H04

CAT Nº H05

CAT.Nº	GROUP		CAT.NAME
H01	PLAYGROUND		
FORMAT		SIZE	
LEGACY EPS			

CAT.Nº	GROUP		CAT.NAME
H03	PLAYGROUND		
FORMAT		SIZE	
LEGACY EPS			

CAT.Nº	GROUP		CAT.NAME
H05	PLAYGROUND		
FORMAT		SIZE	
LEGACY EPS			

CAT.Nº	GROUP		
H07	PLAYGROUND	CAT.NAME	
FORMAT	SIZE	SPRING RIDER	
LEGACY EPS	81KB		

CAT.Nº	GROUP		
H09	PLAYGROUND	CAT.NAME	
FORMAT	SIZE	PING PONG TABLE	
LEGACY EPS	116KB		

CAT.Nº	GROUP		
H08	PLAYGROUND	CAT.NAME	
FORMAT	SIZE	SEE-SAW	
LEGACY EPS	87KB		

CAT.Nº	GROUP		
H10	PLAYGROUND	CAT.NAME	
FORMAT	SIZE	SLIDE 03	
LEGACY EPS	89KB		

DTL

CAT Nº H06

CAT Nº H09

CAT Nº H07

CAT Nº H10

CAT Nº H08

CYCLES I01-20

BICYCLES/CHOPPER/BMX/FIREBIKE/RACING CYCLES/VESPA/MOPED/MOTORBIKE/→

+1006 KILOBYTES

+155 KILOBYTES

+214 KILOBYTES

+177 KILOBYTES

+511 KILOBYTES

+229 KILOBYTES

KILOBYTES

+510 KILOBYTES

LOAD BAR REFERENCE
(INDICATES THE NUMBER OF OBJECTS WITHIN THE ACTIVE SECTION, RELATIVE TO THE OTHER INDIVIDUAL SECTIONS OF THE COMPENDIUM).

I01-05

CAT.Nº	GROUP		
I01	CYCLES	CAT.NAME	
FORMAT	SIZE	BICYCLE 01	
LEGACY EPS	151KB		

CAT.Nº	GROUP		
I03	CYCLES	CAT.NAME	
FORMAT	SIZE	BICYCLE STAND	
LEGACY EPS	106KB		

CAT.Nº	GROUP		
I02	CYCLES	CAT.NAME	
FORMAT	SIZE	BICYCLE 02	
LEGACY EPS	131KB		

CAT.Nº	GROUP		
I04	CYCLES	CAT.NAME	
FORMAT	SIZE	BICYCLE 03	
LEGACY EPS	277KB		

CAT.Nº	GROUP		
I05	CYCLES	CAT.NAME	
FORMAT	SIZE	CHOPPER	
LEGACY EPS	155KB		

DTL

CAT Nº I03

CAT Nº I01

CAT Nº I04

CAT Nº I02

DTL

CAT Nº	GROUP		
I06	CYCLES	CAT.NAME	
FORMAT	SIZE	BMX	
LEGACY EPS	214KB		

CAT Nº	GROUP		
I08	CYCLES	CAT.NAME	
FORMAT	SIZE	FIREBIKE	
LEGACY EPS	177KB		

CAT Nº	GROUP		
I10	CYCLES	CAT.NAME	
FORMAT	SIZE	BICYCLE 05	
LEGACY EPS	150KB		

CAT Nº	GROUP		
I07	CYCLES	CAT.NAME	
FORMAT	SIZE	BICYCLE 04	
LEGACY EPS	289KB		

CAT Nº	GROUP		
I09	CYCLES	CAT.NAME	
FORMAT	SIZE	RACING CYCLE 01B	
LEGACY EPS	186KB		

CAT Nº	GROUP		
I11	CYCLES	CAT.NAME	
FORMAT	SIZE	RACING CYCLE 02	
LEGACY EPS	162KB		

DTL

CAT Nº I06

CAT Nº I07

CAT Nº I08

CAT Nº I09

CAT Nº I10

CAT N° GROUP
I12 CYCLES CAT.NAME
FORMAT SIZE RACING CYCLE 01A
LEGACY EPS 163KB

DTL

CAT
N° ▶ I11

CAT
N° ▶ I12

I13-20

CAT Nº	GROUP		
I13	CYCLES	CAT.NAME	
FORMAT	SIZE	VESPA 01	
LEGACY EPS	123KB		

CAT Nº	GROUP		
I15	CYCLES	CAT.NAME	
FORMAT	SIZE	COVERED MOTORBIKE	
LEGACY EPS	92KB		

CAT Nº	GROUP		
I17	CYCLES	CAT.NAME	
FORMAT	SIZE	MOTORBIKE 02	
LEGACY EPS	115KB		

CAT Nº	GROUP		
I14	CYCLES	CAT.NAME	
FORMAT	SIZE	MOPED	
LEGACY EPS	119KB		

CAT Nº	GROUP		
I16	CYCLES	CAT.NAME	
FORMAT	SIZE	VESPA 02	
LEGACY EPS	106KB		

CAT Nº	GROUP		
I18	CYCLES	CAT.NAME	
FORMAT	SIZE	MOTORBIKE 04	
LEGACY EPS	94KB		

OTL

CAT Nº ▶ I13

CAT Nº ▶ I15

CAT Nº ▼ I16

CAT Nº ▶ I14

CAT Nº	GROUP		
I13	CYCLES	CAT.NAME	
FORMAT	SIZE		
LEGACY EPS			

CAT Nº	GROUP		
I15	CYCLES	CAT.NAME	
FORMAT	SIZE		
LEGACY EPS			

CAT Nº	GROUP		
I17	CYCLES	CAT.NAME	
FORMAT	SIZE		
LEGACY EPS			

CAT N° GROUP
I19 CYCLES CAT.NAME
FORMAT SIZE MOTORBIKE 03
LEGACY EPS 119KB

CAT N° GROUP
I20 CYCLES CAT.NAME
FORMAT SIZE MOTORBIKE 01
LEGACY EPS 98KB

DTL

CAT N° ▶ I17

CAT N° ▶ I19

CAT N° ▶ I20

CAT N° ▶ I18

CONSTRUCTION SITE C01-44

+1881
ANCHOR POINTS

+297
ANCHOR POINTS

+366
ANCHOR POINTS

+1252
ANCHOR POINTS

+73
ANCHOR POINTS

+784
ANCHOR POINTS

+21
ANCHOR POINTS

+132
ANCHOR POINTS

+88985
ANCHOR POINTS

+88
ANCHOR POINTS

+925
ANCHOR POINTS

+5285
ANCHOR POINTS

+4585
ANCHOR POINTS

DIGGERS/TRACTION ENGINE/SIGNS/CONSTRUCTION LAMP/FENCES/FORKLIFTERS/CEMENT MIXERS/STAR LIFTER/WHEELBARROW/BARRIERS/TRAILER/CONTAINER/SCAFFOLDING/CRANES/....→

+1028 KILOBYTES
+101 KILOBYTES
+159 KILOBYTES
+74 KILOBYTES
+243 KILOBYTES
+173 KILOBYTES
+271 KILOBYTES
+93 KILOBYTES
+87 KILOBYTES
+3620 KILOBYTES
+73 KILOBYTES
+154 KILOBYTES
+195 KILOBYTES
+1965 KILOBYTES

▼100 ▼090 ▼080 ▼070 ▼060 ▼050 ▼040 ▼030 ▼020 ▼010 ▼000

LOAD BAR REFERENCE
(INDICATES THE NUMBER OF OBJECTS WITHIN THE ACTIVE SECTION, RELATIVE TO THE OTHER INDIVIDUAL SECTIONS OF THE COMPENDIUM).

J01-14

CAT.Nº	GROUP	
J01	CONSTRUC. SITE	CAT.NAME
FORMAT	SIZE	DIGGER 02
LEGACY EPS	92KB	

CAT.Nº	GROUP	
J02	CONSTRUC. SITE	CAT.NAME
FORMAT	SIZE	DIGGER 04
LEGACY EPS	117KB	

CAT.Nº	GROUP	
J03	CONSTRUC. SITE	CAT.NAME
FORMAT	SIZE	DIGGER 01
LEGACY EPS	110KB	

CAT.Nº	GROUP	
J04	CONSTRUC. SITE	CAT.NAME
FORMAT	SIZE	DIGGER 07
LEGACY EPS	100KB	

CAT.Nº	GROUP	
J05	CONSTRUC. SITE	CAT.NAME
FORMAT	SIZE	DIGGER 05
LEGACY EPS	128KB	

CAT.Nº	GROUP	
J06	CONSTRUC. SITE	CAT.NAME
FORMAT	SIZE	DIGGER 06
LEGACY EPS	97KB	

DTL

CAT Nº J01

CAT Nº J03

CAT Nº J07

CAT Nº J05

CAT Nº J04

CAT Nº J06

CAT Nº J02

CAT.Nº	GROUP			CAT.Nº	GROUP			CAT.Nº	GROUP			CAT.Nº	GROUP		
J07	CONSTRUC. SITE	CAT.NAME		J09	CONSTRUC. SITE	CAT.NAME		J11	CONSTRUC. SITE	CAT.NAME		J13	CONSTRUC. SITE	CAT.NAME	
FORMAT	SIZE	DIGGER 03		FORMAT	SIZE	DIGGER 08		FORMAT	SIZE	CONSTR. SITE SIGN 01		FORMAT	SIZE	CONSTR. SITE SIGN 02	
LEGACY EPS	114KB			LEGACY EPS	99KB			LEGACY EPS	82KB			LEGACY EPS	77KB		

CAT.Nº	GROUP			CAT.Nº	GROUP			CAT.Nº	GROUP			CAT.Nº	GROUP		
J08	CONSTRUC. SITE	CAT.NAME		J10	CONSTRUC. SITE	CAT.NAME		J12	CONSTRUC. SITE	CAT.NAME		J14	CONSTRUC. SITE	CAT.NAME	
FORMAT	SIZE	TRACTION ENGINE		FORMAT	SIZE	DIGGER 09		FORMAT	SIZE	DIGGER 10		FORMAT	SIZE	CONSTRUCTION LAMP	
LEGACY EPS	101KB			LEGACY EPS	84KB			LEGACY EPS	87KB			LEGACY EPS	74KB		

DTL

CAT Nº J08

CAT Nº J12

CAT Nº J10

CAT Nº J09

CAT Nº J14

CAT Nº J11

CAT Nº J13

J15-30

CAT.Nº	GROUP		CAT.NAME		CAT.Nº	GROUP		CAT.NAME		CAT.Nº	GROUP		CAT.NAME	
J15	CONSTRUC. SITE				J17	CONSTRUC. SITE				J19	CONSTRUC. SITE			
FORMAT	SIZE	FENCE 06			FORMAT	SIZE	FORKLIFT 02			FORMAT	SIZE	FENCE 03		
LEGACY EPS	88KB				LEGACY EPS	81KB				LEGACY EPS	103KB			
J16	CONSTRUC. SITE				J18	CONSTRUC. SITE				J20	CONSTRUC. SITE			
FORMAT	SIZE	FENCE 07			FORMAT	SIZE	FENCE 02			FORMAT	SIZE	CEMENT MIXER 03		
LEGACY EPS	87KB				LEGACY EPS	144KB				LEGACY EPS	84KB			

DTL

CAT Nº J15
CAT Nº J16
CAT Nº J17
CAT Nº J18
CAT Nº J19
CAT Nº J21
CAT Nº J20
CAT Nº J22
CAT Nº J23

CAT.Nº	GROUP		CAT.Nº	GROUP		CAT.Nº	GROUP		CAT.Nº	GROUP		CAT.Nº	GROUP	
J21	CONSTRUC. SITE	CAT.NAME	J23	CONSTRUC. SITE	CAT.NAME	J25	CONSTRUC. SITE	CAT.NAME	J27	CONSTRUC. SITE	CAT.NAME	J29	CONSTRUC. SITE	CAT.NAME
FORMAT	SIZE	FENCE 05	FORMAT	SIZE	WHEELBARROW	FORMAT	SIZE	BARRIER 01	FORMAT	SIZE	TRAILER	FORMAT	SIZE	SKIP
LEGACY EPS	157KB		LEGACY EPS	87KB		LEGACY EPS	106KB		LEGACY EPS	73KB		LEGACY EPS	81KB	

CAT.Nº	GROUP		CAT.Nº	GROUP		CAT.Nº	GROUP		CAT.Nº	GROUP		CAT.Nº	GROUP	
J22	CONSTRUC. SITE	CAT.NAME	J24	CONSTRUC. SITE	CAT.NAME	J26	CONSTRUC. SITE	CAT.NAME	J28	CONSTRUC. SITE	CAT.NAME	J30	CONSTRUC. SITE	CAT.NAME
FORMAT	SIZE	FENCE 01	FORMAT	SIZE	STARLIFTER	FORMAT	SIZE	FENCE 04	FORMAT	SIZE	CONTAINER	FORMAT	SIZE	FORKLIFT 01
LEGACY EPS	123KB		LEGACY EPS	93KB		LEGACY EPS	149KB		LEGACY EPS	73KB		LEGACY EPS	92KB	

DTL

CAT Nº J24

CAT Nº J26

CAT Nº J28

CAT Nº J25

CAT Nº J27

CAT Nº J29

CAT Nº J30

J31-36

CAT No	GROUP				CAT No	GROUP				CAT No	GROUP		
J31	CONSTRUC. SITE	CAT.NAME			J33	CONSTRUC. SITE	CAT.NAME			J35	CONSTRUC. SITE	CAT.NAME	
FORMAT	SIZE	SCAFFOLDING			FORMAT	SIZE	BARRIER 02			FORMAT	SIZE	CRANE 02	
LEGACY EPS	195KB				LEGACY EPS	1.82MB				LEGACY EPS	856KB		
J32	CONSTRUC. SITE	CAT.NAME			J34	CONSTRUC. SITE	CAT.NAME			J36	CONSTRUC. SITE	CAT.NAME	
FORMAT	SIZE	BARRIER 03			FORMAT	SIZE	CRANE 03			FORMAT	SIZE	CRANE 01	
LEGACY EPS	1.7MB				LEGACY EPS	895KB				LEGACY EPS	214KB		

DTL

CAT Nº ▾ J31

CAT Nº ▾ J32

CAT Nº ▾ J33

DTL

CAT
N°
▶ ⅃34

CAT
N°
▶ ⅃35

CAT
N°
▾ ⅃36

J37-44

CAT Nº	GROUP			CAT Nº	GROUP			CAT Nº	GROUP		
J37	CONSTRUC. SITE	CAT.NAME		J39	CONSTRUC. SITE	CAT.NAME		J41	CONSTRUC. SITE	CAT.NAME	
FORMAT	SIZE	SILO 01		FORMAT	SIZE	SILO 05		FORMAT	SIZE	SILO 03	
LEGACY EPS	111KB			LEGACY EPS	147KB			LEGACY EPS	115KB		
CAT Nº	GROUP			CAT Nº	GROUP			CAT Nº	GROUP		
J38	CONSTRUC. SITE	CAT.NAME		J40	CONSTRUC. SITE	CAT.NAME		J42	CONSTRUC. SITE	CAT.NAME	
FORMAT	SIZE	SILO 06		FORMAT	SIZE	SILO 02		FORMAT	SIZE	SILO 04	
LEGACY EPS	108KB			LEGACY EPS	99KB			LEGACY EPS	96KB		

DTL

CAT Nº ▶ J39

CAT Nº ▼ J37 CAT Nº ▼ J38

CAT.N° GROUP
J43 CONSTRUC. SITE CAT.NAME
FORMAT SIZE CEMENT MIXER 01
LEGACY EPS 95KB

CAT.N° GROUP
J44 CONSTRUC. SITE CAT.NAME
FORMAT SIZE CEMENT MIXER 02
LEGACY EPS 92KB

DTL

CAT
N° J40

CAT
N° J41

CAT
N° J42

CAT
N° J43

CAT
N° J44

ALPINE DEVICES K01-14

+7412
ANCHOR POINTS

+663
ANCHOR POINTS

+1218
ANCHOR POINTS

+3631
ANCHOR POINTS

+2743
ANCHOR POINTS

+7412
ANCHOR POINTS

CHAIR LIFTS/SK IS/SNOW CANNON S/SKIDOO/SNOW PLOUGH/➡

+764
KILOBYTES

+118
KILOBYTES

+186
KILOBYTES

+195
KILOBYTES

+162
KILOBYTES

LOAD BAR REFERENCE
(INDICATES THE NUMBER OF OBJECTS WITHIN THE ACTIVE SECTION, RELATIVE TO THE OTHER INDIVIDUAL SECTIONS OF THE COMPENDIUM)

K01-08

CAT N°	GROUP		
K01	ALPINE DEVICES	CAT.NAME	
FORMAT	SIZE	CHAIR LIFT 04	
LEGACY EPS	90KB		

CAT N°	GROUP		
K03	ALPINE DEVICES	CAT.NAME	
FORMAT	SIZE	CHAIR LIFT 05	
LEGACY EPS	91KB		

CAT N°	GROUP		
K05	ALPINE DEVICES	CAT.NAME	
FORMAT	SIZE	CHAIR LIFT 06	
LEGACY EPS	83KB		

CAT N°	GROUP		
K02	ALPINE DEVICES	CAT.NAME	
FORMAT	SIZE	SKIS	
LEGACY EPS	118KB		

CAT N°	GROUP		
K04	ALPINE DEVICES	CAT.NAME	
FORMAT	SIZE	CHAIR LIFT 02	
LEGACY EPS	161KB		

CAT N°	GROUP		
K06	ALPINE DEVICES	CAT.NAME	
FORMAT	SIZE	CHAIR LIFT 07	
LEGACY EPS	80KB		

OTL

CAT N° K05

CAT N° K06

CAT N° K01

CAT N° K03

CAT N° K02

CAT N° K04

CAT N°	GROUP		
K03	ALPINE DEVICES	CAT.NAME	
FORMAT	SIZE	CHAIR LIFT 05	
LEGACY EPS	91KB		

CAT N°	GROUP		
K05	ALPINE DEVICES	CAT.NAME	
FORMAT	SIZE	CHAIR LIFT 06	
LEGACY EPS	83KB		

CAT Nº | GROUP
K07 ALPINE DEVICES | CAT.NAME
FORMAT | SIZE | CHAIR LIFT 03
LEGACY EPS 130KB

CAT Nº | GROUP
K08 ALPINE DEVICES | CAT.NAME
FORMAT | SIZE | CHAIR LIFT 01
LEGACY EPS 121KB

DTL

CAT Nº ▶ K07

CAT Nº ▶ K08

K09-14

DTL

CAT.Nº	GROUP				CAT.Nº	GROUP				CAT.Nº	GROUP		
K09	ALPINE DEVICES	CAT.NAME			K11	ALPINE DEVICES	CAT.NAME			K13	ALPINE DEVICES	CAT.NAME	
FORMAT		SIZE	SNOW CANNON 01B		FORMAT		SIZE	SNOW CANNON 02		FORMAT		SIZE	SKIDOO 01A
LEGACY EPS		113KB			LEGACY EPS		163KB			LEGACY EPS		99KB	

CAT.Nº	GROUP				CAT.Nº	GROUP				CAT.Nº	GROUP		
K10	ALPINE DEVICES	CAT.NAME			K12	ALPINE DEVICES	CAT.NAME			K14	ALPINE DEVICES	CAT.NAME	
FORMAT		SIZE	SNOW CANNON 01A		FORMAT		SIZE	SKIDOO 01B		FORMAT		SIZE	SNOW PLOUGH
LEGACY EPS		100KB			LEGACY EPS		96KB			LEGACY EPS		162KB	

CAT Nº ▶ K09

CAT Nº ▶ K10

CAT Nº ▼ K11

DTL

CAT
N°
K12

CAT
N°
K14

CAT
N°
K13

URBAN ENVIRONMENT

L01–41

+52
ANCHOR POINTS

+1218
ANCHOR POINTS

+68
ANCHOR POINTS

+268
ANCHOR POINTS

+323
ANCHOR POINTS

+36777
ANCHOR POINTS

+279
ANCHOR POINTS

+799
ANCHOR POINTS

+26990
ANCHOR POINTS

+1678
ANCHOR POINTS

+285
ANCHOR POINTS

+287
ANCHOR POINTS

+5538
ANCHOR POINTS

+8647
ANCHOR POINTS

TRAFFIC LIGHTS
/POSTBOX/CITYL
IGHT/SUBWAY LI
GHT/TRASH CONT
AINERS/WASTEBA
SKET/BUS STOPS
/STREET LIGHTS
/BENCH/SIGNS/H
YDRANT/TROLLEY
S/TOWER/POWER
POLE/...→

+576 KILOBYTES
+70 KILOBYTES
+71 KILOBYTES
+86 KILOBYTES
+153 KILOBYTES
+1400 KILOBYTES
+175 KILOBYTES
+758 KILOBYTES
+686 KILOBYTES
+687 KILOBYTES
+83 KILOBYTES
+328 KILOBYTES
+82 KILOBYTES
+1905 KILOBYTES

▼100 ▼090 ▼080 ▼070 ▼060 ▼050 ▼040 ▼030 ▼020 ▼010 ▼200

L01-14

DTL

CAT Nº ▶ L11

CAT Nº ▶ L14

CAT Nº ▼ L13

CAT Nº ▼ L12

L15-26

CAT Nº GROUP
L15 URBAN ENVIRONM. CAT.NAME
FORMAT SIZE STREET LIGHT 04
LEGACY EPS 78KB

CAT Nº GROUP
L17 URBAN ENVIRONM. CAT.NAME
FORMAT SIZE RECYCLING CONTAIN.
LEGACY EPS 79KB

CAT Nº GROUP
L19 URBAN ENVIRONM. CAT.NAME
FORMAT SIZE STREET LIGHT 06
LEGACY EPS 75KB

CAT Nº GROUP
L16 URBAN ENVIRONM. CAT.NAME
FORMAT SIZE STREET LIGHT 09
LEGACY EPS 81KB

CAT Nº GROUP
L18 URBAN ENVIRONM. CAT.NAME
FORMAT SIZE STREET LIGHT 07
LEGACY EPS 76KB

CAT Nº GROUP
L20 URBAN ENVIRONM. CAT.NAME
FORMAT SIZE STREET LIGHT 05
LEGACY EPS 75KB

DTL

CAT Nº L15

CAT Nº L16

CAT Nº L17

CAT Nº L18

CAT Nº L19

CAT Nº L20

CAT Nº L21

DTL

L27-36

CAT.Nº	GROUP			CAT.Nº	GROUP			CAT.Nº	GROUP		
L27	URBAN ENVIRONM.	CAT.NAME		L29	URBAN ENVIRONM.	CAT.NAME		L31	URBAN ENVIRONM.	CAT.NAME	
FORMAT	SIZE	SIGN 05		FORMAT	SIZE	TRAFFIC LIGHT 07		FORMAT	SIZE	SIGN 06	
LEGACY EPS	76KB			LEGACY EPS	77KB			LEGACY EPS	74KB		
L28	URBAN ENVIRONM.	CAT.NAME		L30	URBAN ENVIRONM.	CAT.NAME		L32	URBAN ENVIRONM.	CAT.NAME	
FORMAT	SIZE	SIGN 02		FORMAT	SIZE	SIGN 03		FORMAT	SIZE	TROLLEY 02	
LEGACY EPS	77KB			LEGACY EPS	77KB			LEGACY EPS	218KB		

DTL

CAT Nº	GROUP		
L33	URBAN ENVIRONM.	CAT.NAME	
FORMAT	SIZE	SIGN 04	
LEGACY EPS	77KB		

CAT Nº	GROUP		
L35	URBAN ENVIRONM.	CAT.NAME	
FORMAT	SIZE	SIGN 01	
LEGACY EPS	75KB		

CAT Nº	GROUP		
L34	URBAN ENVIRONM.	CAT.NAME	
FORMAT	SIZE	SIGN 07	
LEGACY EPS	73KB		

CAT Nº	GROUP		
L36	URBAN ENVIRONM.	CAT.NAME	
FORMAT	SIZE	TROLLEY 01	
LEGACY EPS	110KB		

DTL

CAT Nº L33

CAT Nº L34

CAT Nº L35

CAT Nº L36

L37-41

CAT.Nº	GROUP				
L37	URBAN ENVIRONM.	CAT.NAME			
FORMAT		SIZE	PYLON		
LEGACY EPS	1.1MB				

CAT.Nº	GROUP				
L38	URBAN ENVIRONM.	CAT.NAME			
FORMAT		SIZE	POWERPOLE		
LEGACY EPS	805KB				

CAT.Nº	GROUP				
L39	URBAN ENVIRONM.	CAT.NAME			
FORMAT		SIZE	TOWER		
LEGACY EPS	82KB				

CAT.Nº	GROUP				
L40	URBAN ENVIRONM.	CAT.NAME			
FORMAT		SIZE	HYDRANT		
LEGACY EPS	83KB				

CAT.Nº	GROUP				
L41	URBAN ENVIRONM.	CAT.NAME			
FORMAT		SIZE	SATELLITE DISH		
LEGACY EPS	97KB				

DTL

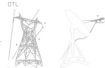

CAT Nº ▶ L37

CAT Nº ▽ L38

CAT.Nº	GROUP		
		CAT.NAME	
FORMAT	SIZE		

CAT.Nº	GROUP		
		CAT.NAME	
FORMAT	SIZE		

CAT.Nº	GROUP		
		CAT.NAME	
FORMAT	SIZE		

DTL

CAT
N° L39

CAT
N° L40

CAT
N° L41

+2853
ANCHOR POINTS

+945
ANCHOR POINTS

+1319
ANCHOR POINTS

+2295
ANCHOR POINTS

+737
ANCHOR POINTS

+32
ANCHOR POINTS

VEHICLES (BP) M01-107

+1839
ANCHOR POINTS

+838
ANCHOR POINTS

+1182
ANCHOR POINTS

+849
ANCHOR POINTS

+1226
ANCHOR POINTS

+1736
ANCHOR POINTS

CITROEN DS//JEEP WRANGLER//JEEP CHEROKEE//ZAZ 968//ZAZ 965//VOLVO V70//VOLVO 360//ALFA ROMEO 156//AUDI A2//CHEVY CORVETTE SR63-3//CITROEN XSARA//VW SHARAN//BMW S2002//...➔

M01-04

DTL

CAT.Nº	GROUP	CAT.NAME		CAT.Nº	GROUP	CAT.NAME
M01	VEHICLES (BP)			M03	VEHICLES (BP)	
FORMAT	SIZE	CITROEN DS B		FORMAT	SIZE	CITROEN DS A
LEGACY EPS	88KB			LEGACY EPS	102KB	
M02	VEHICLES (BP)			M04	VEHICLES (BP)	
FORMAT	SIZE	CITROEN DS D		FORMAT	SIZE	CITROEN DS C
LEGACY EPS	105KB			LEGACY EPS	102KB	

CAT
Nº ▶ **M01**

CAT
Nº ▼ **M02** CAT
Nº ▼ **M03**

DTL

CAT
Nº M04

M05-11

CAT.Nº	GROUP		CAT.NAME
M05	VEHICLES (BP)		JEEP WRANGLER
FORMAT		SIZE	
LEGACY EPS		106KB	

CAT.Nº	GROUP		CAT.NAME
M07	VEHICLES (BP)		ZAZ 968
FORMAT		SIZE	
LEGACY EPS		95KB	

CAT.Nº	GROUP		CAT.NAME
M09	VEHICLES (BP)		ZAZ 965 D
FORMAT		SIZE	
LEGACY EPS		91KB	

CAT.Nº	GROUP		CAT.NAME
M06	VEHICLES (BP)		JEEP CHEROKEE
FORMAT		SIZE	
LEGACY EPS		118KB	

CAT.Nº	GROUP		CAT.NAME
M08	VEHICLES (BP)		ZAZ 965 B
FORMAT		SIZE	
LEGACY EPS		103KB	

CAT.Nº	GROUP		CAT.NAME
M10	VEHICLES (BP)		ZAZ 965 A
FORMAT		SIZE	
LEGACY EPS		95KB	

CAT Nº ▶ M05

CAT Nº ▶ M06

CAT.Nº GROUP
M11 VEHICLES (BP) CAT.NAME
FORMAT SIZE ZAZ 965 C
LEGACY EPS 90KB

DTL

CAT
Nº M07

CAT
Nº M08

CAT
Nº M11

CAT
Nº M09

CAT
Nº M10

M12-20

CAT N°	GROUP		CAT.NAME		CAT N°	GROUP		CAT.NAME		CAT N°	GROUP		CAT.NAME
M12	VEHICLES (BP)		VOLVO V70		M14	VEHICLES (BP)		VOLVO 360 A		M16	VEHICLES (BP)		AUDI A2
FORMAT		SIZE			FORMAT		SIZE			FORMAT		SIZE	
LEGACY EPS		81KB			LEGACY EPS		102KB			LEGACY EPS		106KB	

CAT N°	GROUP		CAT.NAME		CAT N°	GROUP		CAT.NAME		CAT N°	GROUP		CAT.NAME
M13	VEHICLES (BP)		VOLVO 360 D		M15	VEHICLES (BP)		ALFA ROMEO 156		M17	VEHICLES (BP)		AUDI S3
FORMAT		SIZE			FORMAT		SIZE			FORMAT		SIZE	
LEGACY EPS		93KB			LEGACY EPS		102KB			LEGACY EPS		112KB	

DTL

CAT N° M12

CAT N° M13 CAT N° M14

CAT N° M15 CAT N° M17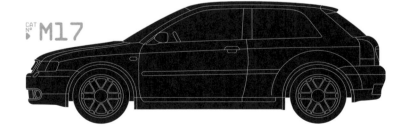

CAT N° M16 CAT N° M18

CAT Nº GROUP
M18 VEHICLES (BP) CAT.NAME
FORMAT SIZE AUDI A4
LEGACY EPS 110KB

CAT Nº GROUP CAT Nº GROUP
M19 VEHICLES (BP) CAT.NAME M20 VEHICLES (BP) CAT.NAME
FORMAT SIZE VOLVO 360 B FORMAT SIZE VOLVO 360 C
LEGACY EPS 104KB LEGACY EPS 105KB

OTL

CAT
Nº ▶ M19

CAT
Nº ▼ M20

M21-27

DTL

CAT №	GROUP		CAT.NAME
M21	VEHICLES (BP)		AUDI A6 A
FORMAT		SIZE	
LEGACY EPS		103KB	

CAT №	GROUP		CAT.NAME
M22	VEHICLES (BP)		AUDI A6 D
FORMAT		SIZE	
LEGACY EPS		92KB	

CAT №	GROUP		CAT.NAME
M23	VEHICLES (BP)		CHEVY CORV SR63-6
FORMAT		SIZE	
LEGACY EPS		107KB	

CAT №	GROUP		CAT.NAME
M24	VEHICLES (BP)		CHEVY CORV. SRAY
FORMAT		SIZE	
LEGACY EPS		110KB	

CAT №	GROUP		CAT.NAME
M25	VEHICLES (BP)		AUDI A6 B
FORMAT		SIZE	
LEGACY EPS		100KB	

CAT №	GROUP		CAT.NAME
M26	VEHICLES (BP)		AUDI A6 C
FORMAT		SIZE	
LEGACY EPS		98KB	

CAT № M21

CAT № M22

CAT № M23

CAT № M24

CAT N° GROUP
M27 VEHICLES (BP)
FORMAT SIZE CAT NAME
LEGACY EPS 99KB CHEVY CORVETTE

OTL

CAT
N° M25

CAT
N° M26

CAT
N° M27

M28-35

CAT.Nº	GROUP	CAT.NAME
M28	VEHICLES (BP)	CITROEN XSARA
FORMAT	SIZE	
LEGACY EPS	118KB	

CAT.Nº	GROUP	CAT.NAME
M29	VEHICLES (BP)	VW SHARAN
FORMAT	SIZE	
LEGACY EPS	97KB	

CAT.Nº	GROUP	CAT.NAME
M30	VEHICLES (BP)	BMW S2002
FORMAT	SIZE	
LEGACY EPS	140KB	

CAT.Nº	GROUP	CAT.NAME
M31	VEHICLES (BP)	SKODA FABIA
FORMAT	SIZE	
LEGACY EPS	106KB	

CAT.Nº	GROUP	CAT.NAME
M32	VEHICLES (BP)	BMW Z3
FORMAT	SIZE	
LEGACY EPS	103KB	

CAT.Nº	GROUP	CAT.NAME
M33	VEHICLES (BP)	VW GOLF 2T
FORMAT	SIZE	
LEGACY EPS	99KB	

DTL

CAT Nº M28

CAT Nº M31

CAT Nº M29

CAT Nº M32

CAT Nº M30

CAT.Nº	GROUP			
M28	VEHICLES (BP)			
M30	VEHICLES (BP)			
M32	VEHICLES (BP)			

CAT Nº	GROUP		
M34	VEHICLES (BP)	CAT.NAME	
FORMAT		SIZE	VW PASSAT
LEGACY EPS	97KB		

CAT Nº	GROUP		
M35	VEHICLES (BP)	CAT.NAME	
FORMAT		SIZE	BMW LIMOUSINE
LEGACY EPS	111KB		

OTL

CAT Nº M34

CAT Nº M33

CAT Nº M35

M36-50

CAT Nº	GROUP		CAT.NAME
M36	VEHICLES (BP)		NISSAN ALMERA
FORMAT	SIZE	95KB	
LEGACY EPS			

CAT Nº	GROUP		CAT.NAME
M38	VEHICLES (BP)		NISSAN DATSUN D
FORMAT	SIZE	99KB	
LEGACY EPS			

CAT Nº	GROUP		CAT.NAME
M40	VEHICLES (BP)		NISSAN DATSUN B
FORMAT	SIZE	88KB	
LEGACY EPS			

CAT Nº	GROUP		CAT.NAME
M37	VEHICLES (BP)		NISSAN DATSUN A
FORMAT	SIZE	108KB	
LEGACY EPS			

CAT Nº	GROUP		CAT.NAME
M39	VEHICLES (BP)		NISSAN DATSUN C
FORMAT	SIZE	92KB	
LEGACY EPS			

CAT Nº	GROUP		CAT.NAME
M41	VEHICLES (BP)		LANCIA A 112
FORMAT	SIZE	118KB	
LEGACY EPS			

DTL

CAT Nº M39

CAT Nº M36

CAT Nº M37 CAT Nº M38

CAT Nº M40

CAT Nº M43

CAT Nº M41

CAT Nº M42

CAT Nº M44 CAT Nº M45

CAT.N°	GROUP	CAT.NAME	FORMAT	SIZE
M42	VEHICLES (BP)	LANCIA 600L B	LEGACY EPS	118KB
M43	VEHICLES (BP)	LANCIA 600L C	LEGACY EPS	107KB
M44	VEHICLES (BP)	LANCIA 600L A	LEGACY EPS	170KB
M45	VEHICLES (BP)	LANCIA 600L D	LEGACY EPS	104KB
M46	VEHICLES (BP)	HONDA ACCORD C	LEGACY EPS	106KB
M47	VEHICLES (BP)	HONDA ACCORD B	LEGACY EPS	112KB
M48	VEHICLES (BP)	HONDA ACCORD D	LEGACY EPS	100KB
M49	VEHICLES (BP)	HONDA ACCORD A	LEGACY EPS	115KB
M50	VEHICLES (BP)	HONDA CIVIC	LEGACY EPS	104KB

DTL

CAT N° M46

CAT N° M47

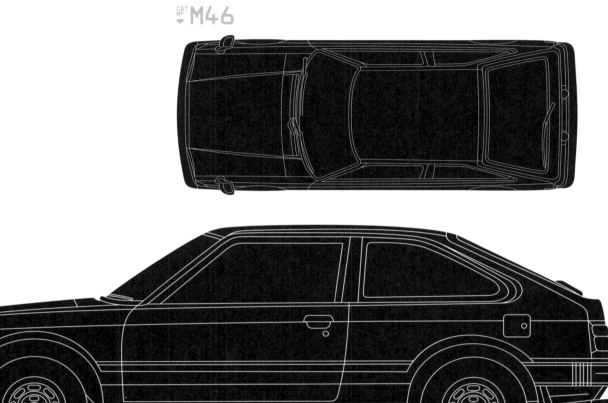

CAT N° M48

CAT N° M49

CAT N° M50

M51-55

DTL

CAT.Nº	GROUP		CAT.NAME
M51	VEHICLES (BP)		MINI COOPER A
FORMAT		SIZE	
LEGACY EPS		140KB	

CAT.Nº	GROUP		CAT.NAME
M52	VEHICLES (BP)		MINI COOPER C
FORMAT		SIZE	
LEGACY EPS		119KB	

CAT.Nº	GROUP		CAT.NAME
M53	VEHICLES (BP)		MINI COOPER D
FORMAT		SIZE	
LEGACY EPS		116KB	

CAT.Nº	GROUP		CAT.NAME
M54	VEHICLES (BP)		MINI COOPER B
FORMAT		SIZE	
LEGACY EPS		127KB	

CAT.Nº	GROUP		CAT.NAME
M55	VEHICLES (BP)		MINI NEW
FORMAT		SIZE	
LEGACY EPS		103KB	

CAT Nº M51

CAT Nº M53

CAT Nº M52

CAT.Nº	GROUP		CAT.NAME
M51	VEHICLES (BP)		MINI COOPER A
FORMAT		SIZE	
LEGACY EPS		140KB	

CAT.Nº	GROUP		CAT.NAME
M53	VEHICLES (BP)		MINI COOPER D
FORMAT		SIZE	
LEGACY EPS		116KB	

CAT
N°
M54

CAT
N°
M55

M56-61

CAT Nº	GROUP			CAT Nº	GROUP			CAT Nº	GROUP	
M56	VEHICLES (BP)	CAT.NAME		M58	VEHICLES (BP)	CAT.NAME		M60	VEHICLES (BP)	CAT.NAME
FORMAT	SIZE	LANDROVER FL A		FORMAT	SIZE	LANDROVER FL B		FORMAT	SIZE	MILITARY ST. CARGO
LEGACY EPS	93KB			LEGACY EPS	95KB			LEGACY EPS	239KB	
M57	VEHICLES (BP)	CAT.NAME		M59	VEHICLES (BP)	CAT.NAME		M61	VEHICLES (BP)	CAT.NAME
FORMAT	SIZE	LANDROVER FL D		FORMAT	SIZE	LANDROVER FL C		FORMAT	SIZE	MILITARY M923
LEGACY EPS	95KB			LEGACY EPS	107KB			LEGACY EPS	137KB	

DTL

CAT Nº M56

CAT Nº M57

CAT Nº M58

CAT Nº M59

DTL

CAT Nº M60

CAT Nº M61

M62-75

DTL

CAT.Nº	GROUP		CAT.Nº	GROUP		CAT.Nº	GROUP	
M62	VEHICLES (BP)	CAT.NAME	M64	VEHICLES (BP)	CAT.NAME	M66	VEHICLES (BP)	CAT.NAME
FORMAT	SIZE	MERCEDES A CLASS	FORMAT	SIZE	MERCEDES AMG55 A	FORMAT	SIZE	MERCEDES AMG55 D
LEGACY EPS	127KB		LEGACY EPS	104KB		LEGACY EPS	110KB	
CAT.Nº	GROUP		CAT.Nº	GROUP		CAT.Nº	GROUP	
M63	VEHICLES (BP)	CAT.NAME	M65	VEHICLES (BP)	CAT.NAME	M67	VEHICLES (BP)	CAT.NAME
FORMAT	SIZE	MERCEDES SLK 320	FORMAT	SIZE	MERCEDES AMG55 C	FORMAT	SIZE	MERCEDES AMG55 B
LEGACY EPS	95KB		LEGACY EPS	99KB		LEGACY EPS	102KB	

CAT Nº ▶ M62

CAT Nº ▶ M63

CAT Nº ▾ M64

CAT Nº ▾ M66

CAT Nº ▾ M67

CAT Nº ▾ M65

CAT.Nº	GROUP			CAT.Nº	GROUP			CAT.Nº	GROUP			CAT.Nº	GROUP		
M68	VEHICLES (BP)	CAT.NAME		M70	VEHICLES (BP)	CAT.NAME		M72	VEHICLES (BP)	CAT.NAME		M74	VEHICLES (BP)	CAT.NAME	
FORMAT	SIZE	SAAB 96 B		FORMAT	SIZE	SAAB 96 A		FORMAT	SIZE	SAAB 900 A		FORMAT	SIZE	SAAB 900 B	
LEGACY EPS	104KB			LEGACY EPS	100KB			LEGACY EPS	100KB			LEGACY EPS	104KB		

CAT.Nº	GROUP			CAT.Nº	GROUP			CAT.Nº	GROUP			CAT.Nº	GROUP		
M69	VEHICLES (BP)	CAT.NAME		M71	VEHICLES (BP)	CAT.NAME		M73	VEHICLES (BP)	CAT.NAME		M75	VEHICLES (BP)	CAT.NAME	
FORMAT	SIZE	SAAB 96 C		FORMAT	SIZE	SAAB 96 D		FORMAT	SIZE	SAAB 900 D		FORMAT	SIZE	SAAB 900 C	
LEGACY EPS	108KB			LEGACY EPS	93KB			LEGACY EPS	93KB			LEGACY EPS	95KB		

DTL

CAT Nº ▶ M68

CAT Nº ▼ M70

CAT Nº ▼ M69

CAT Nº ▼ M71

CAT Nº ▼ M72

CAT Nº ▶ M74

CAT Nº ▼ M73

CAT Nº ▼ M75

M76-79

CAT Nº	GROUP		
M76	VEHICLES (BP)	CAT.NAME	
FORMAT	SIZE	UAZ 3741 D	
LEGACY EPS	111KB		

CAT Nº	GROUP		
M77	VEHICLES (BP)	CAT.NAME	
FORMAT	SIZE	UAZ 3741 C	
LEGACY EPS	93KB		

CAT Nº	GROUP		
M78	VEHICLES (BP)	CAT.NAME	
FORMAT	SIZE	UAZ 3741 A	
LEGACY EPS	132KB		

CAT Nº	GROUP		
M79	VEHICLES (BP)	CAT.NAME	
FORMAT	SIZE	UAZ 3741 B	
LEGACY EPS	107KB		

OTL

CAT Nº M76

CAT Nº M78

CAT Nº M77

CAT Nº M79

DTL

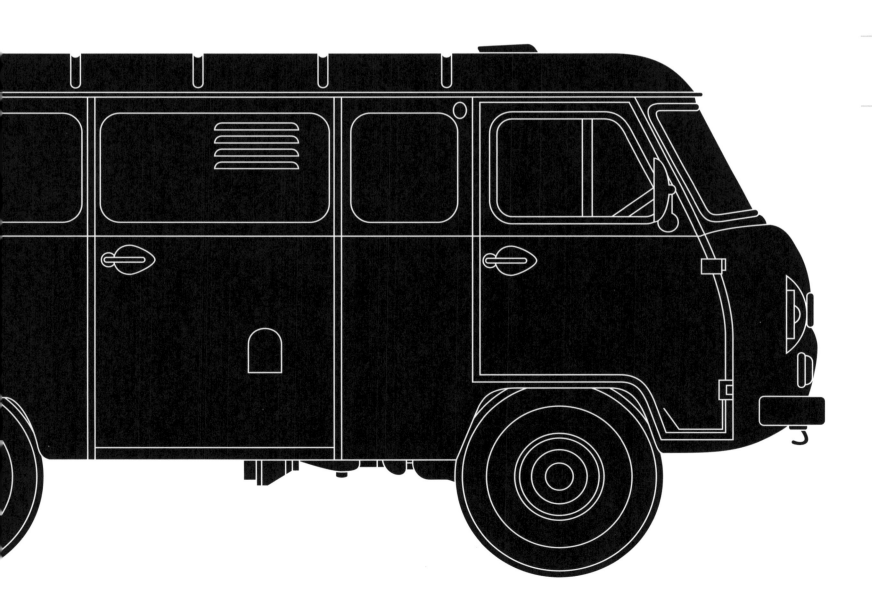

M80-88

DTL

CAT Nº M85

CAT Nº M86

CAT Nº M80

CAT Nº M87

CAT Nº M81

CAT Nº M82

CAT Nº M83

CAT Nº M84

CAT Nº GROUP
M86 VEHICLES (BP) CAT.NAME
FORMAT SIZE YUGO 45 D
LEGACY EPS 98KB

CAT Nº GROUP
M87 VEHICLES (BP) CAT.NAME
FORMAT SIZE YUGO 45 C
LEGACY EPS 93KB

CAT Nº GROUP
M88 VEHICLES (BP) CAT.NAME
FORMAT SIZE YUGO 45 B
LEGACY EPS 92KB

OTL

CAT
Nº M88

M89-93

CAT Nº	GROUP	CAT.NAME
M89	VEHICLES (BP)	VW KÄFER D
FORMAT	SIZE	
LEGACY EPS	148KB	

CAT Nº	GROUP	CAT.NAME
M90	VEHICLES (BP)	VW KÄFER C
FORMAT	SIZE	
LEGACY EPS	133KB	

CAT Nº	GROUP	CAT.NAME
M91	VEHICLES (BP)	VW NEW BEETLE
FORMAT	SIZE	
LEGACY EPS	99KB	

CAT Nº	GROUP	CAT.NAME
M92	VEHICLES (BP)	VW KÄFER B
FORMAT	SIZE	
LEGACY EPS	99KB	

CAT Nº	GROUP	CAT.NAME
M93	VEHICLES (BP)	VW KÄFER A
FORMAT	SIZE	
LEGACY EPS	137KB	

CAT Nº M89

CAT Nº M92

CAT Nº M90

CAT Nº M91

CAT Nº	GROUP	CAT.NAME
M89	VEHICLES (BP)	VW KÄFER D
FORMAT	SIZE	
LEGACY EPS		

CAT Nº	GROUP	CAT.NAME
M91	VEHICLES (BP)	VW NEW BEETLE
FORMAT	SIZE	
LEGACY EPS		

CAT
N° ▶ M93

M94-101

CAT Nº	GROUP			CAT Nº	GROUP		
M94	VEHICLES (BP)		CAT.NAME	M96	VEHICLES (BP)		CAT.NAME
FORMAT		SIZE	TAVRIA STARA B	FORMAT		SIZE	TAVRIA STARA D
LEGACY EPS		84KB		LEGACY EPS		85KB	
M95	VEHICLES (BP)		CAT.NAME	M97	VEHICLES (BP)		CAT.NAME
FORMAT		SIZE	TAVRIA STARA A	FORMAT		SIZE	TAVRIA STARA C
LEGACY EPS		89KB		LEGACY EPS		96KB	

CAT Nº ▾ M94

CAT Nº ▾ M95

CAT Nº ▾ M96

CAT Nº ▾ M97

CAT №	GROUP		
M98	VEHICLES (BP)	CAT.NAME	
FORMAT	SIZE	SHELBY COBRA A	
LEGACY EPS	113KB		

CAT №	GROUP		
M100	VEHICLES (BP)	CAT.NAME	
FORMAT	SIZE	SHELBY COBRA B	
LEGACY EPS	104KB		

CAT №	GROUP		
M99	VEHICLES (BP)	CAT.NAME	
FORMAT	SIZE	SHELBY COBRA D	
LEGACY EPS	101KB		

CAT №	GROUP		
M101	VEHICLES (BP)	CAT.NAME	
FORMAT	SIZE	SHELBY COBRA C	
LEGACY EPS	115KB		

OTL

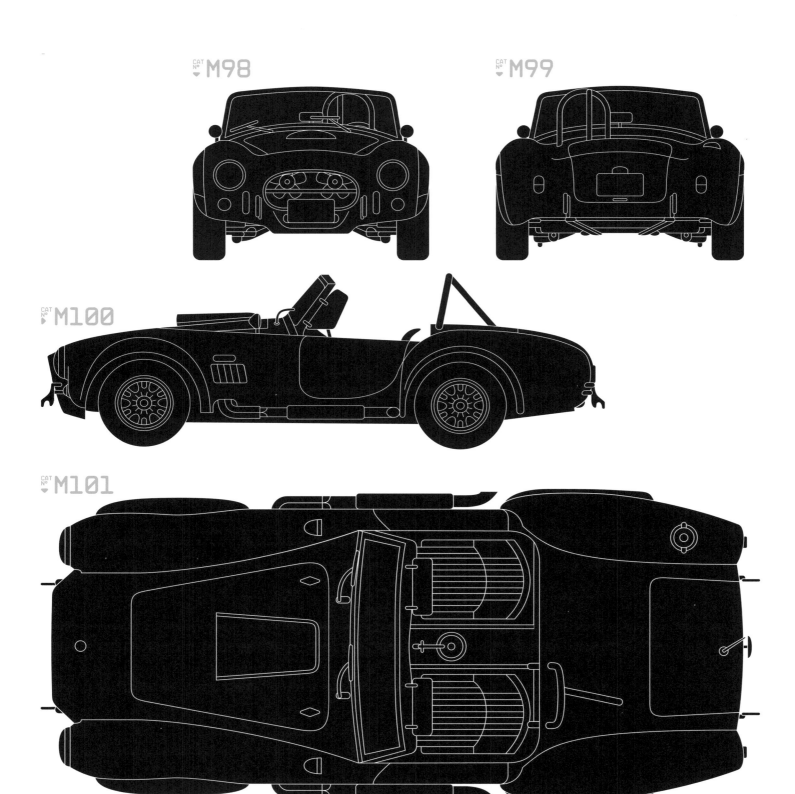

CAT № M98

CAT № M99

CAT № M100

CAT № M101

M102-107

DTL

CAT Nº	GROUP			CAT Nº	GROUP		
M102	VEHICLES (BP)	CAT.NAME		M104	VEHICLES (BP)	CAT.NAME	
FORMAT	SIZE	OPEL KADETT		FORMAT	SIZE	LOTUS ESPRIT	
LEGACY EPS	103KB			LEGACY EPS	99KB		
M103	VEHICLES (BP)	CAT.NAME		M105	VEHICLES (BP)	CAT.NAME	
FORMAT	SIZE	CITROEN CX		FORMAT	SIZE	CITROEN GS	
LEGACY EPS	84KB			LEGACY EPS	101KB		

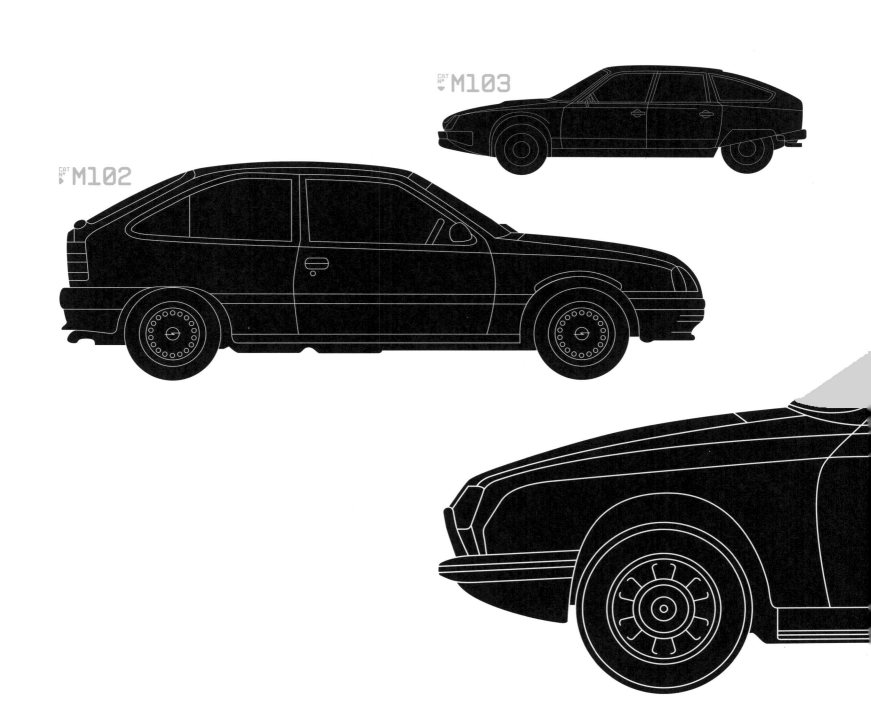

CAT Nº M103

CAT Nº M102

CAT.Nº GROUP
M106 VEHICLES (BP) CAT.NAME
FORMAT SIZE DODGE VIPER
LEGACY EPS 126KB

CAT.Nº GROUP
M107 VEHICLES (BP) CAT.NAME
FORMAT SIZE OPEL OMEGA
LEGACY EPS 107KB

DTL

CAT Nº M104

CAT Nº M106

CAT Nº M107

CAT Nº M105

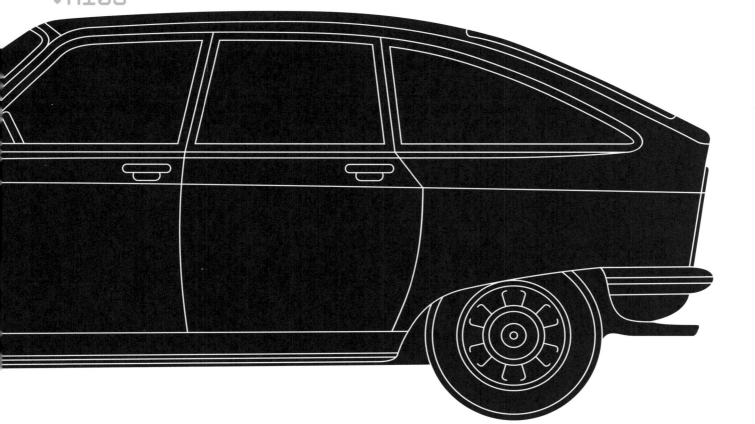

VEHICLES (RG) N01-24

CARS/ICE-CREAM
VAN/JEEP/FUELI
NG VEHICLE/PET
ROL PUMP/TRUCK
/BROADCAST VEH
ICLE/TRAILERS/
CARAVAN/FIRE E
NGINES/TRUCK W
ITH PLOUGH/MOT
OR PLOUGH/➔

+522
KILOBYTES

+74
KILOBYTES

+81
KILOBYTES

+73
KILOBYTES

+90
KILOBYTES

+88
KILOBYTES

+251
KILOBYTES

KILOBYTES

+85
KILOBYTES

+368
KILOBYTES

+232
KILOBYTES

+109
KILOBYTES

▼100 ▼090 ▼080 ▼070 ▼060 ▼050 ▼040 ▼030 ▼020 ▼010

LOAD BAR REFERENCE
(INDICATES THE NUMBER OF OBJECTS WITHIN THE ACTIVE SECTION RELATIVE TO THE OTHER INDIVIDUAL SECTIONS OF THE COMPENDIUM).

N01-12

DTL

CAT Nº	GROUP	
N01	VEHICLES (RG)	CAT NAME
FORMAT	SIZE	CAR 04
LEGACY EPS	74KB	

CAT Nº	GROUP	
N02	VEHICLES (RG)	CAT NAME
FORMAT	SIZE	ICE-CREAM VAN
LEGACY EPS	74KB	

CAT Nº	GROUP	
N03	VEHICLES (RG)	CAT.NAME
FORMAT	SIZE	CAR 06
LEGACY EPS	77KB	

CAT Nº	GROUP	
N04	VEHICLES (RG)	CAT.NAME
FORMAT	SIZE	CAR 03
LEGACY EPS	77KB	

CAT Nº	GROUP	
N05	VEHICLES (RG)	CAT.NAME
FORMAT	SIZE	CAR 01
LEGACY EPS	76KB	

CAT Nº	GROUP	
N06	VEHICLES (RG)	CAT.NAME
FORMAT	SIZE	CAR 07
LEGACY EPS	74KB	

CAT Nº **N01**

CAT Nº **N03**

CAT Nº **N06**

CAT Nº **N02**

CAT Nº **N04**

CAT Nº **N07**

CAT Nº **N05**

CAT.Nº	GROUP		CAT.Nº	GROUP		CAT.Nº	GROUP	
N07	VEHICLES (RG)	CAT.NAME	N09	VEHICLES (RG)	CAT.NAME	N11	VEHICLES (RG)	CAT.NAME
FORMAT	SIZE	CAR 05	FORMAT	SIZE	CAR 02	FORMAT	SIZE	PETROL PUMP
LEGACY EPS	76KB		LEGACY EPS	78KB		LEGACY EPS	90KB	

CAT.Nº	GROUP		CAT.Nº	GROUP		CAT.Nº	GROUP	
N08	VEHICLES (RG)	CAT.NAME	N10	VEHICLES (RG)	CAT.NAME	N12	VEHICLES (RG)	CAT.NAME
FORMAT	SIZE	JEEP	FORMAT	SIZE	FUELING VEHICLE	FORMAT	SIZE	TRUCK
LEGACY EPS	81KB		LEGACY EPS	73KB		LEGACY EPS	88KB	

OTL

N13-24

CAT.Nº	GROUP		CAT.NAME
N13	VEHICLES (RG)		BROADCAST VEHIC. 01
FORMAT		SIZE	
LEGACY EPS		138KB	

CAT.Nº	GROUP		CAT.NAME
N15	VEHICLES (RG)		TRAILER 01
FORMAT		SIZE	
LEGACY EPS		81KB	

CAT.Nº	GROUP		CAT.NAME
N17	VEHICLES (RG)		CARAVAN
FORMAT		SIZE	
LEGACY EPS		85KB	

CAT.Nº	GROUP		CAT.NAME
N14	VEHICLES (RG)		BROADCAST VEHIC. 02
FORMAT		SIZE	
LEGACY EPS		113KB	

CAT.Nº	GROUP		CAT.NAME
N16	VEHICLES (RG)		TRAILER 02
FORMAT		SIZE	
LEGACY EPS		80KB	

CAT.Nº	GROUP		CAT.NAME
N18	VEHICLES (RG)		FIRE ENGINE 02
FORMAT		SIZE	
LEGACY EPS		76KB	

DTL

CAT Nº N13

CAT Nº N14

CAT Nº N15

CAT Nº N16

CAT Nº N17

CAT.No	GROUP	CAT.NAME
N19	VEHICLES (RG)	FIRE ENGINE 03
FORMAT	SIZE	
LEGACY EPS	77KB	

CAT.No	GROUP	CAT.NAME
N21	VEHICLES (RG)	FIRE ENGINE 04
FORMAT	SIZE	
LEGACY EPS	79KB	

CAT.No	GROUP	CAT.NAME
N23	VEHICLES (RG)	FIRE ENGINE 05
FORMAT	SIZE	
LEGACY EPS	78KB	

CAT.No	GROUP	CAT.NAME
N20	VEHICLES (RG)	TRUCK WITH PLOUGH
FORMAT	SIZE	
LEGACY EPS	96KB	

CAT.No	GROUP	CAT.NAME
N22	VEHICLES (RG)	FIRE ENGINE 01
FORMAT	SIZE	
LEGACY EPS	76KB	

CAT.No	GROUP	CAT.NAME
N24	VEHICLES (RG)	MOTOR PLOUGH
FORMAT	SIZE	
LEGACY EPS	109KB	

DTL

CAT No N18
CAT No N20
CAT No N21
CAT No N22
CAT No N19
CAT No N23
CAT No N24

AIRCRAFT (BP) 001-58

BOEING 717/ANTONOV AN-124/BOEING 737/BOEING 747/SCHOPF POWERPUSH/BOEING 747-100/BOEING 757/SCHOPF F396/SAAB 2000/FOKKER 28/SCHOPF F59/BELL 407/BAE 146/...→

+308 KILOBYTES

+204 KILOBYTES

+360 KILOBYTES

+243 KILOBYTES

+383 KILOBYTES

+434 KILOBYTES

+421 KILOBYTES

+373 KILOBYTES

+315 KILOBYTES

+656 KILOBYTES

+293 KILOBYTES

+385 KILOBYTES

+87 KILOBYTES

▾100 ▾090 ▾080 ▾070 ▾060 ▾050 ▾040 ▾030 ▾020 ▾010 ▾000

LOAD BAR REFERENCE
(INDICATES THE NUMBER OF OBJECTS WITHIN THE ACTIVE SECTION, RELATIVE TO THE OTHER INDIVIDUAL SECTIONS OF THE COMPENDIUM.)

001-06

DTL

CAT.Nº	GROUP		
001	AIRCRAFT (BP)	CAT.NAME	
FORMAT	SIZE	BOEING 717 C	
LEGACY EPS	106KB		

CAT.Nº	GROUP		
002	AIRCRAFT (BP)	CAT.NAME	
FORMAT	SIZE	BOEING 717 A	
LEGACY EPS	88KB		

CAT.Nº	GROUP		
003	AIRCRAFT (BP)	CAT.NAME	
FORMAT	SIZE	BOEING 717 B	
LEGACY EPS	124KB		

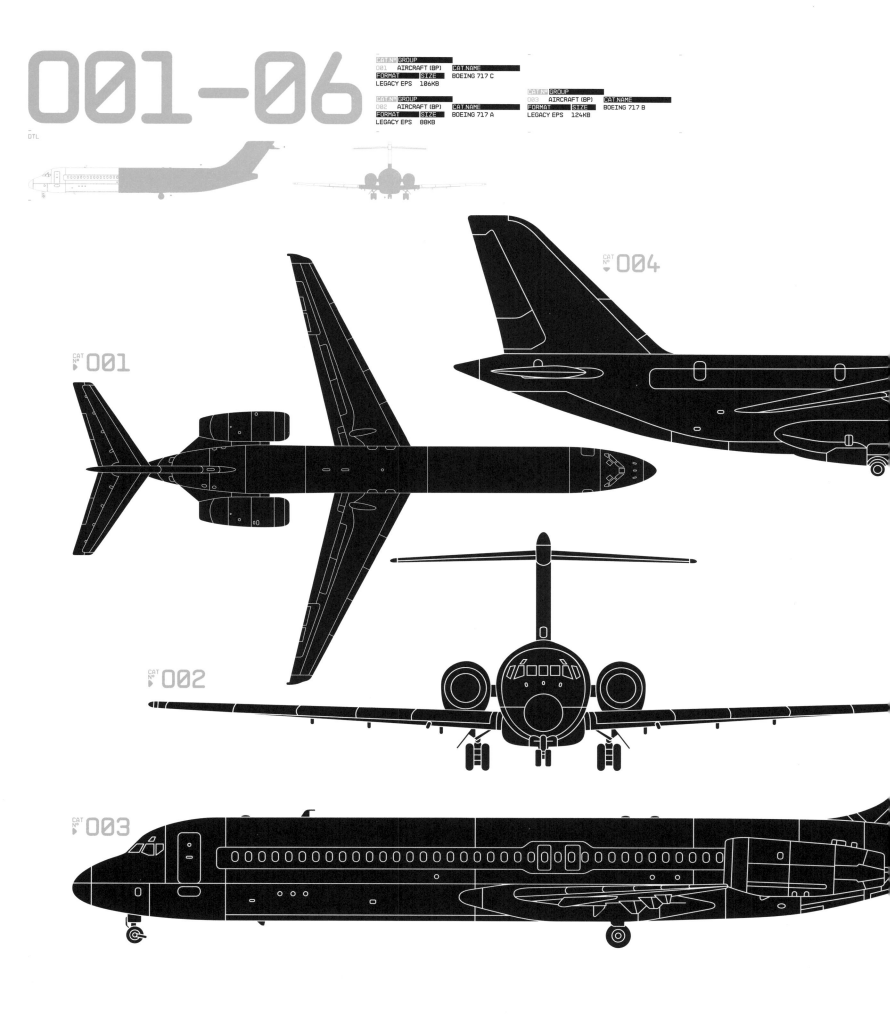

CAT Nº 004

CAT Nº 001

CAT Nº 002

CAT Nº 003

CAT №	GROUP		CAT.NAME
004	AIRCRAFT (BP)		ANTONOV AN-124 B
FORMAT	SIZE		
LEGACY EPS	101KB		

CAT №	GROUP		CAT.NAME
005	AIRCRAFT (BP)		ANTONOV AN-124 A
FORMAT	SIZE		
LEGACY EPS	88KB		

CAT №	GROUP		CAT.NAME
006	AIRCRAFT (BP)		ANTONOV AN-124 C
FORMAT	SIZE		
LEGACY EPS	115KB		

OTL

CAT Nº ▶ 005

CAT Nº ▶ 006

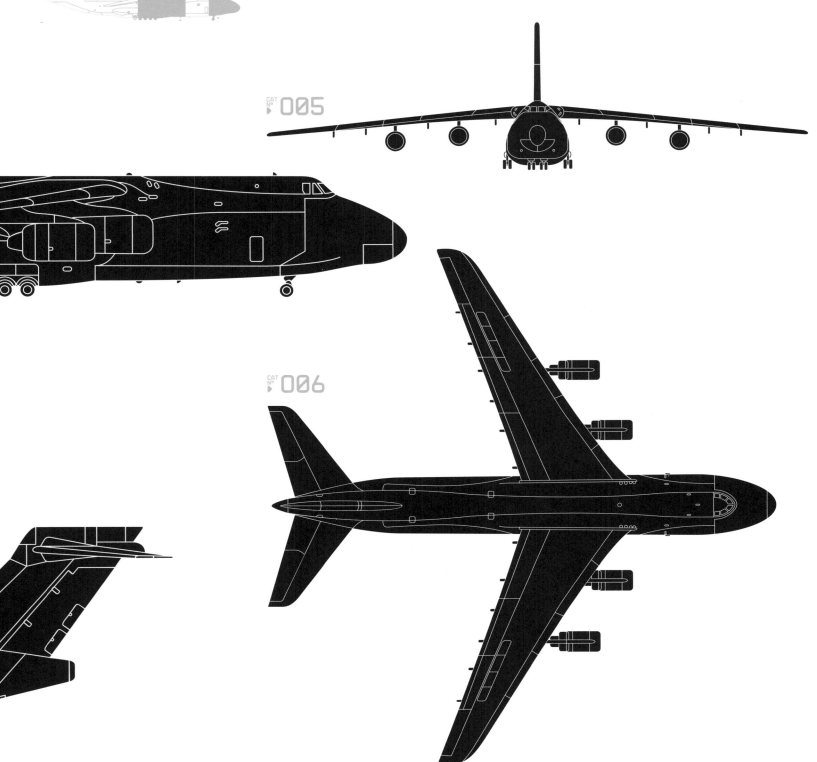

007-15

DTL

CAT Nº 007

CAT Nº 008

CAT Nº 009

CAT Nº 010

CAT Nº 013

CAT Nº	GROUP	CAT.NAME
013	AIRCRAFT (BP)	SCHOPF POWERPUSH B
FORMAT	SIZE	
LEGACY EPS	99KB	

CAT Nº	GROUP	CAT.NAME
014	AIRCRAFT (BP)	SCHOPF POWERPUSH A
FORMAT	SIZE	
LEGACY EPS	113KB	

CAT Nº	GROUP	CAT.NAME
015	AIRCRAFT (BP)	SCHOPF POWERPUSH C
FORMAT	SIZE	
LEGACY EPS	147KB	

OTL

CAT Nº ▶ 011

CAT Nº ▶ 012

CAT Nº ▶ 015

CAT Nº ▼ 014

016-25

DTL

CAT Nº 016

CAT Nº 018

CAT Nº 017

CAT Nº 024

CAT Nº 023

CAT.N°	GROUP			CAT.N°	GROUP		
022	AIRCRAFT (BP)	CAT.NAME		024	AIRCRAFT (BP)	CAT.NAME	
FORMAT	SIZE	BOEING 757 A		FORMAT	SIZE	SCHOPF F396 C	
LEGACY EPS	93KB			LEGACY EPS	185KB		

CAT.N°	GROUP			CAT.N°	GROUP		
023	AIRCRAFT (BP)	CAT.NAME		025	AIRCRAFT (BP)	CAT.NAME	
FORMAT	SIZE	SCHOPF F396 A		FORMAT	SIZE	SCHOPF F396 B	
LEGACY EPS	91KB			LEGACY EPS	97KB		

DTL

CAT N° 019

CAT N° 020

CAT N° 021

CAT N° 022

CAT N° 025

026-34

OTL

CAT Nº	GROUP		CAT Nº	GROUP		CAT Nº	GROUP	
026	AIRCRAFT (BP)	CAT.NAME	028	AIRCRAFT (BP)	CAT.NAME	030	AIRCRAFT (BP)	CAT.NAME
FORMAT	SIZE	SAAB 2000 C	FORMAT	SIZE	SAAB 2000 B	FORMAT	SIZE	FOKKER 28 B
LEGACY EPS	111KB		LEGACY EPS	110KB		LEGACY EPS	84KB	
CAT Nº	GROUP		CAT Nº	GROUP		CAT Nº	GROUP	
027	AIRCRAFT (BP)	CAT.NAME	029	AIRCRAFT (BP)	CAT.NAME	031	AIRCRAFT (BP)	CAT.NAME
FORMAT	SIZE	SAAB 2000 A	FORMAT	SIZE	FOKKER 28 C	FORMAT	SIZE	FOKKER 28 A
LEGACY EPS	91KB		LEGACY EPS	94KB		LEGACY EPS	74KB	

CAT Nº 028

CAT Nº 026

CAT Nº 029

CAT Nº 027

CAT Nº GROUP
032 AIRCRAFT (BP) CAT.NAME
FORMAT SIZE *SCHOPF F59 B
LEGACY EPS 102KB

CAT Nº GROUP
033 AIRCRAFT (BP) CAT.NAME
FORMAT SIZE SCHOPF F59 C
LEGACY EPS 104KB

CAT Nº GROUP
034 AIRCRAFT (BP) CAT.NAME
FORMAT SIZE SCHOPF F59 A
LEGACY EPS 87KB

DTL

CAT Nº ▶ 030

CAT Nº ▶ 031

CAT Nº ▼ 032

CAT Nº ▼ 033

CAT Nº ▼ 034

035-43

DTL

CAT Nº	GROUP		CAT.NAME
035	AIRCRAFT (BP)		BELL 407 A
FORMAT		SIZE	
LEGACY EPS		80KB	

CAT Nº	GROUP		CAT.NAME
036	AIRCRAFT (BP)		BELL 407 C
FORMAT		SIZE	
LEGACY EPS		105KB	

CAT Nº	GROUP		CAT.NAME
037	AIRCRAFT (BP)		BELL 407 B
FORMAT		SIZE	
LEGACY EPS		97KB	

CAT Nº	GROUP		CAT.NAME
038	AIRCRAFT (BP)		BAE 146 A
FORMAT		SIZE	
LEGACY EPS		89KB	

CAT Nº	GROUP		CAT.NAME
039	AIRCRAFT (BP)		BAE 146 B
FORMAT		SIZE	
LEGACY EPS		95KB	

CAT Nº	GROUP		CAT.NAME
040	AIRCRAFT (BP)		BAE 146 C
FORMAT		SIZE	
LEGACY EPS		118KB	

CAT Nº 035

CAT Nº 036

CAT Nº 037

CAT Nº 038

CAT Nº 039

CAT Nº 040

CAT Nº	GROUP		CAT.NAME
	AIRCRAFT (BP)		
FORMAT		SIZE	
LEGACY EPS			

CAT Nº	GROUP		CAT.NAME
	AIRCRAFT (BP)		
FORMAT		SIZE	
LEGACY EPS			

CAT Nº	GROUP		CAT.NAME
	AIRCRAFT (BP)		
FORMAT		SIZE	
LEGACY EPS			

CAT№	GROUP		
041	AIRCRAFT (BP)	CAT.NAME	
FORMAT	SIZE	JETLINER B	
LEGACY EPS	85KB		

CAT№	GROUP		
042	AIRCRAFT (BP)	CAT.NAME	
FORMAT	SIZE	JETLINER A	
LEGACY EPS	82KB		

CAT№	GROUP		
043	AIRCRAFT (BP)	CAT.NAME	
FORMAT	SIZE	JETLINER C	
LEGACY EPS	99KB		

OTL

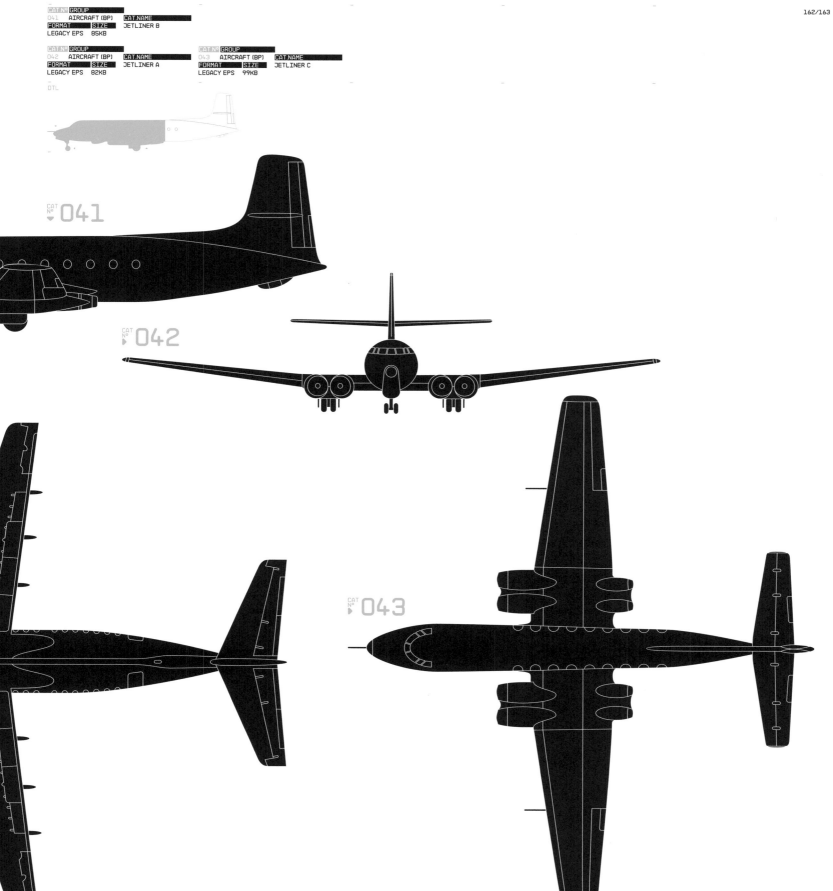

CAT N° 041

CAT N° 042

CAT N° 043

044-49

CAT.Nº	GROUP		CAT.NAME
044	AIRCRAFT (BP)		CONCORDE C
FORMAT		SIZE	
LEGACY EPS		119KB	

CAT.Nº	GROUP		CAT.NAME
045	AIRCRAFT (BP)		CONCORDE A
FORMAT		SIZE	
LEGACY EPS		79KB	

CAT.Nº	GROUP		CAT.NAME
046	AIRCRAFT (BP)		CONCORDE B
FORMAT		SIZE	
LEGACY EPS		79KB	

CAT.Nº	GROUP		CAT.NAME
047	AIRCRAFT (BP)		TUPOLEV TU-204 B
FORMAT		SIZE	
LEGACY EPS		124KB	

CAT.Nº	GROUP		CAT.NAME
048	AIRCRAFT (BP)		TUPOLEV TU-204 A
FORMAT		SIZE	
LEGACY EPS		92KB	

CAT.Nº	GROUP		CAT.NAME
049	AIRCRAFT (BP)		TUPOLEV TU-204 C
FORMAT		SIZE	
LEGACY EPS		133KB	

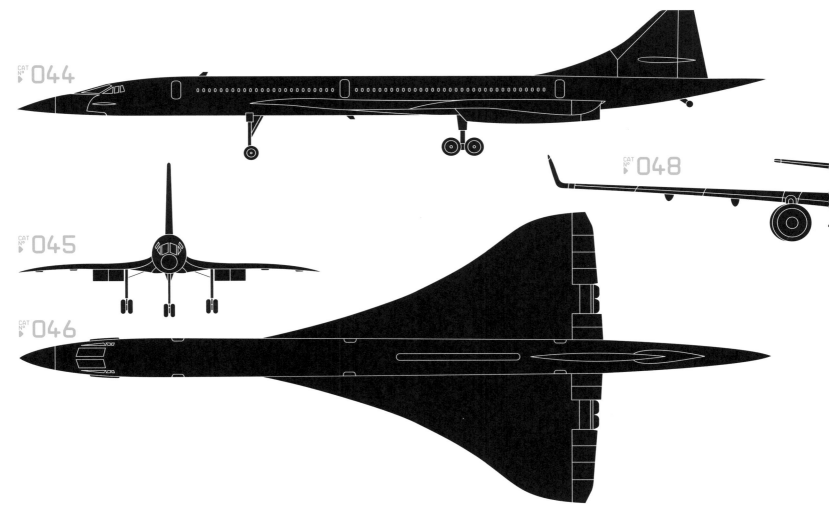

CAT Nº 044

CAT Nº 045

CAT Nº 046

CAT Nº 048

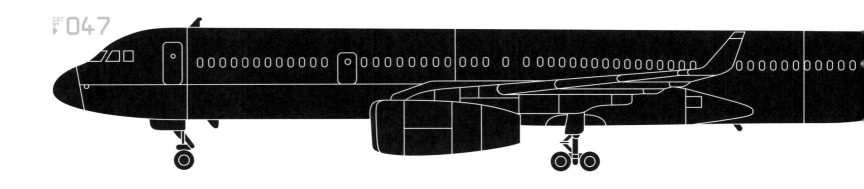

CAT Nº 047

OTL

CAT
Nº ▶049

050-58

DTL

CAT Nº ▶ 050

CAT Nº ▶ 053

CAT Nº ▶ 051

CAT Nº ▶ 052

CAT Nº	GROUP	CAT.NAME
056	AIRCRAFT (BP)	SCHOPF F 110 B
FORMAT	SIZE	
LEGACY EPS	99KB	

CAT Nº	GROUP	CAT.NAME
057	AIRCRAFT (BP)	SCHOPF F 110 A
FORMAT	SIZE	
LEGACY EPS	87KB	

CAT Nº	GROUP	CAT.NAME
058	AIRCRAFT (BP)	SCHOPF F 110 C
FORMAT	SIZE	
LEGACY EPS	138KB	

DTL

CAT Nº 054

CAT Nº 055

CAT Nº 056

CAT Nº 057

CAT Nº 058

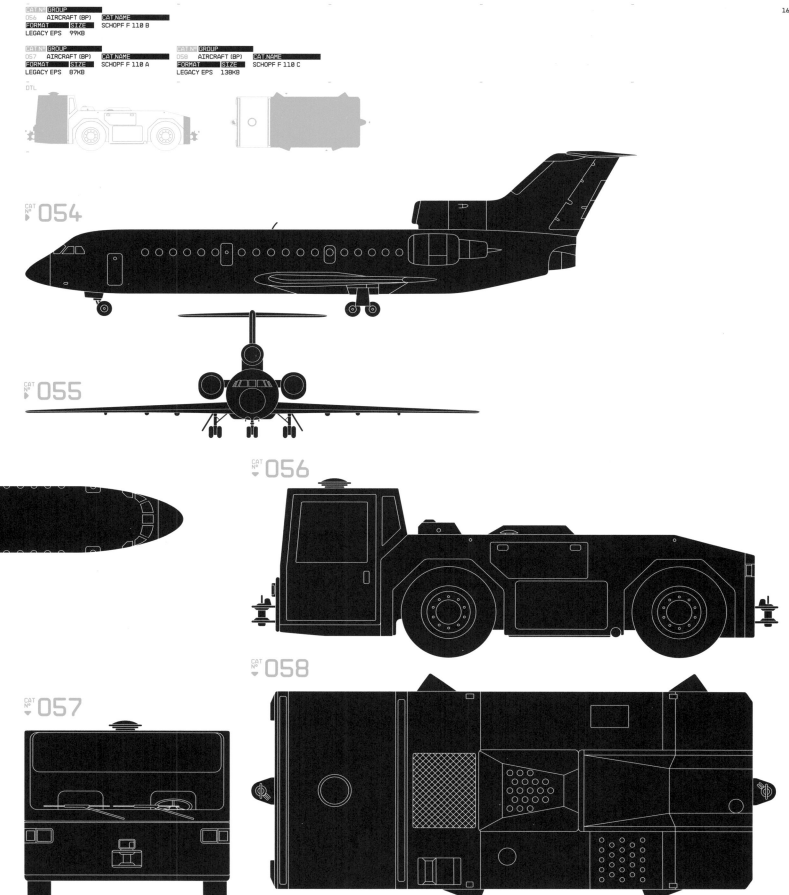

AIRCRAFT (RG) P01-19

ENDEAVOUR FERR
Y/ATLANTIS FER
RY/DISCOVERY/D
ISCOVERY FERRY
/ENDEAVOUR/COL
UMBIA/ATLANTIS
/BOEING 747/BE
LL 47/BELL 407/
BELL 205/LOCKH
EED MARTIN/LOC
KHEED C-130/→

+259
KILOBYTES

+73
KILOBYTES

+73
KILOBYTES

+74
KILOBYTES

+243
KILOBYTES

+78
KILOBYTES

+162
KILOBYTES

+72
KILOBYTES

+91
KILOBYTES

+79
KILOBYTES

+79
KILOBYTES

+73
KILOBYTES

+74
KILOBYTES

LOAD BAR REFERENCE
(INDICATES THE NUMBER OF OBJECTS WITHIN THE ACTIVE SECTION, RELATIVE TO THE OTHER INDIVIDUAL SECTIONS OF THE COMPENDIUM)

P01-09

DTL

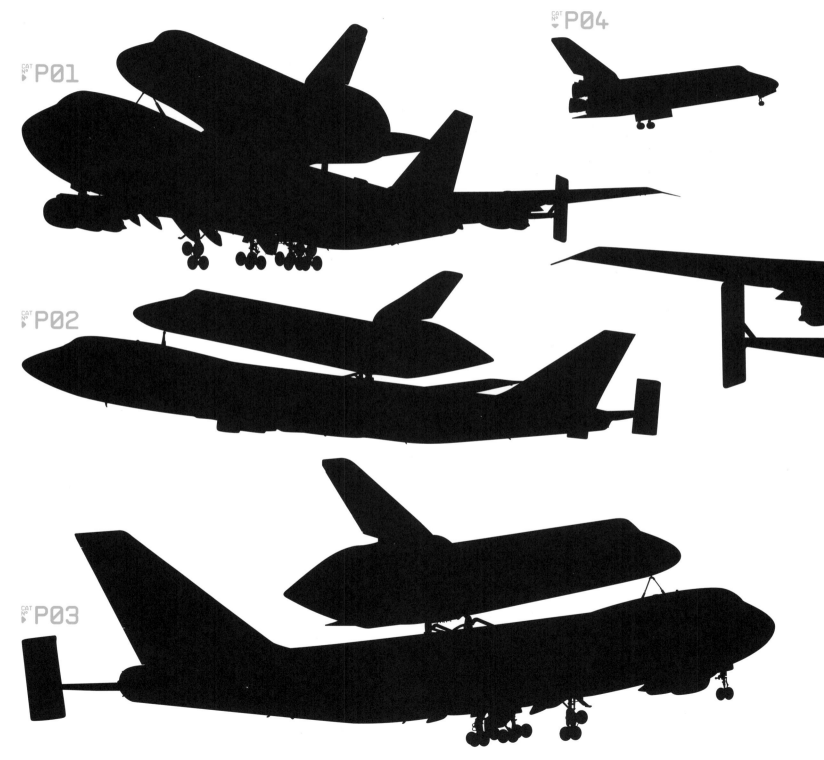

CAT № P01

CAT № P02

CAT № P03

CAT № P04

CAT№	GROUP			
P07	AIRCRAFT (RG)	CAT.NAME		
FORMAT	SIZE	DISCOVERY 01		
LEGACY EPS	76KB			

CAT№	GROUP				CAT№	GROUP		
P08	AIRCRAFT (RG)	CAT.NAME			P09	AIRCRAFT (RG)	CAT.NAME	
FORMAT	SIZE	ENDEAVOUR 01			FORMAT	SIZE	COLUMBIA	
LEGACY EPS	76KB				LEGACY EPS	78KB		

DTL

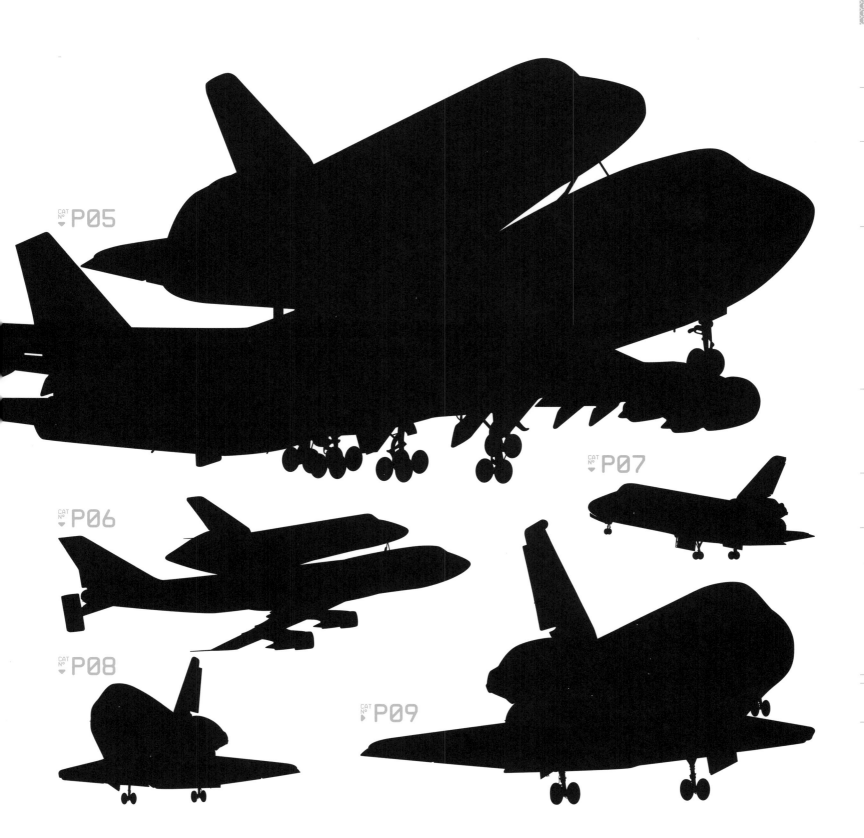

CAT№ P05

CAT№ P06

CAT№ P07

CAT№ P08

CAT№ P09

P10-13

CAT Nº	GROUP		CAT.NAME
P10	AIRCRAFT (RG)		ENDEAVOUR 02
FORMAT	SIZE		
LEGACY EPS	82KB		

CAT Nº	GROUP		CAT.NAME
P11	AIRCRAFT (RG)		ATLANTIS 01
FORMAT	SIZE		
LEGACY EPS	86KB		

CAT Nº	GROUP		CAT.NAME
P12	AIRCRAFT (RG)		ENDEAVOUR 03
FORMAT	SIZE		
LEGACY EPS	85KB		

CAT Nº	GROUP		CAT.NAME
P13	AIRCRAFT (RG)		ATLANTIS 02
FORMAT	SIZE		
LEGACY EPS	76KB		

DTL

CAT Nº P10

CAT Nº P11

CAT Nº P12

DTL

CAT
No P13

CAT Nº	GROUP		CAT.NAME
P14	AIRCRAFT (RG)		BOEING 747
FORMAT		SIZE	
LEGACY EPS	72KB		

CAT Nº	GROUP		CAT.NAME
P16	AIRCRAFT (RG)		BELL 407
FORMAT		SIZE	
LEGACY EPS	79KB		

CAT Nº	GROUP		CAT.NAME
P18	AIRCRAFT (RG)		LOCKHEED MARTIN
FORMAT		SIZE	
LEGACY EPS	73KB		

CAT Nº	GROUP		CAT.NAME
P15	AIRCRAFT (RG)		BELL 47
FORMAT		SIZE	
LEGACY EPS	91KB		

CAT Nº	GROUP		CAT.NAME
P17	AIRCRAFT (RG)		BELL 205
FORMAT		SIZE	
LEGACY EPS	79KB		

CAT Nº	GROUP		CAT.NAME
P19	AIRCRAFT (RG)		LOCKHEED C-130
FORMAT		SIZE	
LEGACY EPS	74KB		

CAT Nº P14

CAT Nº P15

CAT Nº P16

CAT
Nº P17

CAT
Nº P19

CAT
Nº P18

BAU (Q–R)

URBAN PEOPLE/WORKING PEOPLE/

+89 OBJECTS

+51 OBJECTS

URBAN PEOPLE 001-89

DANCERS/KUNG F
U FIGHTERS/BOY
S/PEDESTRIANS/
MAN WITH DOG/OL
D WOMEN/BYSTAN
DER/KIDS/OLD M
AN/PUNKS/GIRLS
WITH SUSHI/SHO
PPER/WHEEL CHAI
R USERS/COMPET
ENCE TEAM/...→

Q01-16

CAT.Nº	GROUP		CAT.NAME
001	URBAN PEOPLE		DANCER 01
FORMAT	SIZE		
LEGACY EPS	91KB		

CAT.Nº	GROUP		CAT.NAME
003	URBAN PEOPLE		KUNG FU FIGHTER 01
FORMAT	SIZE		
LEGACY EPS	91KB		

CAT.Nº	GROUP		CAT.NAME
005	URBAN PEOPLE		DANCER 12
FORMAT	SIZE		
LEGACY EPS	84KB		

CAT.Nº	GROUP		CAT.NAME
002	URBAN PEOPLE		DANCER 08
FORMAT	SIZE		
LEGACY EPS	85KB		

CAT.Nº	GROUP		CAT.NAME
004	URBAN PEOPLE		DANCER 10
FORMAT	SIZE		
LEGACY EPS	86KB		

CAT.Nº	GROUP		CAT.NAME
006	URBAN PEOPLE		DANCER 07
FORMAT	SIZE		
LEGACY EPS	90KB		

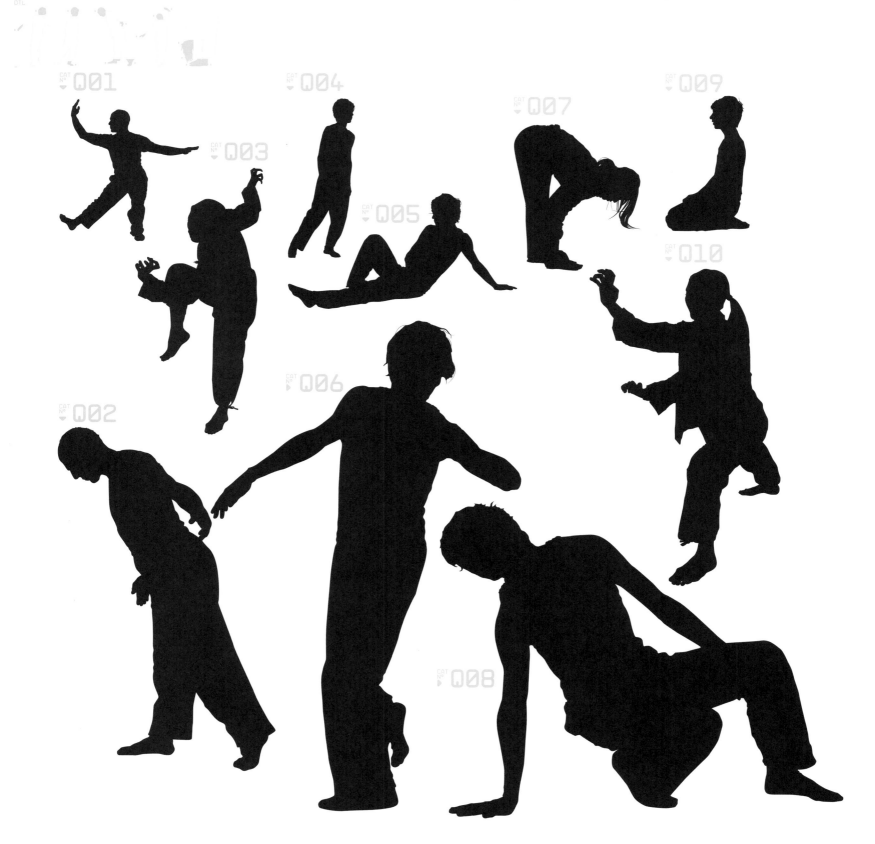

CAT Nº Q01
CAT Nº Q02
CAT Nº Q03
CAT Nº Q04
CAT Nº Q05
CAT Nº Q06
CAT Nº Q07
CAT Nº Q08
CAT Nº Q09
CAT Nº Q10

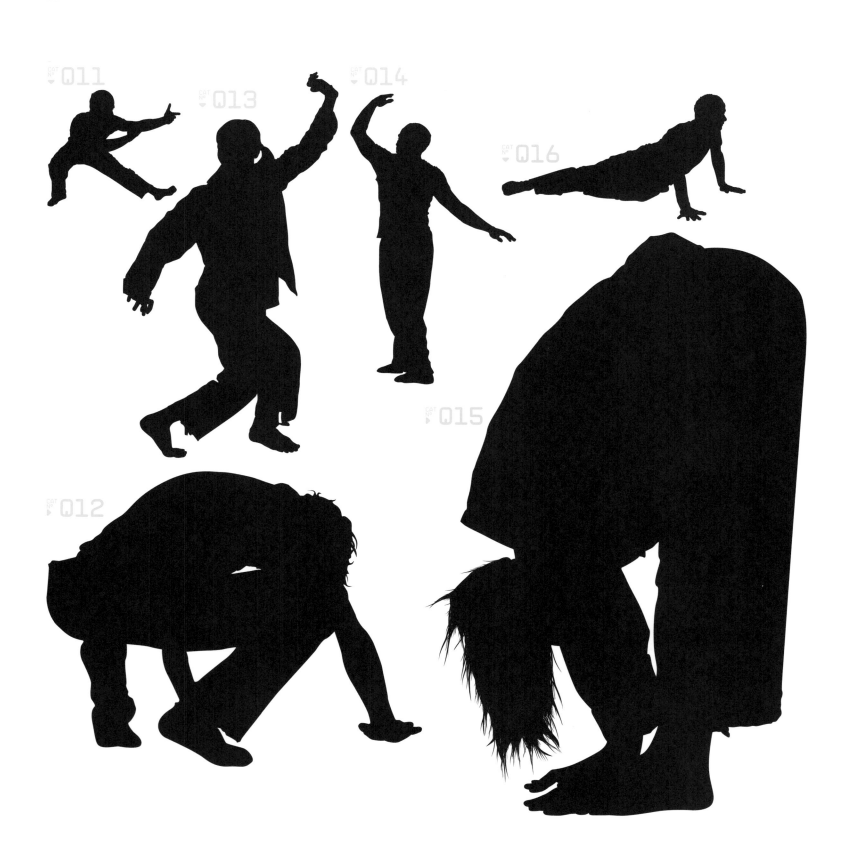

CAT.Nº	GROUP		CAT.Nº	GROUP		CAT.Nº	GROUP		CAT.Nº	GROUP		CAT.Nº	GROUP	
007	URBAN PEOPLE		009	URBAN PEOPLE		011	URBAN PEOPLE		013	URBAN PEOPLE		015	URBAN PEOPLE	
FORMAT	SIZE	CAT.NAME	FORMAT	SIZE	CAT.NAME	FORMAT	SIZE	CAT.NAME	FORMAT	SIZE	CAT.NAME	FORMAT	SIZE	CAT.NAME
LEGACY EPS	89KB	DANCER 19	LEGACY EPS	80KB	DANCER 04	LEGACY EPS	89KB	DANCER 02	LEGACY EPS	92KB	KUNG FU FIGHTER 03	LEGACY EPS	82KB	DANCER 11

CAT.Nº	GROUP		CAT.Nº	GROUP		CAT.Nº	GROUP		CAT.Nº	GROUP		CAT.Nº	GROUP	
008	URBAN PEOPLE		010	URBAN PEOPLE		012	URBAN PEOPLE		014	URBAN PEOPLE		016	URBAN PEOPLE	
FORMAT	SIZE	CAT.NAME	FORMAT	SIZE	CAT.NAME	FORMAT	SIZE	CAT.NAME	FORMAT	SIZE	CAT.NAME	FORMAT	SIZE	CAT.NAME
LEGACY EPS	90KB	DANCER 05	LEGACY EPS	94KB	KUNG FU FIGHTER 02	LEGACY EPS	82KB	DANCER 09	LEGACY EPS	90KB	DANCER 06	LEGACY EPS	267KB	KUNG FU FIGHTER 04

DTL

Q17-23

CAT.N°	GROUP			CAT.N°	GROUP			CAT.N°	GROUP	
017	URBAN PEOPLE	CAT.NAME		019	URBAN PEOPLE	CAT.NAME		021	URBAN PEOPLE	CAT.NAME
FORMAT	SIZE	DANCER 13		FORMAT	SIZE	DANCER 16		FORMAT	SIZE	DANCER 17
LEGACY EPS	84KB			LEGACY EPS	92KB			LEGACY EPS	88KB	

CAT.N°	GROUP			CAT.N°	GROUP			CAT.N°	GROUP	
018	URBAN PEOPLE	CAT.NAME		020	URBAN PEOPLE	CAT.NAME		022	URBAN PEOPLE	CAT.NAME
FORMAT	SIZE	DANCER 14		FORMAT	SIZE	DANCER 03		FORMAT	SIZE	DANCER 18
LEGACY EPS	83KB			LEGACY EPS	88KB			LEGACY EPS	87KB	

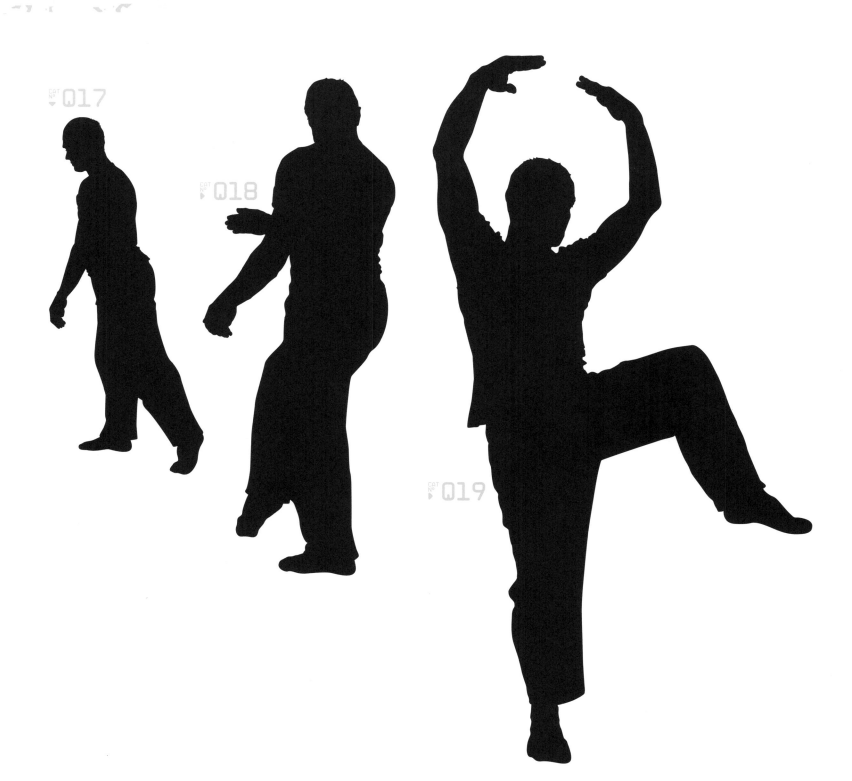

CAT N° Q17

CAT N° Q18

CAT N° Q19

CAT Nº GROUP
023 URBAN PEOPLE CAT NAME
FORMAT SIZE DANCER 15
LEGACY EPS 91KB

DTL

CAT Nº Q20

CAT Nº Q22

CAT Nº Q23

CAT Nº Q21

Q24-39

CAT.Nº	GROUP	CAT.NAME
024	URBAN PEOPLE	BOY 01
FORMAT	SIZE	
LEGACY EPS	85KB	

CAT.Nº	GROUP	CAT.NAME
025	URBAN PEOPLE	PEDESTRIAN 09
FORMAT	SIZE	
LEGACY EPS	86KB	

CAT.Nº	GROUP	CAT.NAME
026	URBAN PEOPLE	MAN WITH DOG
FORMAT	SIZE	
LEGACY EPS	613KB	

CAT.Nº	GROUP	CAT.NAME
027	URBAN PEOPLE	OLD WOMAN 01
FORMAT	SIZE	
LEGACY EPS	86KB	

CAT.Nº	GROUP	CAT.NAME
028	URBAN PEOPLE	BYSTANDER 07
FORMAT	SIZE	
LEGACY EPS	91KB	

CAT.Nº	GROUP	CAT.NAME
029	URBAN PEOPLE	OLD WOMAN 02
FORMAT	SIZE	
LEGACY EPS	79KB	

CAT.Nº	GROUP		CAT.Nº	GROUP		CAT.Nº	GROUP		CAT.Nº	GROUP		CAT.Nº	GROUP	
030	URBAN PEOPLE	CAT.NAME	032	URBAN PEOPLE	CAT.NAME	034	URBAN PEOPLE	CAT.NAME	036	URBAN PEOPLE	CAT.NAME	038	URBAN PEOPLE	CAT.NAME
FORMAT	SIZE	KID 01	FORMAT	SIZE	KID 02	FORMAT	SIZE	PUNK 01	FORMAT	SIZE	PEDESTRIAN 06	FORMAT	SIZE	PEDESTRIAN 11
LEGACY EPS	89KB		LEGACY EPS	102KB		LEGACY EPS	87KB		LEGACY EPS	79KB		LEGACY EPS	92KB	

CAT.Nº	GROUP		CAT.Nº	GROUP		CAT.Nº	GROUP		CAT.Nº	GROUP		CAT.Nº	GROUP	
031	URBAN PEOPLE	CAT.NAME	033	URBAN PEOPLE	CAT.NAME	035	URBAN PEOPLE	CAT.NAME	037	URBAN PEOPLE	CAT.NAME	039	URBAN PEOPLE	CAT.NAME
FORMAT	SIZE	OLD MAN	FORMAT	SIZE	BOY 02	FORMAT	SIZE	GIRLS WITH SUSHI	FORMAT	SIZE	PEDESTRIAN 08	FORMAT	SIZE	PUNK 02
LEGACY EPS	82KB		LEGACY EPS	107KB		LEGACY EPS	107KB		LEGACY EPS	93KB		LEGACY EPS	119KB	

Q40-53

CAT.N°	GROUP		CAT.NAME
040	URBAN PEOPLE		PEDESTRIAN 05
FORMAT		SIZE	
LEGACY EPS		87KB	

CAT.N°	GROUP		CAT.NAME
041	URBAN PEOPLE		PEDESTRIAN 01
FORMAT		SIZE	
LEGACY EPS		87KB	

CAT.N°	GROUP		CAT.NAME
042	URBAN PEOPLE		WOMAN SHOPPING 04
FORMAT		SIZE	
LEGACY EPS		80KB	

CAT.N°	GROUP		CAT.NAME
043	URBAN PEOPLE		PEDESTRIAN 10
FORMAT		SIZE	
LEGACY EPS		86KB	

CAT.N°	GROUP		CAT.NAME
044	URBAN PEOPLE		MAN WITH TROLLEY
FORMAT		SIZE	
LEGACY EPS		76KB	

CAT.N°	GROUP		CAT.NAME
045	URBAN PEOPLE		WOMAN SHOPPING 01
FORMAT		SIZE	
LEGACY EPS		92KB	

CAT.N°	GROUP			CAT.N°	GROUP			CAT.N°	GROUP			CAT.N°	GROUP		
046	URBAN PEOPLE	CAT.NAME		048	URBAN PEOPLE	CAT.NAME		050	URBAN PEOPLE	CAT.NAME		052	URBAN PEOPLE	CAT.NAME	
FORMAT	SIZE	WOMAN WITH TROLLEY		FORMAT	SIZE	PEDESTRIANS 01		FORMAT	SIZE	PHOTOGRAPHER 01		FORMAT	SIZE	WHEELCHAIR USERS	
LEGACY EPS	117KB			LEGACY EPS	100KB			LEGACY EPS	90KB			LEGACY EPS	97KB		

CAT.N°	GROUP			CAT.N°	GROUP			CAT.N°	GROUP			CAT.N°	GROUP		
047	URBAN PEOPLE	CAT.NAME		049	URBAN PEOPLE	CAT.NAME		051	URBAN PEOPLE	CAT.NAME		053	URBAN PEOPLE	CAT.NAME	
FORMAT	SIZE	PEDESTRIAN 03		FORMAT	SIZE	WOMAN SHOPPING 02		FORMAT	SIZE	PHOTOGRAPHER 02		FORMAT	SIZE	PEDESTRIAN 07	
LEGACY EPS	89KB			LEGACY EPS	91KB			LEGACY EPS	87KB			LEGACY EPS	101KB		

QTL

CAT N° 048
CAT N° 050
CAT N° 051
CAT N° 052
CAT N° 049
CAT N° 053

Q54-65

CAT.Nº	GROUP	CAT.NAME
Q54	URBAN PEOPLE	PARTY PEOPLE
FORMAT	SIZE	
LEGACY EPS	285KB	

CAT.Nº	GROUP	CAT.NAME
Q56	URBAN PEOPLE	GUY 04
FORMAT	SIZE	
LEGACY EPS	310KB	

CAT.Nº	GROUP	CAT.NAME
Q58	URBAN PEOPLE	PEDESTRIAN 02
FORMAT	SIZE	
LEGACY EPS	85KB	

CAT.Nº	GROUP	CAT.NAME
Q55	URBAN PEOPLE	GUY 01
FORMAT	SIZE	
LEGACY EPS	221KB	

CAT.Nº	GROUP	CAT.NAME
Q57	URBAN PEOPLE	GUITARIST
FORMAT	SIZE	
LEGACY EPS	106KB	

CAT.Nº	GROUP	CAT.NAME
Q59	URBAN PEOPLE	GUY 02
FORMAT	SIZE	
LEGACY EPS	295KB	

CAT.N°	GROUP		CAT.NAME
060	URBAN PEOPLE		YOUNG COUPLE
FORMAT	SIZE		
LEGACY EPS	105KB		

CAT.N°	GROUP		CAT.NAME
062	URBAN PEOPLE		BEACH GIRL 01
FORMAT	SIZE		
LEGACY EPS	110KB		

CAT.N°	GROUP		CAT.NAME
064	URBAN PEOPLE		SITTING MAN 01
FORMAT	SIZE		
LEGACY EPS	91KB		

CAT.N°	GROUP		CAT.NAME
061	URBAN PEOPLE		WOMAN SHOPPING 03
FORMAT	SIZE		
LEGACY EPS	90KB		

CAT.N°	GROUP		CAT.NAME
063	URBAN PEOPLE		MAN WITH A TRICYCLE
FORMAT	SIZE		
LEGACY EPS	160KB		

CAT.N°	GROUP		CAT.NAME
065	URBAN PEOPLE		GUY 03
FORMAT	SIZE		
LEGACY EPS	205KB		

CAT N° 062

CAT N° 064

CAT N° 065

CAT N° 063

Q66-74

CAT.N°	GROUP			CAT.N°	GROUP			CAT.N°	GROUP		
Q66	URBAN PEOPLE		CAT.NAME	Q68	URBAN PEOPLE		CAT.NAME	Q70	URBAN PEOPLE		CAT.NAME
FORMAT		SIZE	BOY WITH BIKE	FORMAT		SIZE	PEDESTRIANS 03	FORMAT		SIZE	PEDESTRIANS 04
LEGACY EPS		133KB		LEGACY EPS		99KB		LEGACY EPS		97KB	
Q67	URBAN PEOPLE		CAT.NAME	Q69	URBAN PEOPLE		CAT.NAME	Q71	URBAN PEOPLE		CAT.NAME
FORMAT		SIZE	PEDESTRIAN 04	FORMAT		SIZE	WHEELCHAIR USER 01	FORMAT		SIZE	PEDESTRIANS 02
LEGACY EPS		85KB		LEGACY EPS		135KB		LEGACY EPS		93KB	

DTL
1

Q68

Q66

Q70

Q71

Q67

Q72

Q69

CAT.No GROUP
Q72 URBAN PEOPLE CAT.NAME
FORMAT SIZE WHEELCHAIR USER 02
LEGACY EPS 93KB

CAT.No GROUP
Q73 URBAN PEOPLE CAT.NAME
FORMAT SIZE SCHOOLKIDS 01
LEGACY EPS 117KB

CAT.No GROUP
Q74 URBAN PEOPLE CAT.NAME
FORMAT SIZE SCHOOLKIDS 02
LEGACY EPS 107KB

DTL

CAT
Nº Q73

CAT
Nº Q74

Q75-82

CAT.N°	GROUP		CAT.NAME
075	URBAN PEOPLE		BYSTANDER 01
FORMAT		SIZE	
LEGACY EPS		106KB	

CAT.N°	GROUP		CAT.NAME
077	URBAN PEOPLE		BYSTANDER 03
FORMAT		SIZE	
LEGACY EPS		106KB	

CAT.N°	GROUP		CAT.NAME
079	URBAN PEOPLE		BYSTANDER 04
FORMAT		SIZE	
LEGACY EPS		83KB	

CAT.N°	GROUP		CAT.NAME
076	URBAN PEOPLE		BYSTANDER 02
FORMAT		SIZE	
LEGACY EPS		83KB	

CAT.N°	GROUP		CAT.NAME
078	URBAN PEOPLE		FOOTBALL PLAYER
FORMAT		SIZE	
LEGACY EPS		100KB	

CAT.N°	GROUP		CAT.NAME
080	URBAN PEOPLE		COMPETENCE TEAM
FORMAT		SIZE	
LEGACY EPS		216KB	

CAT N° 075
CAT N° 076
CAT N° 077
CAT N° 079
CAT N° 080
CAT N° 078

CAT.N° GROUP
081 URBAN PEOPLE CAT.NAME
FORMAT SIZE FOOTBALL PLAYERS
LEGACY EPS 139KB

CAT.N° GROUP
082 URBAN PEOPLE CAT.NAME
FORMAT SIZE BEACH GIRL 02
LEGACY EPS 477KB

DTL

CAT
N°
▶ 081

CAT
N°
▶ 082

Q83-89

CAT.Nº GROUP 083 URBAN PEOPLE CAT.NAME
FORMAT SIZE SITTING MAN 02
LEGACY EPS 85KB

CAT.Nº GROUP 085 URBAN PEOPLE CAT.NAME
FORMAT SIZE BOYS FIGHTING
LEGACY EPS 137KB

CAT.Nº GROUP 087 URBAN PEOPLE CAT.NAME
FORMAT SIZE GIRL SITTING
LEGACY EPS 296KB

CAT.Nº GROUP 084 URBAN PEOPLE CAT.NAME
FORMAT SIZE BOY WITH SAUSAGE
LEGACY EPS 90KB

CAT.Nº GROUP 086 URBAN PEOPLE CAT.NAME
FORMAT SIZE BEACH COUPLE
LEGACY EPS 200KB

CAT.Nº GROUP 088 URBAN PEOPLE CAT.NAME
FORMAT SIZE BYSTANDER 05
LEGACY EPS 1.25MB

CAT Nº 084

CAT Nº 085

CAT Nº 083

CAT.Nº GROUP
089 URBAN PEOPLE CAT.NAME
FORMAT SIZE BYSTANDER 06
LEGACY EPS 181KB
DTL

CAT Nº 088
CAT Nº 089
CAT Nº 086
CAT Nº 087

WORKING PEOPLE R01-51

POLICE/AIR CONTROLLER/KEBAB SELLER/TRUCKER/MECHANIC/FIREMEN/PAINTERS/DOCTOR/FISHERMEN/STEEL WORKER/SAUSAGE SELLER/PLUMBER/BUILDING WORKERS/SURVEYOR/...→

→1146 KILOBYTES
→182 KILOBYTES
→80 KILOBYTES
→543 KILOBYTES
→83 KILOBYTES
→180 KILOBYTES
→243 KILOBYTES
→92 KILOBYTES

LOAD BAR REFERENCE
(INDICATES THE NUMBER OF OBJECTS WITHIN THE ACTIVE SECTION, RELATIVE TO THE OTHER INDIVIDUAL SECTIONS OF THE COMPILATION)

R01-09

CAT.Nº	GROUP		CAT.Nº	GROUP		CAT.Nº	GROUP	
R01	WORKING PEOPLE	CAT.NAME	R03	WORKING PEOPLE	CAT.NAME	R05	WORKING PEOPLE	CAT.NAME
FORMAT	SIZE	POLICE OFFICER 03	FORMAT	SIZE	POLICE OFFICER 01	FORMAT	SIZE	AIRPORT MARSHALLER
LEGACY EPS	80KB		LEGACY EPS	77KB		LEGACY EPS	85KB	
R02	WORKING PEOPLE	CAT.NAME	R04	WORKING PEOPLE	CAT.NAME	R06	WORKING PEOPLE	CAT.NAME
FORMAT	SIZE	POLICE OFFICER 02	FORMAT	SIZE	POLICE OFFICERS	FORMAT	SIZE	POLICE OFFICER 04
LEGACY EPS	92KB		LEGACY EPS	97KB		LEGACY EPS	84KB	

R01
R02
R03
R04
R05
R06
R07
R08

CAT.N° GROUP
R07 WORKING PEOPLE CAT.NAME
FORMAT SIZE POLICE OFFICER 06
LEGACY EPS 441KB

CAT.N° GROUP
R08 WORKING PEOPLE CAT.NAME
FORMAT SIZE POLICE OFFICER 05
LEGACY EPS 88KB

CAT.N° GROUP
R09 WORKING PEOPLE CAT.NAME
FORMAT SIZE RIOT POLICE
LEGACY EPS 102KB

CAT
N° ▸ R09

R10-17

CAT.№ GROUP
R10 WORKING PEOPLE CAT.NAME
FORMAT SIZE DESIGN ENGINEER 01
LEGACY EPS 737KB

CAT.№ GROUP
R12 WORKING PEOPLE CAT.NAME
FORMAT SIZE DESIGN ENGINEER 05
LEGACY EPS 759KB

CAT.№ GROUP
R11 WORKING PEOPLE CAT.NAME
FORMAT SIZE DESIGN ENGINEER 02
LEGACY EPS 753KB

CAT.№ GROUP
R13 WORKING PEOPLE CAT.NAME
FORMAT SIZE DESIGN ENGINEER 03
LEGACY EPS 722KB

CAT.№ GROUP
R14 WORKING PEOPLE CAT.NAME
FORMAT SIZE DESIGN ENGINEER 04
LEGACY EPS 730KB

DTL

CAT N° R10

CAT N° R12

CAT N° R13

CAT N° R11

CAT N° R14

CAT.№ GROUP
R10 WORKING PEOPLE CAT.NAME
FORMAT SIZE DESIGN ENGINEER 01

CAT.№ GROUP
R12 WORKING PEOPLE CAT.NAME
FORMAT SIZE DESIGN ENGINEER 05

CAT.N° GROUP
R15 WORKING PEOPLE CAT.NAME
FORMAT SIZE KEBAB SELLER 02
LEGACY EPS 93KB

CAT.N° GROUP
R16 WORKING PEOPLE CAT.NAME
FORMAT SIZE KEBAB SELLER 01
LEGACY EPS 89KB

CAT.N° GROUP
R17 WORKING PEOPLE CAT.NAME
FORMAT SIZE TRUCKER
LEGACY EPS 80KB

CAT
N° ▶R15

CAT
N° ▶R16

CAT
N° ▶R17

R18-26

CAT.N° GROUP
R18 WORKING PEOPLE CAT.NAME
FORMAT SIZE MECHANIC 01
LEGACY EPS 285KB

CAT.N° GROUP
R19 WORKING PEOPLE CAT.NAME
FORMAT SIZE MECHANIC 02
LEGACY EPS 582KB

CAT.N° GROUP
R20 WORKING PEOPLE CAT.NAME
FORMAT SIZE MECHANIC 03
LEGACY EPS 336KB

DTL

CAT N° R18

CAT N° R19

CAT N° R20

CAT.Nº	GROUP		CAT.NAME
R21	WORKING PEOPLE		FIREMAN 01
FORMAT		SIZE	
LEGACY EPS	91KB		

CAT.Nº	GROUP		CAT.NAME
R23	WORKING PEOPLE		FIREMEN 02
FORMAT		SIZE	
LEGACY EPS	102KB		

CAT.Nº	GROUP		CAT.NAME
R25	WORKING PEOPLE		FIREMAN 03
FORMAT		SIZE	
LEGACY EPS	95KB		

CAT.Nº	GROUP		CAT.NAME
R22	WORKING PEOPLE		FIREMEN 03
FORMAT		SIZE	
LEGACY EPS	105KB		

CAT.Nº	GROUP		CAT.NAME
R24	WORKING PEOPLE		FIREMAN 02
FORMAT		SIZE	
LEGACY EPS	110KB		

CAT.Nº	GROUP		CAT.NAME
R26	WORKING PEOPLE		FIREMEN 01
FORMAT		SIZE	
LEGACY EPS	95KB		

DTL

CAT Nº R25

CAT Nº R24

CAT Nº R26

CAT Nº R21

CAT Nº R22

CAT Nº R23

R27-35

CAT.N°	GROUP		CAT.NAME
R27	WORKING PEOPLE		PAINTER 06
FORMAT		SIZE	
LEGACY EPS		966KB	

CAT.N°	GROUP		CAT.NAME
R29	WORKING PEOPLE		FISHERMAN 01
FORMAT		SIZE	
LEGACY EPS		204KB	

CAT.N°	GROUP		CAT.NAME
R31	WORKING PEOPLE		FISHERMAN 02
FORMAT		SIZE	
LEGACY EPS		92KB	

CAT.N°	GROUP		CAT.NAME
R28	WORKING PEOPLE		DOCTOR
FORMAT		SIZE	
LEGACY EPS		83KB	

CAT.N°	GROUP		CAT.NAME
R30	WORKING PEOPLE		STEEL WORKER
FORMAT		SIZE	
LEGACY EPS		243KB	

CAT.N°	GROUP		CAT.NAME
R32	WORKING PEOPLE		SAUSAGE SELLER
FORMAT		SIZE	
LEGACY EPS		92KB	

CAT.N° GROUP
R33 WORKING PEOPLE CAT.NAME
FORMAT SIZE STERMANN
LEGACY EPS 95KB

CAT.N° GROUP
R34 WORKING PEOPLE CAT.NAME
FORMAT SIZE MAN WITH CART
LEGACY EPS 110KB

CAT.N° GROUP
R35 WORKING PEOPLE CAT.NAME
FORMAT SIZE GRISSEMANN
LEGACY EPS 85KB

DTL

CAT
N° ▶R35

CAT
N° ▼R33

CAT
N° ▶R34

R36-51

CAT.№	GROUP			CAT.№	GROUP			CAT.№	GROUP		
R36	WORKING PEOPLE	CAT.NAME		R38	WORKING PEOPLE	CAT.NAME		R40	WORKING PEOPLE	CAT.NAME	
FORMAT	SIZE	BUILDING WORKER 01		FORMAT	SIZE	BUILDING WORKER 05		FORMAT	SIZE	BUILDING WORKER 02	
LEGACY EPS	96KB			LEGACY EPS	96KB			LEGACY EPS	99KB		
R37	WORKING PEOPLE	CAT.NAME		R39	WORKING PEOPLE	CAT.NAME		R41	WORKING PEOPLE	CAT.NAME	
FORMAT	SIZE	PLASTERER		FORMAT	SIZE	BUILDING WORKER 03		FORMAT	SIZE	PLUMBER	
LEGACY EPS	99KB			LEGACY EPS	91KB			LEGACY EPS	92KB		

DTL

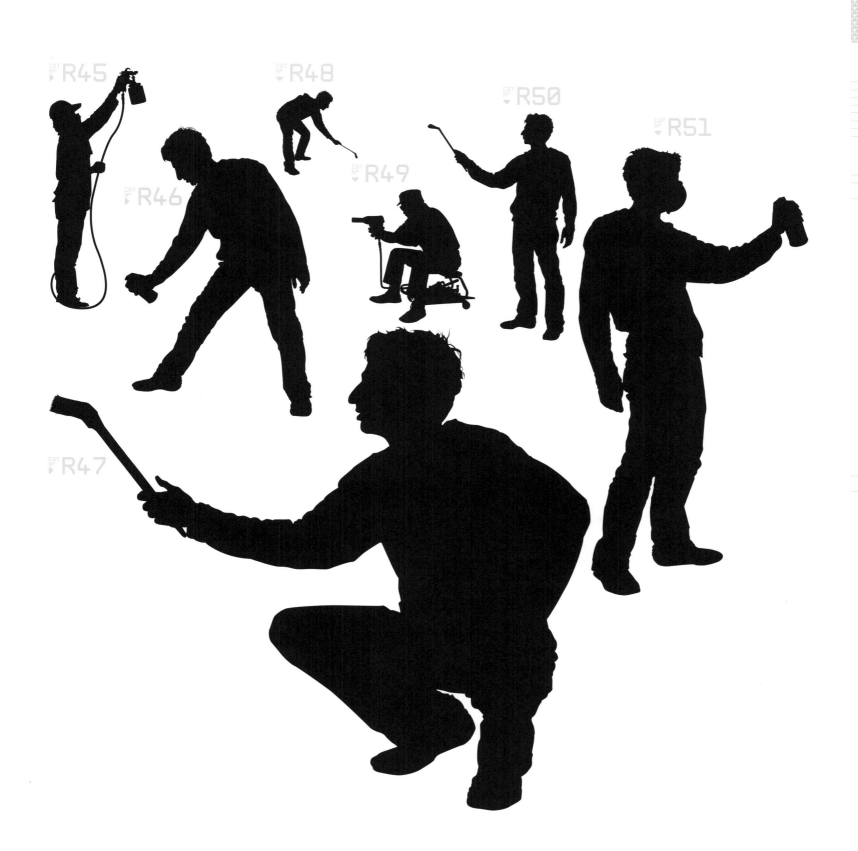

WELT (S–Z)

INSECTS/BIRDS/ [+57 OBJECTS] [+15 OBJECTS]
MAMMALS/FOOD/M [+15 OBJECTS] [+40 OBJECTS]
USHROOMS/LEAVE [+16 OBJECTS]
S/PLANTS/TREES [+37 OBJECTS] [+23 OBJECTS]
/→ [+23 OBJECTS]

INSECTS S01-57

PAPILIO/PAVIEI
A SUPERBA/CHAL
COLEPIDIUS/TRG
OCEPHALA/POLYB
OTHRIS SUMPTUM
OSA/PELIDNOTA
AUREOCUPREA/PE
LIDNOTA PUNCTA
TA/CHRYSOCARAB
US AURONITENS/
CHELODERUS/...→

LOAD BAR REFERENCE
(INDICATES THE NUMBER OF OBJECTS WITHIN THE ACTIVE SECTION RELATIVE TO THE OTHER INDIVIDUAL SECTIONS OF THE COMPENDIUM)

▼100 ▼090 ▼080 ▼070 ▼060 ▼050 ▼040 ▼030 ▼020 ▼010

CAT.N	GROUP		CAT.NAME		CAT.N	GROUP		CAT.NAME		CAT.N	GROUP		CAT.NAME
S01	INSECTS		PAPILIO 06		S03	INSECTS		PAPILIO 02		S05	INSECTS		PAPILIO 09
FORMAT		SIZE			FORMAT		SIZE			FORMAT		SIZE	
LEGACY EPS		510KB			LEGACY EPS		479KB			LEGACY EPS		657KB	
CAT.N	GROUP		CAT.NAME		CAT.N	GROUP		CAT.NAME		CAT.N	GROUP		CAT.NAME
S02	INSECTS		PAPILIO 08		S04	INSECTS		PAPILIO 05		S06	INSECTS		PAPILIO 04
FORMAT		SIZE			FORMAT		SIZE			FORMAT		SIZE	
LEGACY EPS		571KB			LEGACY EPS		428KB			LEGACY EPS		417KB	

S01

S02

S03

S04

S05

S15-29

CAT.N	GROUP		CAT.NAME
S15	INSECTS		PAVIEIA SUPERBA
FORMAT	SIZE		
LEGACY EPS	104KB		

CAT.N	GROUP		CAT.NAME
S17	INSECTS		TRAGOCEPHALA
FORMAT	SIZE		
LEGACY EPS	99KB		

CAT.N	GROUP		CAT.NAME
S19	INSECTS		POLYBOTHRIS SUMPT.
FORMAT	SIZE		
LEGACY EPS	96KB		

CAT.N	GROUP		CAT.NAME
S16	INSECTS		CHALCOLEPIDIUS
FORMAT	SIZE		
LEGACY EPS	100KB		

CAT.N	GROUP		CAT.NAME
S18	INSECTS		TRAGOCEPHALA CRAS.
FORMAT	SIZE		
LEGACY EPS	98KB		

CAT.N	GROUP		CAT.NAME
S20	INSECTS		PELIDNOTA AUREOCU.
FORMAT	SIZE		
LEGACY EPS	97KB		

S15
S16
S17
S18

S19
S20
S21

S22
S23
S24
S25

CAT.Nº	GROUP		CAT.NAME	
S21	INSECTS			
FORMAT	SIZE		PELIDNOTA PUNCTATA	
LEGACY EPS	94KB			

CAT.Nº	GROUP		CAT.NAME	
S23	INSECTS			
FORMAT	SIZE		CHELODERUS	
LEGACY EPS	92KB			

CAT.Nº	GROUP		CAT.NAME	
S25	INSECTS			
FORMAT	SIZE		PACHYTERIA EQUEST.	
LEGACY EPS	91KB			

CAT.Nº	GROUP		CAT.NAME	
S27	INSECTS			
FORMAT	SIZE		ROSALIA ALPINA	
LEGACY EPS	109KB			

CAT.Nº	GROUP		CAT.NAME	
S22	INSECTS			
FORMAT	SIZE		CHRYSOCARABUS AUR.	
LEGACY EPS	98KB			

CAT.Nº	GROUP		CAT.NAME	
S24	INSECTS			
FORMAT	SIZE		EURYPHAGUS LUNDI	
LEGACY EPS	94KB			

CAT.Nº	GROUP		CAT.NAME	
S26	INSECTS			
FORMAT	SIZE		STERNOTOMIS	
LEGACY EPS	101KB			

CAT.Nº	GROUP		CAT.NAME	
S28	INSECTS			
FORMAT	SIZE		CHRYSOPHORA AURON.	
LEGACY EPS	98KB			

CAT.Nº	GROUP		CAT.NAME	
S29	INSECTS			
FORMAT	SIZE		PSEUDOMYAGRUS	
LEGACY EPS	99KB			

S30-45

CAT.N	GROUP			CAT.N	GROUP			CAT.N	GROUP		
S30	INSECTS		CAT.NAME	S32	INSECTS		CAT.NAME	S34	INSECTS		CAT.NAME
FORMAT		SIZE	THEODOSIA PARAKEN.	FORMAT		SIZE	CELOSTERNA	FORMAT		SIZE	CERAMBYCIDAE
LEGACY EPS		92KB		LEGACY EPS		77KB		LEGACY EPS		95KB	

CAT.N	GROUP			CAT.N	GROUP			CAT.N	GROUP		
S31	INSECTS		CAT.NAME	S33	INSECTS		CAT.NAME	S35	INSECTS		CAT.NAME
FORMAT		SIZE	PLINTHOCOELIUM	FORMAT		SIZE	PACHYTERIA DIMID.	FORMAT		SIZE	GYMNETIS PANTHER.
LEGACY EPS		97KB		LEGACY EPS		97KB		LEGACY EPS		95KB	

S30 S31 S32 S33 S34

S35 S36 S37

GROUP INSECTS — CAT.NAME GYMNESIS STELLATA — FORMAT LEGACY EPS — SIZE 91KB
GROUP INSECTS — CAT.NAME EUPHOLUS BENNETTI — FORMAT LEGACY EPS — SIZE 97KB
GROUP INSECTS — CAT.NAME PHAEDIMUS JAGO — FORMAT LEGACY EPS — SIZE 92KB
GROUP INSECTS — CAT.NAME POYBOTHRIS QUADRI. — FORMAT LEGACY EPS — SIZE 92KB
GROUP INSECTS — CAT.NAME CHRYSINA BEYERI — FORMAT LEGACY EPS — SIZE 95KB

GROUP INSECTS — CAT.NAME STEPHANORRHINA — FORMAT LEGACY EPS — SIZE 95KB
GROUP INSECTS — CAT.NAME CHRYSOPHORA CHRYS. — FORMAT LEGACY EPS — SIZE 95KB
GROUP INSECTS — CAT.NAME MOUHOTIA PLANIPEN. — FORMAT LEGACY EPS — SIZE 99KB
GROUP INSECTS — CAT.NAME CHRYSINA VICTORINA — FORMAT LEGACY EPS — SIZE 90KB
GROUP INSECTS — CAT.NAME EUCHROEA CLEMENTI — FORMAT LEGACY EPS — SIZE 90KB

S38 S39 S40 S41 S42
S43 S44 S45

S46-57

CAT.N	GROUP			CAT.N	GROUP			CAT.N	GROUP		
S46	INSECTS		CAT.NAME	S48	INSECTS		CAT.NAME	S50	INSECTS		CAT.NAME
FORMAT		SIZE	EUPHOLUS SP 01	FORMAT		SIZE	ARANEA	FORMAT		SIZE	SEMIOTUS LETEIPEN.
LEGACY EPS	93KB			LEGACY EPS	77KB			LEGACY EPS	945KB		
CAT.N	GROUP			CAT.N	GROUP			CAT.N	GROUP		
S47	INSECTS		CAT.NAME	S49	INSECTS		CAT.NAME	S51	INSECTS		CAT.NAME
FORMAT		SIZE	CHRYSOPHORA PYROS.	FORMAT		SIZE	FORMICA	FORMAT		SIZE	CHRYSOCHROA
LEGACY EPS	100KB			LEGACY EPS	90KB			LEGACY EPS	91KB		

CAT.Nº	GROUP		
S52	INSECTS	CAT.NAME	
FORMAT	SIZE	SEMIOTUS LIGNEUS	
LEGACY EPS	93KB		

CAT.Nº	GROUP		
S54	INSECTS	CAT.NAME	
FORMAT	SIZE	LOCUSTA	
LEGACY EPS	91KB		

CAT.Nº	GROUP		
S56	INSECTS	CAT.NAME	
FORMAT	SIZE	EUPATORUS GRACIL.	
LEGACY EPS	85KB		

CAT.Nº	GROUP		
S53	INSECTS	CAT.NAME	
FORMAT	SIZE	DICRANORRHINA D.	
LEGACY EPS	93KB		

CAT.Nº	GROUP		
S55	INSECTS	CAT.NAME	
FORMAT	SIZE	EUPHOLUS SP 02	
LEGACY EPS	74KB		

CAT.Nº	GROUP		
S57	INSECTS	CAT.NAME	
FORMAT	SIZE	GOLOFA PIZARRO	
LEGACY EPS	81KB		

DTL

S54

S55

S56

S57

BIRDS T01-15

SEAGULL/DUCKS/OSPREY/PIGEONS/EAGLE/HERON/TITMOUSE/→

◥100 ◥090 ◥080 ◥070 ◥060 ◥050 ◥040 ◥030 ◥020 ◥010 ◥000

LOAD BAR REFERENCE
(INDICATES THE NUMBER OF OBJECTS WITHIN THE ACTIVE SECTION RELATIVE TO THE OTHER INDIVIDUAL SECTIONS OF THE COMPENDIUM)

T01-15

CAT.N GROUP		CAT.NAME
T01 BIRDS		SEAGULL 01
FORMAT	SIZE	
LEGACY EPS	74KB	

CAT.N GROUP		CAT.NAME
T02 BIRDS		DUCK 01
FORMAT	SIZE	
LEGACY EPS	93KB	

CAT.N GROUP		CAT.NAME
T03 BIRDS		OSPREY
FORMAT	SIZE	
LEGACY EPS	84KB	

CAT.N GROUP		CAT.NAME
T04 BIRDS		PIGEON 03
FORMAT	SIZE	
LEGACY EPS	81KB	

CAT.N GROUP		CAT.NAME
T05 BIRDS		PIGEON 04
FORMAT	SIZE	
LEGACY EPS	84KB	

CAT.N GROUP		CAT.NAME
T06 BIRDS		PIGEON 01
FORMAT	SIZE	
LEGACY EPS	96KB	

CAT.N	GROUP				CAT.NAME	
T07	BIRDS					
FORMAT		SIZE		PIGEON 02		
LEGACY EPS		88KB				

CAT.N	GROUP			CAT.NAME	
T09	BIRDS				
FORMAT		SIZE	EAGLE		
LEGACY EPS		75KB			

CAT.N	GROUP			CAT.NAME	
T11	BIRDS				
FORMAT		SIZE	DUCK 03		
LEGACY EPS		1.25MB			

CAT.N	GROUP			CAT.NAME	
T13	BIRDS				
FORMAT		SIZE	HERON		
LEGACY EPS		88KB			

CAT.N	GROUP			CAT.NAME	
T08	BIRDS				
FORMAT		SIZE	DUCK 02		
LEGACY EPS		1.75MB			

CAT.N	GROUP			CAT.NAME	
T10	BIRDS				
FORMAT		SIZE	SEAGULL 02		
LEGACY EPS		79KB			

CAT.N	GROUP			CAT.NAME	
T12	BIRDS				
FORMAT		SIZE	SEAGULL 03		
LEGACY EPS		80KB			

CAT.N	GROUP			CAT.NAME	
T14	BIRDS				
FORMAT		SIZE	TITMOUSE		
LEGACY EPS		655KB			

CAT.N	GROUP			CAT.NAME	
T15	BIRDS				
FORMAT		SIZE	BIRD		
LEGACY EPS		83KB			

DTL

T13

T09

T14

T12

T10

T11

T15

MAMMALS U01-15

DALMATIAN/BOXER/RATS/PITBULLS/TURTLE/GUINEA PIG/HORSE/CAT/PIGS/→

+936
KILOBYTES

+94
KILOBYTES

+2392
KILOBYTES

+202
KILOBYTES

+77
KILOBYTES

+763
KILOBYTES

+101
KILOBYTES

+992
KILOBYTES

+423
KILOBYTES

LOAD BAR REFERENCE
(INDICATES THE NUMBER OF OBJECTS WITHIN THE ACTIVE SECTION RELATIVE TO THE OTHER INDIVIDUAL SECTIONS OF THE COMPENDIUM.)

U01-15

CAT.NR	GROUP		CAT.NAME	
U01	MAMMALS			
FORMAT		SIZE	DALMATIAN	
LEGACY EPS		936KB		

CAT.NR	GROUP		CAT.NAME	
U02	MAMMALS			
FORMAT		SIZE	BOXER	
LEGACY EPS		94KB		

CAT.NR	GROUP		CAT.NAME	
U03	MAMMALS			
FORMAT		SIZE	RAT 01	
LEGACY EPS		762KB		

CAT.NR	GROUP		CAT.NAME	
U04	MAMMALS			
FORMAT		SIZE	RAT 02	
LEGACY EPS		1.57MB		

CAT.NR	GROUP		CAT.NAME	
U05	MAMMALS			
FORMAT		SIZE	PITBULL 01	
LEGACY EPS		92KB		

CAT.NR	GROUP		CAT.NAME	
U06	MAMMALS			
FORMAT		SIZE	TURTLE	
LEGACY EPS		77KB		

U01 U08 U05 U02 U10 U09 U06 U03 U04 U07

	GROUP		CAT.NAME	
U07	MAMMALS			
FORMAT		SIZE	GUINEA PIG	
LEGACY EPS	753KB			

	GROUP		CAT.NAME	
U09	MAMMALS			
FORMAT		SIZE	PITBULL 02	
LEGACY EPS	110KB			

	GROUP		CAT.NAME	
U11	MAMMALS			
FORMAT		SIZE	PIG 01	
LEGACY EPS	85KB			

	GROUP		CAT.NAME	
U13	MAMMALS			
FORMAT		SIZE	PIG 02	
LEGACY EPS	82KB			

	GROUP		CAT.NAME	
U08	MAMMALS			
FORMAT		SIZE	HORSE	
LEGACY EPS	101KB			

	GROUP		CAT.NAME	
U10	MAMMALS			
FORMAT		SIZE	CAT	
LEGACY EPS	992KB			

	GROUP		CAT.NAME	
U12	MAMMALS			
FORMAT		SIZE	PIG 03	
LEGACY EPS	93KB			

	GROUP		CAT.NAME	
U14	MAMMALS			
FORMAT		SIZE	PIG 04	
LEGACY EPS	82KB			

	GROUP		CAT.NAME	
U15	MAMMALS			
FORMAT		SIZE	PIG 05	
LEGACY EPS	81KB			

DTL

FOOD V01-39

ROCKET/F IELD M
USHROOMS/CHILI
S/ROCKET LEAVE
S/GREEN PEPPER
/PINEAPPLE/APP
LES/ONIONS/AVO
CADO/FENNEL/PE
AR/BANANA/LEEK
/ARTICHOKE/CHE
RRY TOMATOES/L
OBSTER/...➜

+106
KILOBYTES

+108
KILOBYTES

+506
KILOBYTES

+102
KILOBYTES

+154
KILOBYTES

+159
KILOBYTES

+825
KILOBYTES

+75
KILOBYTES

+165
KILOBYTES

+75
KILOBYTES

+75
KILOBYTES

+96
KILOBYTES

+95
KILOBYTES

+829
KILOBYTES

▜100 ▜090 ▜080 ▜070 ▜060 ▜050 ▜040 ▜030 ▜020 ▜010 ▜000

V01-15

CAT.N	GROUP		CAT.NAME
V01	FOOD		ROCKET
FORMAT	SIZE		
LEGACY EPS	106KB		

CAT.N	GROUP		CAT.NAME
V02	FOOD		FIELD MUSHROOMS
FORMAT	SIZE		
LEGACY EPS	102KB		

CAT.N	GROUP		CAT.NAME
V03	FOOD		CHILI 01
FORMAT	SIZE		
LEGACY EPS	74KB		

CAT.N	GROUP		CAT.NAME
V04	FOOD		CHILI 02
FORMAT	SIZE		
LEGACY EPS	74KB		

CAT.N	GROUP		CAT.NAME
V05	FOOD		CHILI 03
FORMAT	SIZE		
LEGACY EPS	77KB		

CAT.N	GROUP		CAT.NAME
V05	FOOD		ROCKET LEAVES
FORMAT	SIZE		
LEGACY EPS	102KB		

V01 V06 V07 V10 V08 V11 V02 V03 V09 V12 V04 V05

GROUP FOOD
CAT.NAME CHILI 04
FORMAT LEGACY EPS SIZE 70KB

GROUP FOOD
CAT.NAME GREEN PEPPER 01
FORMAT LEGACY EPS SIZE 75KB

GROUP FOOD
CAT.NAME CHILI 07
FORMAT LEGACY EPS SIZE 70KB

GROUP FOOD
CAT.NAME PINEAPPLE
FORMAT LEGACY EPS SIZE 105KB

GROUP FOOD
CAT.NAME CHILI 05
FORMAT LEGACY EPS SIZE 70KB

GROUP FOOD
CAT.NAME CHILI 06
FORMAT LEGACY EPS SIZE 70KB

GROUP FOOD
CAT.NAME GREEN PEPPER 02
FORMAT LEGACY EPS SIZE 79KB

GROUP FOOD
CAT.NAME APPLE 01
FORMAT LEGACY EPS SIZE 85KB

GROUP FOOD
CAT.NAME APPLE 02
FORMAT LEGACY EPS SIZE 74KB

V13

V14

V15

V16-29

CAT.N°	GROUP		CAT.NAME
V16	FOOD		ONION 01
FORMAT	SIZE		
LEGACY EPS	80KB		

CAT.N°	GROUP		CAT.NAME
V17	FOOD		AVOCADO
FORMAT	SIZE		
LEGACY EPS	75KB		

CAT.N°	GROUP		CAT.NAME
V18	FOOD		FENNEL
FORMAT	SIZE		
LEGACY EPS	1.85MB		

CAT.N°	GROUP		CAT.NAME
V19	FOOD		PEAR
FORMAT	SIZE		
LEGACY EPS	75KB		

CAT.N°	GROUP		CAT.NAME
V20	FOOD		ONION 02
FORMAT	SIZE		
LEGACY EPS	72KB		

CAT.N°	GROUP		CAT.NAME
V21	FOOD		ONION 03
FORMAT	SIZE		
LEGACY EPS	73KB		

CAT.N:	GROUP		
V22	FOOD	CAT.NAME	
FORMAT	SIZE	BANANA	
LEGACY EPS	76KB		

CAT.N:	GROUP		
V24	FOOD	CAT.NAME	
FORMAT	SIZE	ARTICHOKE	
LEGACY EPS	80KB		

CAT.N:	GROUP		
V26	FOOD	CAT.NAME	
FORMAT	SIZE	CHERRY TOMATO 03	
LEGACY EPS	87KB		

CAT.N:	GROUP		
V28	FOOD	CAT.NAME	
FORMAT	SIZE	CHERRY TOMATO 01	
LEGACY EPS	82KB		

CAT.N:	GROUP		
V23	FOOD	CAT.NAME	
FORMAT	SIZE	LEEK	
LEGACY EPS	96KB		

CAT.N:	GROUP		
V25	FOOD	CAT.NAME	
FORMAT	SIZE	CHERRY TOMATO 02	
LEGACY EPS	88KB		

CAT.N:	GROUP		
V27	FOOD	CAT.NAME	
FORMAT	SIZE	TOMATOES	
LEGACY EPS	82KB		

CAT.N:	GROUP		
V29	FOOD	CAT.NAME	
FORMAT	SIZE	CHERRY TOMATO 04	
LEGACY EPS	92KB		

V25

V26

V28

V29

V27

V30-39

CAT.N	GROUP		CAT.NAME		CAT.N	GROUP		CAT.NAME		CAT.N	GROUP		CAT.NAME
V30	FOOD		LOBSTER 01		V32	FOOD		SHRIMP 02		V33	FOOD		SHRIMP 01
FORMAT		SIZE			FORMAT		SIZE			FORMAT		SIZE	
LEGACY EPS		727KB			LEGACY EPS		89KB			LEGACY EPS		88KB	
V31	FOOD		SHRIMP 03		V33	FOOD		CRAB		V35	FOOD		LOBSTER 02
FORMAT		SIZE			FORMAT		SIZE			FORMAT		SIZE	
LEGACY EPS		89KB			LEGACY EPS		85KB			LEGACY EPS		101KB	

V30

V31

V34

V32

V33

V35

CAT.N GROUP		
FOOD	CAT.NAME	
FORMAT	SIZE	OCTOPUS 01
LEGACY EPS	114KB	

CAT.N GROUP		
FOOD	CAT.NAME	
FORMAT	SIZE	OCTOPUS 03
LEGACY EPS	85KB	

CAT.N GROUP		
FOOD	CAT.NAME	
FORMAT	SIZE	OCTOPUS 02
LEGACY EPS	92KB	

CAT.N GROUP		
FOOD	CAT.NAME	
FORMAT	SIZE	FISHBONE
LEGACY EPS	138KB	

MUSHROOMS W01-16

LECCINUM SCABR
UM/AGARICUS AU
GUST/RUSSULA A
URATA/PANAELUS
CINCTULUS/OUDE
MANSIELLAM/PSE
UDOCLYTOCYBE C
YATHIFORMIS/PS
ILOCYBE AZURES
CENS/CALOCERA
VISCOSA/...→

LOAD BAR REFERENCE
[INDICATES THE NUMBER OF OBJECTS WITHIN THE ACTIVE SECTION, RELATIVE TO THE OTHER INDIVIDUAL SECTIONS OF THE COMPENDIUM]

W01-16

CAT.N.	GROUP			CAT.NAME	
W01	MUSHROOMS			LECCINUM SCABRUM	
FORMAT		SIZE			
LEGACY EPS		72KB			

CAT.N.	GROUP			CAT.NAME	
W03	MUSHROOMS			RUSSULA AURATA	
FORMAT		SIZE			
LEGACY EPS		70KB			

CAT.N.	GROUP			CAT.NAME	
W05	MUSHROOMS			OUDEMANSIELLA M. 02	
FORMAT		SIZE			
LEGACY EPS		104KB			

CAT.N.	GROUP			CAT.NAME	
W02	MUSHROOMS			AGARICUS AUGUST	
FORMAT		SIZE			
LEGACY EPS		76KB			

CAT.N.	GROUP			CAT.NAME	
W05	MUSHROOMS			PANAELUS CINCTULUS	
FORMAT		SIZE			
LEGACY EPS		77KB			

CAT.N.	GROUP			CAT.NAME	
W05	MUSHROOMS			PSEUDOCLYTOCYBE C.	
FORMAT		SIZE			
LEGACY EPS		75KB			

CAT.N° GROUP
W07 MUSHROOMS
FORMAT SIZE CAT.NAME
LEGACY EPS 73KB PSYLOCIBE AZUR.

CAT.N° GROUP
W09 MUSHROOMS
FORMAT SIZE CAT.NAME
LEGACY EPS 95KB CALOCERA VISCOSA

CAT.N° GROUP
W09 MUSHROOMS
FORMAT SIZE CAT.NAME
LEGACY EPS 71KB BOLETUS EDULIS 02

CAT.N° GROUP
W10 MUSHROOMS
FORMAT SIZE CAT.NAME
LEGACY EPS 76KB OUDEMANSIELLA M. 01

CAT.N° GROUP
W11 MUSHROOMS
FORMAT SIZE CAT.NAME
LEGACY EPS 70KB BOLETUS EDULIS 04

CAT.N° GROUP
W12 MUSHROOMS
FORMAT SIZE CAT.NAME
LEGACY EPS 85KB AMANITA MUSCARIA

CAT.N° GROUP
W13 MUSHROOMS
FORMAT SIZE CAT.NAME
LEGACY EPS 100KB RAMARIA EUMORPHIA

CAT.N° GROUP
W14 MUSHROOMS
FORMAT SIZE CAT.NAME
LEGACY EPS 81KB MACROLEPIOTA PROC.

CAT.N° GROUP
W15 MUSHROOMS
FORMAT SIZE CAT.NAME
LEGACY EPS 69KB BOLETUS EDULIS 03

CAT.N° GROUP
W16 MUSHROOMS
FORMAT SIZE CAT.NAME
LEGACY EPS 75KB BOLETUS EDULIS 01

DTL

LEAVES X01-37

X01-13

CAT.N.	GROUP		
X01	LEAVES	CAT.NAME	
FORMAT	SIZE	LEAVES 01.01	
LEGACY EPS	71KB		

CAT.N.	GROUP		
X03	LEAVES	CAT.NAME	
FORMAT	SIZE	LEAVES 01.03	
LEGACY EPS	81KB		

CAT.N.	GROUP		
X05	LEAVES	CAT.NAME	
FORMAT	SIZE	LEAVES 01.05	
LEGACY EPS	83KB		

CAT.N.	GROUP		
X02	LEAVES	CAT.NAME	
FORMAT	SIZE	LEAVES 01.02	
LEGACY EPS	96KB		

CAT.N.	GROUP		
X04	LEAVES	CAT.NAME	
FORMAT	SIZE	LEAVES 01.04	
LEGACY EPS	83KB		

CAT.N.	GROUP		
X06	LEAVES	CAT.NAME	
FORMAT	SIZE	LEAVES 01.06	
LEGACY EPS	91KB		

LEAVES 01.01/LEAVES 01.02/LEAVES 01.03/LEAVES 01.04/LEAVES 01.05/LEAVES 01.06/LEAVES 01.07/LEAVES 01.08/LEAVES 01.09/LEAVES 01.10/LEAVES 01.11/LEAVES 01.12/... →

+81
KILOBYTES

+83
KILOBYTES

+83
KILOBYTES

+91
KILOBYTES

+10
KILOBYTES

+86
KILOBYTES

+88
KILOBYTES

+79
KILOBYTES

+85
KILOBYTES

+119
KILOBYTES

+86
KILOBYTES

▼100 ▼090 ▼080 ▼070 ▼060 ▼050 ▼040 ▼030 ▼020 ▼010 ▼000

GROUP LEAVES
CAT.NAME
X07 LEAVES
FORMAT SIZE LEAVES 01.07
LEGACY EPS 88KB

GROUP LEAVES
CAT.NAME
X09 LEAVES
FORMAT SIZE LEAVES 01.09
LEGACY EPS 79KB

GROUP LEAVES
CAT.NAME
X11 LEAVES
FORMAT SIZE LEAVES 01.11
LEGACY EPS 119KB

GROUP LEAVES
CAT.NAME
X08 LEAVES
FORMAT SIZE LEAVES 01.08
LEGACY EPS 83KB

GROUP LEAVES
CAT.NAME
X10 LEAVES
FORMAT SIZE LEAVES 01.10
LEGACY EPS 85KB

GROUP LEAVES
CAT.NAME
X12 LEAVES
FORMAT SIZE LEAVES 01.12
LEGACY EPS 86KB

GROUP LEAVES
CAT.NAME
X13 LEAVES
FORMAT SIZE LEAVES 01.13
LEGACY EPS 85KB

CAT.N	GROUP		CAT.NAME
X14	LEAVES		LEAVES 02.01
FORMAT	SIZE		
LEGACY EPS	128KB		

CAT.N	GROUP		CAT.NAME
X16	LEAVES		LEAVES 02.03
FORMAT	SIZE		
LEGACY EPS	134KB		

CAT.N	GROUP		CAT.NAME
X15	LEAVES		LEAVES 02.2
FORMAT	SIZE		
LEGACY EPS	165KB		

CAT.N	GROUP		CAT.NAME
X17	LEAVES		LEAVES 02.04
FORMAT	SIZE		
LEGACY EPS	150KB		

X14

X15

X16

X17

CAT.N°	GROUP			CAT.N°	GROUP		
X18	LEAVES		CAT.NAME	X20	LEAVES		CAT.NAME
FORMAT		SIZE	LEAVES 02.05	FORMAT		SIZE	LEAVES 02.07
LEGACY EPS		169KB		LEGACY EPS		143KB	

CAT.N°	GROUP			CAT.N°	GROUP		
X19	LEAVES		CAT.NAME	X21	LEAVES		CAT.NAME
FORMAT		SIZE	LEAVES 02.06	FORMAT		SIZE	LEAVES 02.08
LEGACY EPS		152KB		LEGACY EPS		156KB	

DTL

X18

X19

X20

X21

X22-29

CAT.N GROUP		CAT.NAME
LEAVES		LEAVES 03.01
FORMAT	SIZE	
LEGACY EPS	132KB	

CAT.N GROUP		CAT.NAME
LEAVES		LEAVES 03.03
FORMAT	SIZE	
LEGACY EPS	106KB	

CAT.N GROUP		CAT.NAME
LEAVES		LEAVES 03.02
FORMAT	SIZE	
LEGACY EPS	136KB	

CAT.N GROUP		CAT.NAME
LEAVES		LEAVES 03.04
FORMAT	SIZE	
LEGACY EPS	132KB	

X22

X23

X24

X25

CAT.N° GROUP		CAT.N° GROUP	
X26 LEAVES	CAT.NAME	X28 LEAVES	CAT.NAME
FORMAT SIZE	LEAVES 03.05	FORMAT SIZE	LEAVES 03.07
LEGACY EPS 123KB		LEGACY EPS 148KB	

CAT.N° GROUP		CAT.N° GROUP	
X27 LEAVES	CAT.NAME	X29 LEAVES	CAT.NAME
FORMAT SIZE	LEAVES 03.06	FORMAT SIZE	LEAVES 03.08
LEGACY EPS 147KB		LEGACY EPS 123KB	

DTL

X26

X27

X28

X29

X30-37

CAT.N°	GROUP		CAT.NAME
X30	LEAVES		LEAVES 04.01
FORMAT	SIZE		
LEGACY EPS	120KB		

CAT.N°	GROUP		CAT.NAME
X31	LEAVES		LEAVES 04.02
FORMAT	SIZE		
LEGACY EPS	156KB		

CAT.N°	GROUP		CAT.NAME
X32	LEAVES		LEAVES 04.03
FORMAT	SIZE		
LEGACY EPS	115KB		

CAT.N°	GROUP		CAT.NAME
X33	LEAVES		LEAVES 04.04
FORMAT	SIZE		
LEGACY EPS	731KB		

CAT.N: GROUP			CAT.N: GROUP		
X34 LEAVES		CAT.NAME	X36 LEAVES		CAT.NAME
FORMAT	SIZE	LEAVES 04.05	FORMAT	SIZE	LEAVES 04.07
LEGACY EPS	126KB		LEGACY EPS	107KB	

CAT.N: GROUP			CAT.N: GROUP		
X35 LEAVES		CAT.NAME	X37 LEAVES		CAT.NAME
FORMAT	SIZE	LEAVES 04.06	FORMAT	SIZE	LEAVES 04.08
LEGACY EPS	104KB		LEGACY EPS	166KB	

X34

X35

X36

X37

PLANTS ^{Y01-23}

PLANT ON A TROL
LEY/POTTED PLA
NTS/...→

+286
KILOBYTES

+488
KILOBYTES

LOAD BAR REFERENCE
(INDICATES THE NUMBER OF OBJECTS WITHIN THE ACTIVE SECTION, RELATIVE TO THE OTHER INDIVIDUAL SECTIONS OF THE COMPENDIUM)

GROUP
PLANTS CAT.NAME
FORMAT SIZE PLANT 05
LEGACY EPS 365KB

GROUP
PLANTS CAT.NAME
FORMAT SIZE PLANT 08
LEGACY EPS 88KB

GROUP
PLANTS CAT.NAME
FORMAT SIZE PLANT 12
LEGACY EPS 136KB

GROUP
PLANTS CAT.NAME
FORMAT SIZE PLANT 11
LEGACY EPS 967KB

GROUP
PLANTS CAT.NAME
FORMAT SIZE PLANT 02
LEGACY EPS 106KB

GROUP
PLANTS CAT.NAME
FORMAT SIZE PLANT 09
LEGACY EPS 111KB

DTL

Y02

Y01

CAT NR Y05

CAT NR Y06

CAT NR Y03

CAT NR Y08

CAT NR Y04

CAT NR Y07

CAT.N	GROUP		CAT.NAME
Y09	PLANTS		PLANT 13
FORMAT	SIZE		
LEGACY EPS	79KB		

CAT.N	GROUP		CAT.NAME
Y11	PLANTS		PLANT 03
FORMAT	SIZE		
LEGACY EPS	115KB		

CAT.N	GROUP		CAT.NAME
Y13	PLANTS		PLANT 06
FORMAT	SIZE		
LEGACY EPS	89KB		

CAT.N	GROUP		CAT.NAME
Y10	PLANTS		PLANT 04
FORMAT	SIZE		
LEGACY EPS	79KB		

CAT.N	GROUP		CAT.NAME
Y12	PLANTS		PLANT 17
FORMAT	SIZE		
LEGACY EPS	125KB		

CAT.N	GROUP		CAT.NAME
Y14	PLANTS		PLANT 16
FORMAT	SIZE		
LEGACY EPS	164KB		

CAT.N° GROUP
Y15 PLANTS CAT.NAME
FORMAT SIZE PLANT 15
LEGACY EPS 119KB

CAT.N° GROUP
Y17 PLANTS CAT.NAME
FORMAT SIZE PLANT 14
LEGACY EPS 154KB

CAT.N° GROUP
Y16 PLANTS CAT.NAME
FORMAT SIZE PLANT 18
LEGACY EPS 137KB

CAT.N° GROUP
Y18 PLANTS CAT.NAME
FORMAT SIZE PLANT 01
LEGACY EPS 519KB

CAT.N° GROUP
Y19 PLANTS CAT.NAME
FORMAT SIZE PLANT 19
LEGACY EPS 164KB

OTL

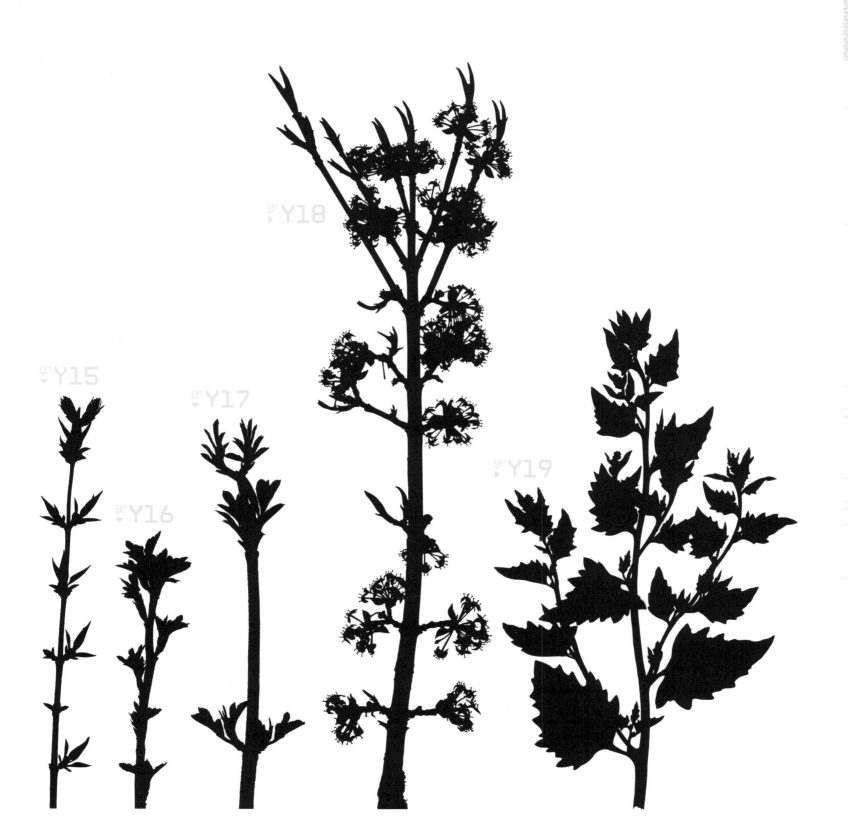

Y20-23

CAT.NO	GROUP			CAT.NO	GROUP		
Y20	PLANTS		CAT.NAME	Y22	PLANTS		CAT.NAME
FORMAT	SIZE		PLANT ON A TROLLEY	FORMAT	SIZE		POTTED PLANT 02
LEGACY EPS	286KB			LEGACY EPS	90KB		
CAT.NO	GROUP			CAT.NO	GROUP		
Y21	PLANTS		CAT.NAME	Y23	PLANTS		CAT.NAME
FORMAT	SIZE		POTTED PLANT 01	FORMAT	SIZE		POTTED PLANT 03
LEGACY EPS	165KB			LEGACY EPS	225KB		

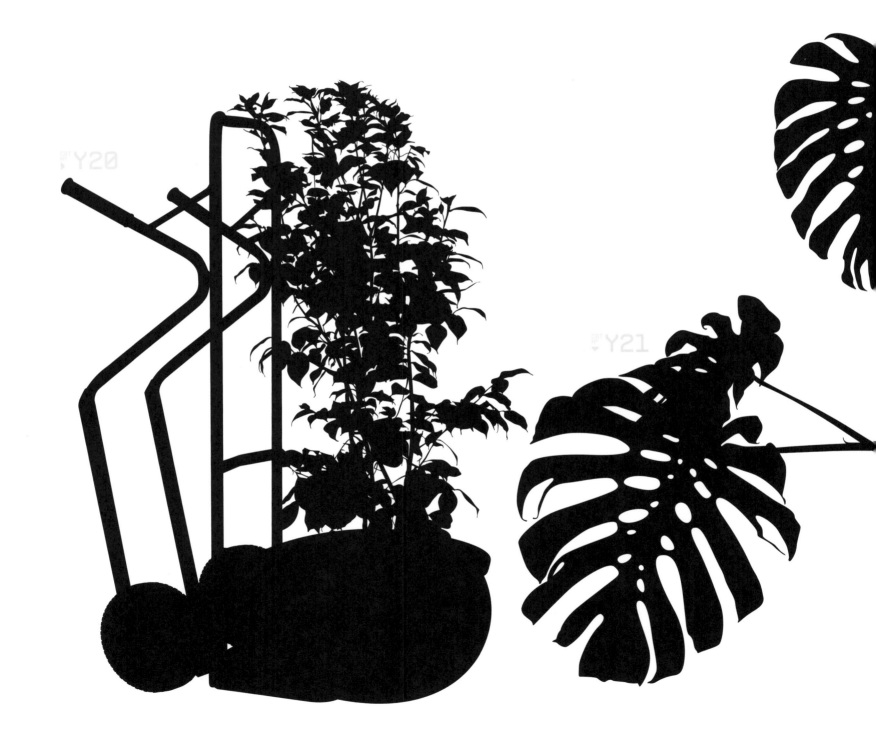

Y20

Y21

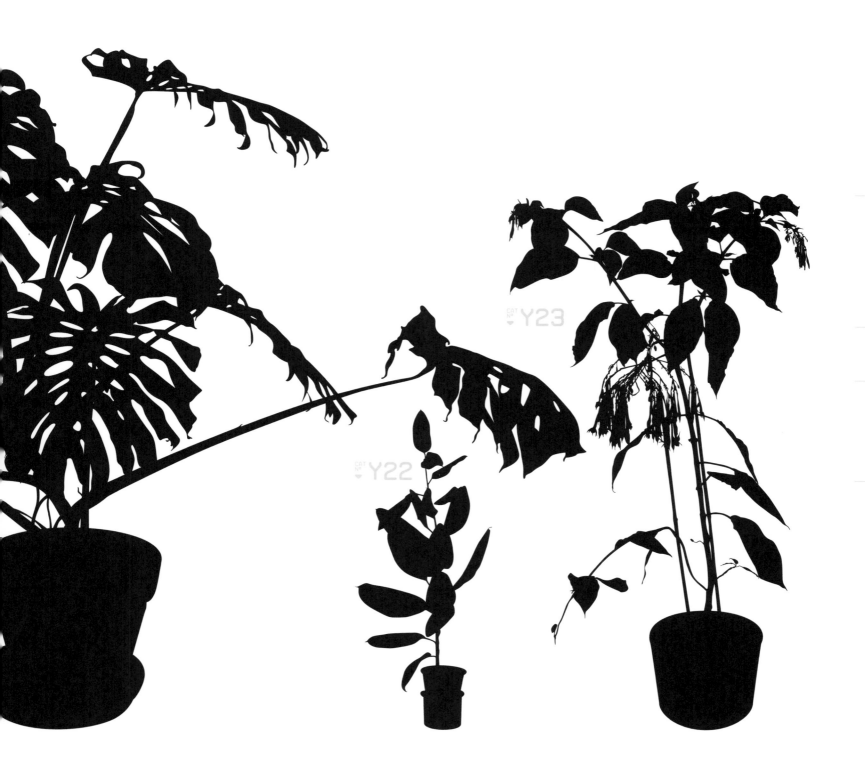

Y23

Y22

TREES Z01-23

ELM TREES/NEUB AUM/CHESTNUTTR EES/LIME TREES /POPLAR TREES/ ALDER TREE/WHI TE POPLAR TREE/ MAPLE TREE/OAK TREE/→

+4244
KILOBYTES

+99
KILOBYTES

+3334
KILOBYTES

+9828
KILOBYTES

+2668
KILOBYTES

+311V
KILOBYTES

+3300
KILOBYTES

LOAD BAR REFERENCE
(INDICATES THE NUMBER OF OBJECTS WITHIN THE ACTIVE SECTION RELATIVE TO THE OTHER INDIVIDUAL SECTIONS OF THE COMPENDIUM)

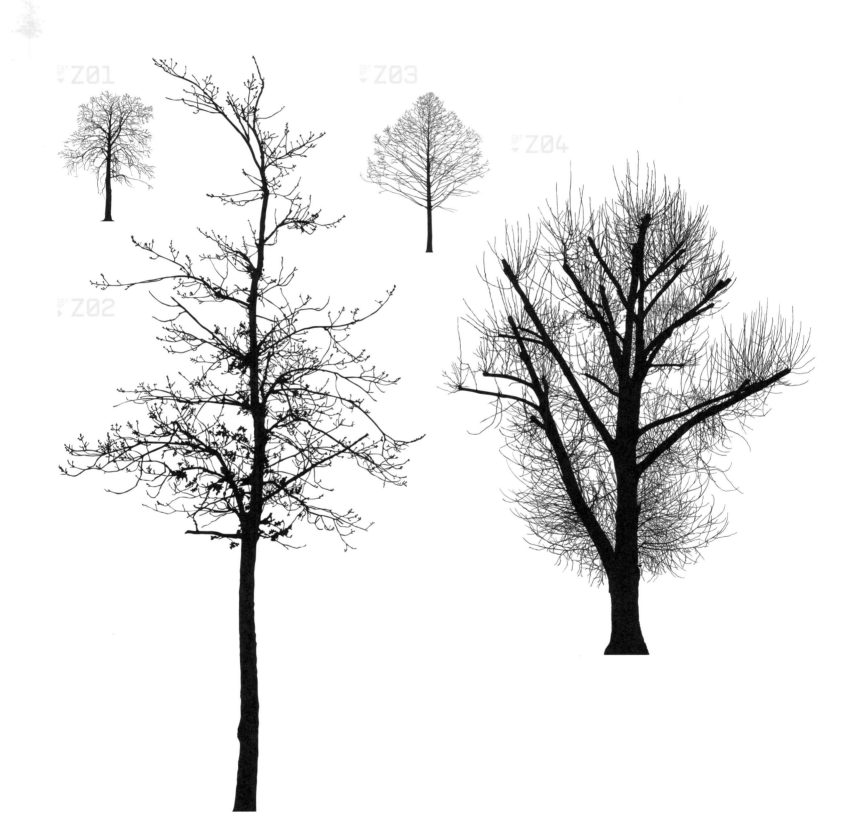

Z01-07

CAT.N	GROUP			CAT.N	GROUP			CAT.N	GROUP		
Z01	TREES	CAT.NAME		Z03	TREES	CAT.NAME		Z05	TREES	CAT.NAME	
FORMAT	SIZE	TREE 02		FORMAT	SIZE	TREE 03		FORMAT	SIZE	ELM TREE 01	
LEGACY EPS	1.61MB			LEGACY EPS	1.72MB			LEGACY EPS	263KB		
CAT.N	GROUP			CAT.N	GROUP			CAT.N	GROUP		
Z02	TREES	CAT.NAME		Z04	TREES	CAT.NAME		Z06	TREES	CAT.NAME	
FORMAT	SIZE	TREE 04		FORMAT	SIZE	TREE 05		FORMAT	SIZE	ELM TREE 02	
LEGACY EPS	977KB			LEGACY EPS	4MB			LEGACY EPS	268KB		

Z01

Z03

Z04

Z02

GROUP
Z07 TREES CAT.NAME
FORMAT SIZE ELM TREE 03
LEGACY EPS 873KB

Z08-10

CAT.N	GROUP		CAT.NAME
Z08	TREES		NEUBAUM
FORMAT	SIZE		
LEGACY EPS	99KB		

CAT.N	GROUP		CAT.NAME
Z09	TREES		CHESTNUT TREE 02
FORMAT	SIZE		
LEGACY EPS	1.62MB		

CAT.N	GROUP		CAT.NAME
Z10	TREES		CHESTNUT TREE 01
FORMAT	SIZE		
LEGACY EPS	414KB		

► Z08

NEUBAUM
®
Grüner Apfel

► Z09

Z10

Z11-13

CAT.N°	GROUP		
Z11	TREES	CAT.NAME	
FORMAT	SIZE	LIME TREE 02	
LEGACY EPS	4.16MB		

CAT.N°	GROUP		
Z12	TREES	CAT.NAME	
FORMAT	SIZE	LIME TREE 01	
LEGACY EPS	3MB		

CAT.N°	GROUP		
Z13	TREES	CAT.NAME	
FORMAT	SIZE	CHESTNUT TREE 03	
LEGACY EPS	2.66MB		

DTL

Z11

Z12

CAT.N.	GROUP		
Z14	TREES	CAT.NAME	
FORMAT	SIZE	POPLAR TREE 02	
LEGACY EPS	2.84MB		

CAT.N.	GROUP		
Z15	TREES	CAT.NAME	
FORMAT	SIZE	POPLAR TREE 01	
LEGACY EPS	3.64MB		

OTL

Z14

Z16-20

CAT.NR	GROUP		CAT.NAME		FORMAT	SIZE
216	TREES		ALDER TREE		LEGACY EPS	2.66MB
218	TREES		ELM TREE 04		LEGACY EPS	2.84MB
217	TREES		CHESTNUT TREE 04		LEGACY EPS	1.3MB
219	TREES		TREE 01		LEGACY EPS	1.56MB
220	TREES		WHITE POPLAR TREE		LEGACY EPS	3.9MB

Z16

Z17

Z18

Z19

Z20

Z21-23

CAT.N GROUP
Z21 TREES CAT.NAME
FORMAT SIZE MAPLE TREE
LEGACY EPS 311KB

CAT.N GROUP
Z22 TREES CAT.NAME
FORMAT SIZE TREE 06
LEGACY EPS 865KB

CAT.N GROUP
Z23 TREES CAT.NAME
FORMAT SIZE OAK TREE
LEGACY EPS 3.3MB

DTL

Z21

Z22

WELTBAUNEU

THE FOLLOWING PAGES REPRESENT A DIALOGUE BETWEEN AN URBAN AND A RURAL WORLD. THE TWO WORLDS, SHOWN IN THE FORM OF PANORAMIC MAPS, HAVE BEEN PRINTED ON
OPPOSITE SIDES OF A SINGLE, LARGE SHEET OF PAPER. BOTH WORLDS ARE CUT AND FOLDED ACROSS MULTIPLE PAGES, ACCORDING TO THE LOGIC OF THE PRINTING AND BINDING PROCESS.
THE CROSSED PAGE ICON SHOWS YOU YOUR CURRENT LOCATION ON THE MAP(S).

FROM HERE ON BLIND/…↵

WBN/LOCATION

WBN/LIST OF OBJECTS IN USE
SECT. /P. /G.N° /NAME
01/A 157 016 SCHOPF POWERPUSH G
01/B 156 013 SCHOPF POWERPUSH B
01/C 153 024 SCHOPF F396 C

80MM→

80MM→

80MM

80MM

80MM

80MM

CONTINUED ON PAGE 278
03/E-01/G

CONTINUED ON PAGE 288
N/-B4/1B6

WBN/LIST OF OBJECTS IN USE
SECT./P. /C/N° /NAME
07/L 269 272 WHITE POPLAR TREE

WBN/LOCATION

CONTINUED ON PAGE 279
09/H-07/K

CONTINUED ON PAGE 288
12/L-18/N

WBN/LOCATION

WBN/LIST OF OBJECTS IN USE
SECT. /P. /C.Nº /NAME
07/A 138 M05 YUGO 45 A
08/A 122 M14 VOLVO 360 A
09/A 128 M44 LANCIA 600L A
07/A 131 M56 MINI COOPER B
07/A 121 M08 ZAZ 965 B
08/A 121 M07 ZAZ 96B
07/B 135 M70 SAAB 96 A
07/B 135 M68 SAAB 96 B
07/C 119 M04 CITROEN DS C
08/C 118 M01 CITROEN DS B
08/C 118 M03 CITROEN DS
09/C 118 M06 CITROEN DS
08/C 118 M02 CITROEN DS D

CONTINUED ON PAGE 287
06/A-04/D

80MM→

80MM→

80MM

80MM

12/A-10/D

CONTINUED ON PAGE 280
09/E-07/G

80MM→

CONTINUED ON PAGE 273

CONTINUED ON PAGE 294
06/H-B4/K

CONTINUED ON PAGE 274
03/A-01/0

WBN/LOCATION

WBN/LIST OF OBJECTS IN USE
SECT. /P. /C.Nº /NAME
02/E 131 M55 MINI NEW
01/F 130 M52 MINI COOPER C
02/F 131 M54 MINI COOPER B
01/G 130 M51 MINI COOPER A
03/G 130 M53 MINI COOPER D

80MM→

80MM

80MM

80MM

80MM→

80MM→

CONTINUED ON PAGE 283
06/E-04/0

CONTINUED ON PAGE 262
12/M-18/K

CONTINUED ON PAGE 284
08/M-04/K

WW08

87/K 267/278 POPLAR TREE 01
08/I 267 319 POPLAR TREE 01
87/I 267 219 WHITE POPLAR TREE
04/H 357 415 POPLAR TREE
BELT NO. PCL# NAME
KEYLIST OF OBJECTS IN USE

WW08

80MM→

WBN/LOCATION

WBN/LIST OF OBJECTS IN USE
SECT. /P. /C.Nº /NAME
07/E 140 M22 VW KÄFER B
07/G 162 037 BELL 407 B

← CONTINUED ON PAGE 283
06/E-04./G

12/E-10/G

80MM

CONTINUED ON PAGE 285
12/A-10/D

WBN/LOCATION

WBN/LIST OF OBJECTS IN USE
SECT. /P. /C.Nº /NAME
10/E 140 M22 VW KÄFER B
10/G 162 037 BELL 407 B

80MM→

80MM

80MM

CONTINUED ON PAGE 288
09/E-07/G

CONTINUED ON PAGE 294
15/E-13/G

80MM→

80MM→

CONTINUED ON PAGE 286
12/L-10/N

CONTINUED ON PAGE 293
15/H-13/K

CONTINUED ON PAGE 279
09/H-07/K

WW08

WW08

WW08

WW08

WBN/LIST OF OBJECTS IN USE

SECT./P.	/C.N°	/NAME
10/I 269	220	WHITE POPLAR TREE
11/I 271	221	OAK TREE
11/I 264	212	LIME TREE 01

WBN/LOCATION

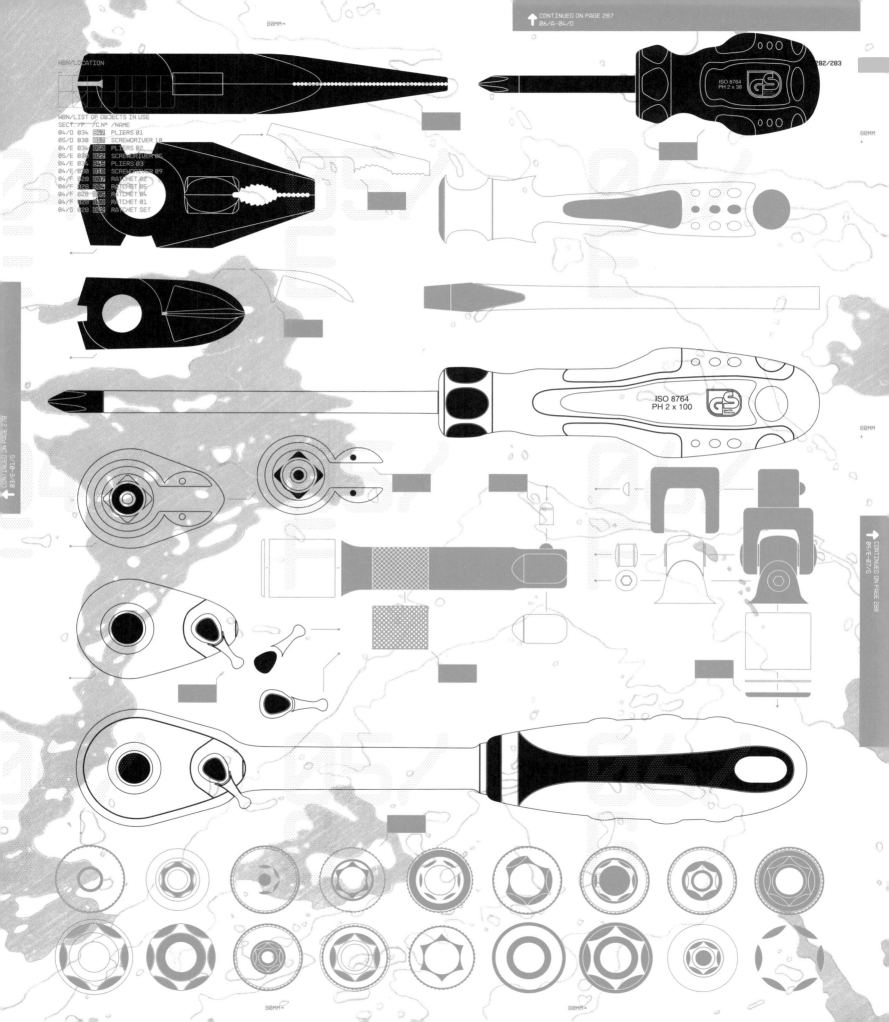

CONTINUED ON PAGE 287
06/A-04/D

282/283

WBN/LOCATION

WBN/LIST OF OBJECTS IN USE
SECT. 7P. /C.Nº /NAME

04/D	034	B47	PLIERS 01
05/D	030	B17	SCREWDRIVER 10
04/E	036	B58	PLIERS 02
05/E	030	B22	SCREWDRIVER 05
04/E	034	B45	PLIERS 03
04/E	030	B18	SCREWDRIVER 09
04/F	028	B07	RATCHET 02
06/F	028	B04	RATCHET 05
04/F	028	B05	RATCHET 04
04/F	028	B08	RATCHET 01
04/G	028	B02	RATCHET SET

ISO 8764
PH 2 x 38

ISO 8764
PH 2 x 100

CONTINUED ON PAGE 278
03/E-01/G

CONTINUED ON PAGE 280
09/E-07/C

80MM→

80MM

80MM

80MM→

80MM→

CONTINUED ON PAGE 288
89/H-84/N

CONTINUED ON PAGE 279
89/H-87/K

CONTINUED ON PAGE 277
83/H-87/K

WBN/LIST OF OBJECTS IN USE
SECT./P. /CN° /NAME
84/I 269 220 WHITE POPLAR TREE

WBN/LOCATION

80MM

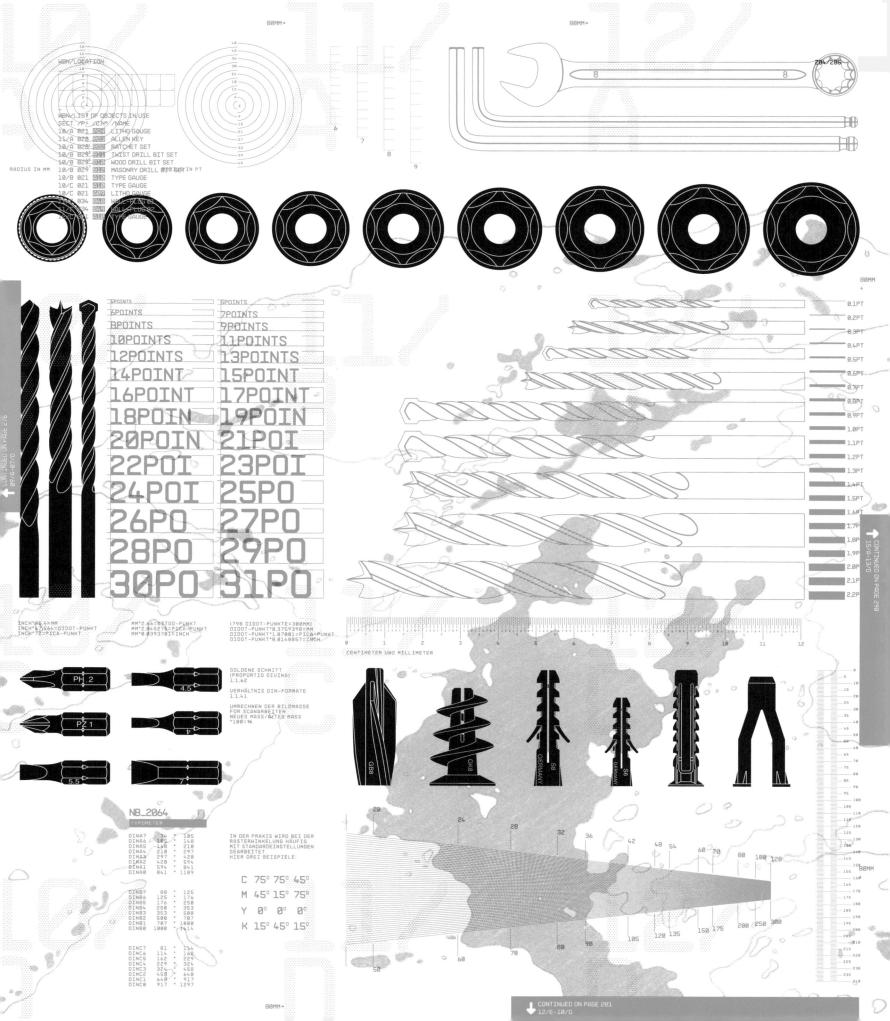

WRN/LOCATION

WRN/LIST OF OBJECTS IN USE
SECT. /P° /LN° /NAME

10/A	021	A04	LITHO/GAUGE
11/A	028	A05	ALLEN KEY
10/A	028	A06	RATCHET SET
10/B	029	A10	TWIST DRILL BIT SET
10/B	029	A09	WOOD DRILL BIT SET
10/B	029	A12	MASONRY DRILL BIT SET IN PT
10/B	021	A10	TYPE GAUGE
10/C	021	A10	TYPE GAUGE
10/C	021	A09	LITHO GAUGE
11/C	034	A16	WALL PLUG 01
11/C	034	A17	WALL PLUG 02
11/C	021	A10	TYPE GAUGE

RADIUS IN MM

80MM→ 80MM→ 80MM→ 80MM→

80MM

↑ CONTINUED ON PAGE 276
09/A-07/0

5POINTS	5POINTS
6POINTS	7POINTS
8POINTS	9POINTS
10POINTS	11POINTS
12POINTS	13POINTS
14POINT	15POINT
16POINT	17POINT
18POIN	19POIN
20POIN	21POI
22POI	23POI
24POI	25PO
26PO	27PO
28PO	29PO
30PO	31PO

0.1PT
0.2PT
0.3PT
0.4PT
0.5PT
0.6PT
0.7PT
0.8PT
0.9PT
1.0PT
1.1PT
1.2PT
1.3PT
1.4PT
1.5PT
1.6PT
1.7PT
1.8PT
1.9PT
2.0PT
2.1P
2.2P

→ CONTINUED ON PAGE 290
15/A-13/0

INCH*25.4=MM
INCH*67.5564=DIDOT-PUNKT
INCH*72=PICA-PUNKT

MM*2.66=DIDOT-PUNKT
MM*2.845275=PICA-PUNKT
MM*0.0393701=INCH

1798 DIDOT-PUNKTE=300MM!
DIDOT-PUNKT*0.375939=MM
DIDOT-PUNKT*1.07001=PICA-PUNKT
DIDOT-PUNKT*0.0148057=INCH

0 1 2 3 4 5 6 7 8 9 10 11 12
CENTIMETER UND MILLIMETER

PH.2
PZ 1
4.5
5.5
7

GOLDENE SCHNITT
(PROPORTIO DIVINA)
1:1.62

VERHÄLTNIS DIN-FORMATE
1:1.41

UMRECHNEN DER BILDMASSE
FÜR SCANARBEITEN:
NEUES MASS/ALTES MASS
*100=%

GB8 GK8 S8 S6 GERMANY

NB_2064
TYPOMETER

DINA7	74	*	105
DINA6	105	*	148
DINA5	148	*	210
DINA4	210	*	297
DINA3	297	*	420
DINA2	420	*	594
DINA1	594	*	841
DINA0	841	*	1189

IN DER PRAXIS WIRD BEI DER
RASTERWINKELUNG HÄUFIG
MIT STANDARDEINSTELLUNGEN
GEARBEITET.
HIER DREI BEISPIELE:

C 75° 75° 45°

M 45° 15° 75°

Y 0° 0° 0°

K 15° 45° 15°

DINB7	88	*	125
DINB6	125	*	176
DINB5	176	*	250
DINB4	250	*	353
DINB3	353	*	500
DINB2	500	*	707
DINB1	707	*	1000
DINB0	1000	*	1414

DINC7	81	*	114
DINC6	114	*	162
DINC5	162	*	229
DINC4	229	*	324
DINC3	324	*	458
DINC2	458	*	648
DINC1	648	*	917
DINC0	917	*	1297

80MM

CONTINUED ON PAGE 289
15/L-13/N

CONTINUED ON PAGE 273
09/L-07/N

CONTINUED ON PAGE 282
12/H-16/K

WBN/LIST OF OBJECTS IN USE
SECT. /P. /CN° /NAME
10/L 269 WHITE POPLAR TREE
11/L 271 OAK TREE
11/L 268 ARLE TREE

WBN/LOCATION

WBN/LOCATION

WBN/LIST OF OBJECTS IN USE

SECT.	N°	N°	NAME
04/A	033	041	EDDING 850 OPEN
05/A	033	041	EDDING 850 OPEN
05/A	033	037	EDDING 500 OPEN
05/A	033	037	EDDING 3300 OPEN
06/B	032	029	COPIC MARKER CLOSED
06/B	032	031	ISOGRAPH PEN 025
06/B	032	032	ISOGRAPH PEN 050
06/B	032	033	ISOGRAPH PEN 070
05/B	032	027	INDIAN INK
04/C	032	024	COMPASSES
05/D	032	025	CUTTER

5-16 mm

5-16 mm

1-5 mm

2-7 mm

0.25 0.50 0.70

80MM→ 80MM→ 80MM 80MM 80MM

CONTINUED ON PAGE 274
03/A-01/0

CONTINUED ON PAGE 276
07/A-07/0

CONTINUED ON PAGE 283
06/E-04/G

CONTINUED ON PAGE 286
124-187/N

WBN/LI9T-86-08J5G1S IN USE
SECT./P. 4/6M/ /W6ME
13/K 269 ZZØ WHITE POPLAR TREE

CONTINUED ON PAGE 293

WBN/LOCATION

CONTINUED ON PAGE 285
12/A-10/0

80MM

18-A-16-0

80MM

80MM→

CONTINUED ON PAGE 302
24/L-22/N

CONTINUED ON PAGE 295
ST/H-19/K

CONTINUED ON PAGE 303
18/A-16/O

CONTINUED ON PAGE 301
24/A-22/O

CONTINUED ON PAGE 296
21/E-19/G

WBN/LOCATION

WBN/LIST OF OBJECTS IN USE
SECT. /P. /C.N° /NAME

19/A	156	087	BOEING 737 C
20/A	154	081	BOEING 717 C
21/A	160	029	FOKKER 28 C
19/B	159	020	BOEING 757 C
20/B	154	081	BOEING 717 C
21/B	154	081	BOEING 717 C
19/C	154	081	BOEING 717 C
21/C	157	012	BOEING 747 C
19/C	160	029	FOKKER 28 C
20/C	157	012	BOEING 747 C
21/C	154	081	BOEING 717 C
19/C	160	029	FOKKER 28 C

80MM

80MM

80MM

CONTINUED ON PAGE 289
15/L-13/N

CONTINUED ON PAGE 300
18/H-16/K

CONTINUED ON PAGE 282
12/H-18/K

WBN/LIST OF OBJECTS IN USE
SECT. /P. /C.N° /NAME
13/1 157 WHITE POPLAR TREE

WBN/LOCATION

CONTINUED ON PAGE 290
15/A-13/D

WBN/LOCATION

WBN/LIST OF OBJECTS IN USE
SECT/ /C.N° /NAME
13/D 154 084 ANTONOV AN-124 B
15/Q 021 A09 LITHO GAUGE
15/Q 021 A10 TYPE GAUGE
13/F 155 086 ANTONOV AN-124 C
15/F 155 085 ANTONOV AN-124 A

80MM

NB_2064

DINA7	74	*	105	GOLDENE SCHNITT
DINA6	105	*	148	(PROPORTIO DIVINA)
DINA5	148	*	210	1:1.62
DINA4	210	*	297	
DINA3	297	*	420	VERHÄLTNIS DIN-FORMATE
DINA2	420	*	594	1:1.41
DINA1	594	*	841	
DINA0	841	*	1189	

DINB7	88	*	125	UMRECHNEN DER BILDMASSE
DINB6	125	*	176	FOR SCANARBEITEN
DINB5	176	*	250	NEUES MASS/ALTES MASS
DINB4	250	*	353	*100=%
DINB3	353	*	500	
DINB2	500	*	707	INCH*25.4=MM
DINB1	707	*	1000	INCH*67.564=DIDOT-PUNKT
DINB0	1000	*	1414	INCH*72=PICA-PUNKT

DINC7	81	*	114	(798 DIDOT-PUNKTE=300MM)
DINC6	114	*	162	DIDOT-PUNKT*0.3759390=MM
DINC5	162	*	229	DIDOT-PUNKT*1.07001=PICA-PUNKT
DINC4	229	*	324	DIDOT-PUNKT*0.014806?=INCH
DINC3	324	*	458	
DINC2	458	*	648	MM*2.66=DITOD-PUNKT
DINC1	648	*	917	MM*2.84527S=PICA-PUNKT
DINC0	917	*	1297	MM*0.0393701=INCH

C 75° 75° 45° IN DER PRAXIS WIRD BEI DER
 RASTERWINKELUNG HÄUFIG
M 45° 15° 75° MIT STANDARDEINSTELLUNGEN
 GEARBEITET
Y 0° 0° 0° HIER DREI BEISPIELE:

K 15° 45° 15°

80MM

80MM

80MM

CONTINUED ON PAGE 281
12/E-18/G

CONTINUED ON PAGE 292
18/E-16/G

80MM

80MM

CONTINUED ON PAGE 291
27/L-19/N

294/295

80MM

80MM

CONTINUED ON PAGE 289
24/H-22/K

CONTINUED ON PAGE 308
18/H-16/K

80MM

OAK TREE
19/I 271
SECT./P. /C.N° /NAME
NBN/LIST OF OBJECTS IN USE

NBN/LOCATION

80MM

80MM

CONTINUED ON PAGE 292
21/A-19/D

WBN/LOCATION

WBN/LIST OF OBJECTS IN USE
SECT. /P. /C.N° /NAME
19/E 164 04.7 TUPOLEV TU-204 B
19/E 165 04.7 TUPOLEV TU-204 C
21/E 165 04.9 TUPOLEV TU-204 C
19/E 164 04.8 TUPOLEV TU-204
21/G 164 03 TUPOLEV TU-204

80MM→

80MM

CONTINUED ON PAGE 299
1B/E-16/G

CONTINUED ON PAGE 297
24/E-22/G

80MM→

80MM→

80MM
80MM
80MM
80MM
80MM
80MM

21-E-19/6
CONTAINER ON PAGE 396

24/6 15¢ BOEING 717 C
23/6 165 TUPOLEV TU-184 C
SEAT /P. /C.N° /NAME
MBN/LIST OF OBJECTS IN USE

MBN/LOCATION

WBN/LIST OF OBJECTS IN USE
SECT. /P. /C.Nº /NAME
22/I 271 723 OAK TREE

CONTINUED ON PAGE 295
21/H-19/K

CONTINUED ON PAGE 302
24/L-22/N

CONTINUED ON PAGE 296
21/E-19/G

CONTINUED ON PAGE 303
18/A-16/G

80MM←

80MM←

←80MM

80MM→

80MM→

80MM

15-E-13/G

WBN/LIST OF OBJECTS IN USE
SECT./P.-/.../CN° /NAME
17/D-023 R22 ZIP B
16/F-023 M20 DISKETTE B
17/F-022 C13 MO B

WBN/LIST OF OBJECTS IN USE

WBN/LOCATION

WBN/LIST OF OBJECTS IN USE
SECT. /P. /C.Nº /NAME
18/J 271 723 OAK TREE

80MM→ 80MM→ 80MM

15/H-13/K
CONTINUED ON PAGE 273

21/H-19/K
CONTINUED ON PAGE 295

CONTINUED ON PAGE 297

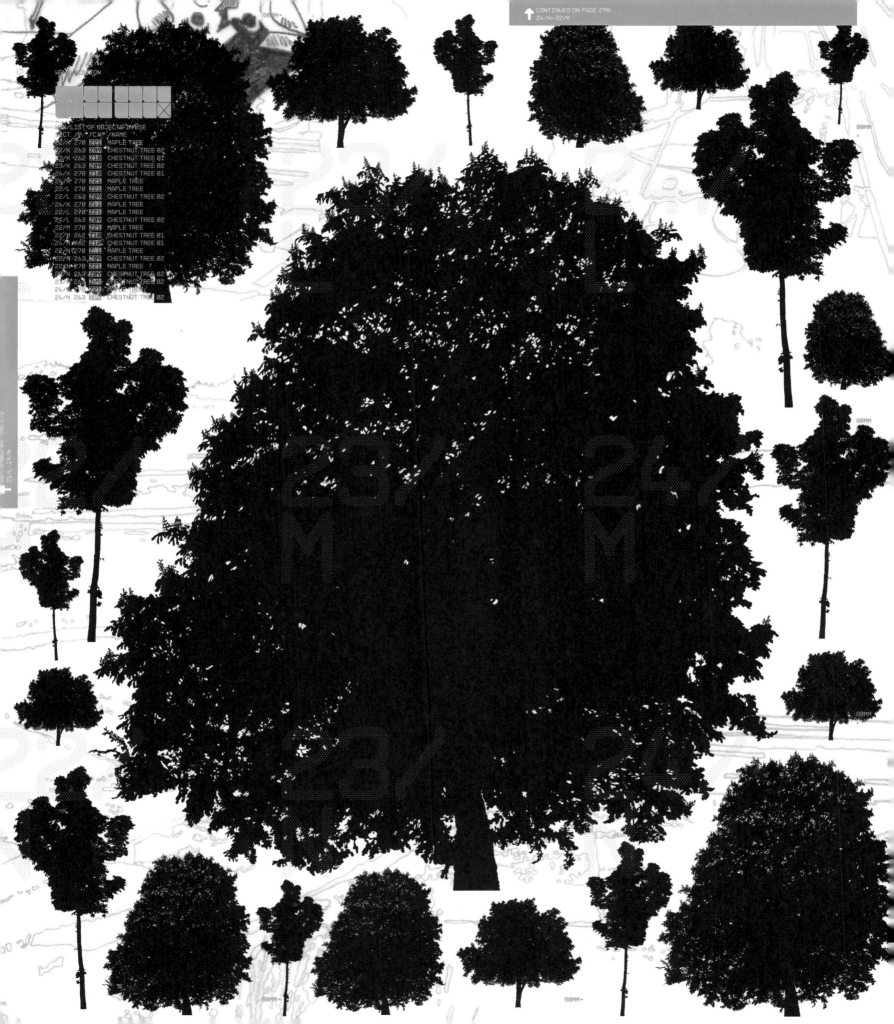

CONTINUED ON PAGE 292
21/A-19/D

CONTINUED ON PAGE 299
15/A-13/D

OLYMPUS
MICROCASSETTE
XB 60
MC-60
JAPAN
JAPAN/JAPON
3-256
A

TDK
DAT
09

16/A 025 M2V	DAT F		
17/A 025 M3V	MD B		
16/B 025 M3B	MINI D/F		
17/B 024 M2D	MINI TAPE F		
18/B 025 M3D	MINI D/F		
16/B 025 M3B	MINI D/F B		

MON/LOT-DF-0252CE10-01-0DE
/P. /C.N° /NAME

80MM
80MM
80MM
80MM
80MM

WELTBAU NEU

STEFAN GANDL
NEUBAU

DIE GESTALTEN VERLAG

INCL.
1 X DATA CARRIER
(INSIDE DATA CARRIER
SHELL)

ISBN 3-89955-072-2

NBW-CDROM

CONTAINING
124.7 FREE EDITABLE
EXCLUSIVE VECTOR OBJECTS
BY NEUBAU

CONTINUE
→